# Essentials

# Autodesk® 3ds Max®

2010

# Foundation for Games

A hands-on introduction to the same tools and techniques professional game
artists use. Learn to create visually rich c[...]
today's most popular games.

Autodesk®

# Autodesk®

PUBLISHED BY: AUTODESK, INC.
111 MCINNIS PARKWAY
SAN RAFAEL, CA 94903, USA

Focal Press is an imprint of Elsevier
30 Corporate Drive, Suite 400, Burlington, MA 01803, USA
Linacre House, Jordan Hill, Oxford OX2 8DP, UK

**NOTICES**
Knowledge and best practice in this field are constantly changing. As new research and experience broaden
our understanding, changes in research methods, professional practices, or medical treatment may become
necessary.
Practitioners and researchers must always rely on their own experience and knowledge in evaluating and using
any information, methods, compounds, or experiments described herein. In using such information or methods
they should be mindful of their own safety and the safety of others, including parties for whom they have a
professional responsibility.

To the fullest extent of the law, neither the Publisher nor the authors, contributors, or editors, assume any
liability for any injury and/or damage to persons or property as a matter of products liability, negligence or
otherwise, or from any use or operation of any methods, products, instructions, or ideas contained in the
material herein.

**LIBRARY OF CONGRESS CATALOGING-IN-PUBLICATION DATA**
Application submitted

**BRITISH LIBRARY CATALOGUING-IN-PUBLICATION DATA**
A catalogue record for this book is available from the British Library.

ISBN: 978-0-240-81194-9

For information on all Focal Press publications
visit our website at www.elsevierdirect.com

09 10 11 12  5 4 3 2 1

Printed in the United States of America

## Acknowledgments

**Michiel Schriever**
Art Direction

**Luke Pauw**
Sr. Graphic Designer

**Elise O'Keefe**
Copy Editor

**Peter Verboom**
Video Producer

**Lenni Rodrigues & Linda Sellheim**
Project Leads

**Lenni Rodrigues**
Program Development Manager

**Richard Lane**
Senior Manager, Customer Learning

**Paul Mailhot**
Sr. Director, Autodesk Learning

**Special thanks go out to:**
Laura Lewin, Kathryn Spencer, Rebecca Pease, Carmela Bourassa, Tonya Holder, Mary Ruijs, Amer Yassine, Marc Dahan, Sebastien Primeau, Steven Schain, Luc St-Onge, Paul Verrall, Sarah Blay, Roberto Ziche.

# Primary Authors

**Donald Ott** | Prop Artist

Donald B. Ott II is a prop artist at High Moon Studios where he is currently working on an unannounced project slated for release in 2010. After graduating high school, he joined the Marine Corps and spent close to eight years enlisted, with services ranging from Infantryman to being a member of the Marine Corps Recruit Depot Color Guard. Having always had a passion for games, after service in the Marines he decided to get into the industry and received his bachelor of science degree in video game art and design.

Ott likes to think of himself as a success story when it comes to education, in that he had no prior 3D experience before going to school, and by the time he graduated he was top of his class and had various opportunities for employment. He has always had a passion for video games and considers himself fortunate to get to work in such an amazing and exciting industry. His work history includes working on virtual reality simulation games for the United States Army as well as various government contracts. He is currently on his third game title at High Moon Studios, and he has been teaching game modeling–related classes and workshops at various colleges for more than two years.

**Tyler Wanlass** | Level Artist

Starting at an incredibly young age, Tyler has been creating games, big and small for almost 13 years. Naturally when he's not at work he's usually thinking about games, playing games, making games, or writing about them. He would also like to think there's a certain leitmotif that plays just before his next big idea pops into his head! Currently he is a level artist at the Activision owned High Moon Studios where he is working on an as of yet, unannounced title for the Xbox 360 and Playstation 3. Prior to his current game, he shipped the *Bourne Conspiracy* for the aforementioned consoles.

**Andy Livingston** | Enviroment Artist

Andy Livingston, native of Pennsylvania, attended Brigham Young University in Provo, Utah receiving a BA degree in Communications/Advertising. He later attended the Art Institute of California – San Diego receiving a BS degree in Game Art and Design. Since then he's worked for Sony Online Entertainment as an Environment Artist for *Everquest*. After that he moved to Los Angeles to work for Activision at Luxoflux Studios. There he's helped create environments for *Kung Fu Panda* the game and most recently *Transformers: Revenge of the Fallen*. His day to day activities as an Environment artist consist of building levels and props, as well as texturing the models he creates. He enjoys drawing, modeling, and spending time with his wife and 4 children.

# Table of Contents

**Project 03**

## How to use this book

How you use *Learning Autodesk 3ds Max 2010* will depend on your experience with computer graphics and 3D animation. This book moves at a fast pace and is designed to help you develop your 3D skills. If this is your first experience with 3D software, it is suggested that you read through each lesson, before you begin to work through the tutorial projects.

**Updates to this book**

In an effort to ensure your continued success with the lessons in this book, please visit our web site for the latest updates available: *www.autodesk.com/learningtools-updates*

**Autodesk packaging**

This book can be used with either **Autodesk® 3ds Max® 2010**, **Autodesk® 3ds Max Design® 2010**, or the free 30-day trial version of **Autodesk® 3ds Max®**, as the lessons included here focus on functionality shared among all three software packages.

**Learning Autodesk 3ds Max 2010 DVD-ROM**

On the DVD you will find Projects 4, 5 and 6 where you will learn to model the *Rook* character, animate the *Rook* and render the final scene for your portfolio or reel. The DVD-ROM also contains several resources to accelerate your learning experience including:

- 3ds Max getting started videos
- Link to trial version of Sketchbook Pro 2010
- Support files

**Installing support files**

Before beginning the lessons in this book, you will need to install the lesson support files. Copy the project directories found in the *support_files* folder on the DVD disc to the *3ds Max\projects* directory on your computer. Launch 3ds Max software and set the project by going to **File** → **Project** → **Set...** and selecting the appropriate project.

**Example**: *C:\Documents and Settings\username\My Documents\3dsmax\projects*

# Project 01

Project 1 is the beginning of your journey into the world of Autodesk® 3ds Max® software and making art for games. In Lesson 2 we will begin by exploring the user interface, known as the UI, as you begin to understand how to move around and navigate in 3D. Next, for Lesson 3 we will discuss primitives as the basic building blocks for creating 3D art. From there, in Lesson 4, we will look at improving our workflow with various methods, starting with layers as well as understand what copies, instances, and references are. Lesson 5 will move past the primitives and into the world of the editable polygon mesh—the staple of creating quality 3D for games. Lastly, in Lesson 6 we will discuss materials and textures and explain the process of giving our objects a recognizable surface. At the end of this project you should be comfortable with navigating the 3ds Max 2010 interface and creating objects, and understand the principles of textures and materials.

# Lesson 01

## Introduction to Modeling for Games

Welcome to *Autodesk® 3ds Max® 2010 | Foundation for Games*. In this book, and through the following lessons, you will be taken through the step-by-step processes of the sort of tasks you could expect to accomplish when working as a game artist. While this book is intended for the beginner 3D artist, following along these lessons will propel you beyond the beginner level and into a more comfortable position with the software when it comes to 3D modeling for games. There are a broad range of topics covered in this book, but it should give you a sampling of the many disciplines and allow you to find one that is the right fit for you. Whether you prefer modeling props, rigging, animating, level building, or character creation, this book covers many of these fields to help you decide. But before you can take the first step, it is important to understand a little about the industry and the software behind being a game artist.

**In this lesson, you will learn the following:**

- Introduction to the gaming industry

- Additional learning outside of this book

- Where to get help with Autodesk 3ds Max

## Introduction to the game industry

Whether you prefer the home computer, the consoles, the handhelds, or the cell phones, there is no denying that video games are all around us. For years video games have slowly but certainly found their way into our homes and into our lives. Through that growth we have also seen a huge improvement in the technology advancements as well. Gone are the days of boxes onscreen representing characters, only to make way for cinematic experiences that are more engrossing and interactive than we ever could have imagined.

Through this growth as well we have seen a larger investment made into the financial side of game development. While there are still a few success stories out there of the clichéd "three guys in a garage," for the most part, games are a multimillion-dollar industry, with multimillion-dollar budgets. Studios that develop games can expect anywhere from one to three years to develop a game, with some going even longer. The studios themselves could have 30, 40, or even 100+ people on staff.

Like cinema, our field is competitive, difficult to break into, and requires a lot of hard work and effort to work in the game industry. Compared to film, some games cost more to create, take longer to make, and similarly can be considered a flop or a success in the blink of an eye.

It is a tough industry, but when it comes to risk versus reward, there are few careers as exciting as the game industry. We have all played a game and watched a cut scene or had a monster jump out and scare us that influenced our emotion and left us with a memorable experience. Being the one to build those experiences and breathe life into these games is only part of the fun of working in the game industry.

*Breathing life into your creations as a game artist is only part of the fun!*

**Project 01**

## Positions available in the game industry

While many of the titles are different from studio to studio, there are a multitude of jobs available when working in the game industry. As bigger-budget games become the norm, studios have been looking for people with a specific set of skills. Unless you are at a smaller "garage" studio, you likely will not have to be an expert at everything, but rather an expert in your specific field. While this book focuses mainly on the art side, there are plenty of other opportunities out there. Here are just a few of the fields you may consider.

1   **3D Artist / Shader Artist**

Whether you are a character artist, a prop artist, or an environment artist, the 3D artist is responsible for creating the 3D art that populates the world in video games. Whether they are adjusting lighting on a level or building a finished piece of architecture, the 3D artist is on the job! A shader artist may work directly with the 3D artist to create advanced materials that go beyond traditional texturing.

2   **Animator**

The animator is the one responsible for making everything move. Whether your character needs to do a summersault or a car needs to flip over, the animator is in charge of the motion.

3   **Rigger/Setup**

A rigger is someone who goes between the animator and the artist and sets up all the bones and skin inside characters or objects so that they can move. It is a very technical process, but animation could not exist without rigging.

4   **Technical Artist**

The technical artist goes between the programming and the artist to bridge the gap between the two. They can also be responsible for creating tools and improving the workflow pipeline across all disciplines. A technical artist is the jack of all trades.

5   **Programming/Engine Programming**

The programming team is responsible for the "under the hood" work behind making your game and your game engine run. Whether they are making your weapons work, your AI react the way they are supposed to, or setting up a new multiplayer game type, the programmers never have a shortage of work. Regardless of what sort of game you are making or how big your budget is, the programmers are the ones responsible for making things happen!

## 6    Concept Art/Cinematics

The concept artist is responsible for putting ideas down on paper so that the 3D artist has a blueprint to work from. They take direction from the lead artist and try to imagine and visualize what the game is going to look like. The cinematic teams can be utilized to either concept action flow or movement in the game, as well as the ingame cinematics. If you have ever seen a story board for a film, the cinematics team can be found drawing these up to visualize what the action is going to look like.

## 7    Game Designer / Technical Design

The game designer is responsible for conceptualizing and building the fun. When working with a technical designer, they are responsible for coming up with, and building, the ideas for what is going to actually happen in a game. They work with balancing, pacing, and building to create an experience you will enjoy.

## 8    FX / Audio

For every explosion or laser blast you have seen, an FX artist might have been responsible for creating it. If it is in your game and it needs sound, you call the audio team. The audio department is responsible for the sound effects, music, voices, and more inside your game.

*All of the different disciplines work together to create an epic experience.*

## Going beyond this book.

This book will work with you as a guide to your introduction into the world of games, particularly as it applies to working with Autodesk 3ds Max 2010 software as an artist. As technology progresses, the gaming industry is moving with it. If you have ever bought a computer, you know about technology. No text could ever hope to have the latest techniques, as by the time it is published something new, faster, and better is already there.

Thankfully the gaming industry has a wealth of resources beyond the software to help you learn more and keep up to date with the latest and greatest techniques. There are plenty of web forums and game art communities that are filled with other people just like you who are willing to lend a hand or assist with any technique you might be confused with. Just to name a few:

**http://www.autodesk.com/community**  Your one-stop shopping for all things Autodesk, ranging from forums, tutorials, or downloads, this is a great start for additional learning.

**http://forums.cgsociety.org**  With more than 380,000 members, CGSociety is still one of the bigger and the best forums related to all things computer generated. Registration is free.

**http://boards.polycount.net** With more than 15,000 members, Polycount is where hardened veterans and noobies alike come together to learn and share the latest techniques in game art. Registration is free.

**http://gameartisans.org/forums**  With more than 23,000 members, Game Artisans is yet another great community for sharing and learning about 3D techniques. Registration is free.

**http://www.autodesk.com/creativecareers** Creative Careers Classified is a new micro-site that lives within the AREA online community and is designed to expose students to a wide range of entry-to-mid level jobs and help them get the skills they need to obtain these jobs.

## Additional help with 3ds Max 2010

While much of the topics covered in this book should guide you with a step-by-step instruction, sometimes it is easy to get confused. The first thing you should do if confusion strikes is bring up 3ds Max software's extensive Help feature. Once you have the program open, press the F1 key on your keyboard to access the Help. You can browse the default Contents, or if you would like to search, click the Search tab and type in the subject you need more information on. Much of the information covered in this book can also be explored further through the Help menu.

*Inside 3ds Max, press F1 to access the extensive Help feature.*

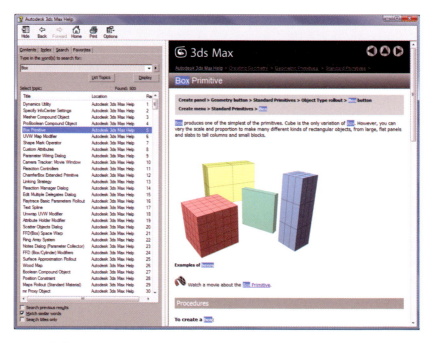

*To search for a topic, click the Search tab and type the subject you would like more information on.*

## Conclusion

Congratulations! You have completed your first lesson. Hopefully you now have a better understanding of the game industry, know a little about a few of the jobs that make up the industry, and are now armed with a few tools needed to do some additional learning if needed beyond this book. In the following lesson we will begin by opening 3ds Max, and learning about some of the key elements in the user interface.

# Lesson 02
## Interface and UI

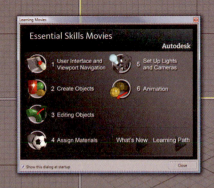

In this lesson, you will learn the basic fundamentals of the Autodesk® 3ds Max® 2010 interface. While it can seem somewhat daunting the first time you open 3ds Max, we will cover the fundamentals you will need to start creating 3D art in no time. As you begin to explore the 3ds Max user interface (UI), we will look at some of the important elements as it pertains to a 3D game artist.

**In this lesson, you will learn the following:**

## Opening Autodesk 3ds Max 2010

After installing 3ds Max 2010 you can open it two separate ways. One is by simply double-clicking on the icon that 3ds Max will have generated during installation on your desktop.

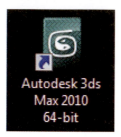

*3ds Max 2010 desktop icon.*

Alternatively, you can navigate to 3ds Max in Windows® by navigating to **Start** → **Programs** → **Autodesk** → **Autodesk 3ds Max 2010**. Upon launch you should be given two options. If you have purchased 3ds Max 2010 you will have an activation code that came with the software documentation. Follow the steps on-screen during the activation process to launch the software. If you are using 3ds Max on a trial basis, choose that option and the software should load with a 30-day trial that has all of the features of the regular version for a limited time.

Once the software loads, you will see 3ds Max software's first splash screen.

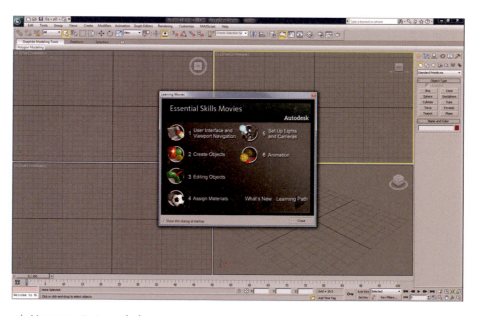

*3ds Max 2010 startup splash screen.*

Here you will find that the first splash screen points you in the direction of Essential Skills Movies. These short movies are designed to jump start you in the direction of whatever it is you are using 3ds Max 2010 for. By clicking on any of the six movie choices, 3ds Max will automatically launch your default Internet browser and begin playing a short video, giving you some basic instruction on your topic of choice. These video clips are just a small taste of the help that is available for you when learning the software.

The **What's New** option will launch your default Internet browser and take you to the Autodesk website dedicated to explaining the newest features in this version of 3ds Max. If you are familiar with previous versions of 3ds Max, this site will provide you with additional training and videos on the most recent additions to the software.

The **Learning Path** option will launch your default Internet browser and take you the Autodesk 3ds Max Service and Support website. This site can point you in the direction of a multitude of topics regarding 3ds Max, including tutorials, discussion forums, additional help and documentation, as well as events and seminars. If you are new to 3ds Max, this is a great resource for furthering your education or finding answers to questions you may have while learning the software.

Lastly, on the bottom left of the box you can check on or off under **Show this dialog at startup** to show this popup when you launch 3ds Max or not. If you decide to not have the box pop up at launch, but would like access to any of these features, you can find them under the **Help** menu on the main toolbar.

Once you have clicked **Close**, you are looking at the default 3ds Max 2010 interface. Take a moment to get familiar with the basics of the interface as we start to address some of the key elements.

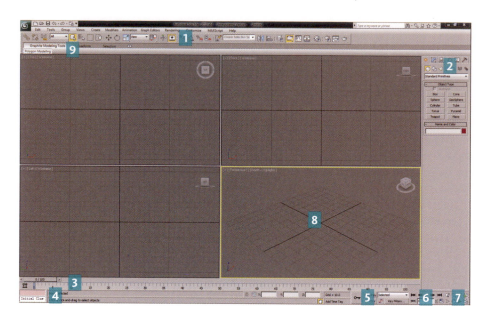

*The 3ds Max 2010 interface.*

## Key Interface Elements

Using the image above as a guide, let's look at some of the main UI elements in 3ds Max 2010.

**1**  **Main Toolbar**

The main toolbar provides quick access to tools and dialog boxes for many of the most common tasks in 3ds Max 2010.

**2**  **Command Panel and Menu Bar**

The command panel comprises six user-interface panels that give you access to most of the modeling features of 3ds Max 2010, as well as some animation features, display choices, and miscellaneous utilities. To switch to a different panel, **LMB** click the tab at the top of the command panel.

**3**  **Time Slider**

The time slider lets you navigate along the timeline and jump to any animation frame in your scene. You can quickly set position and rotation or scale keys by **RMB** clicking the time slider and choosing the desired key from the Create Key dialog box. We will discuss animation and the time slider further in Lesson 11, as well as Projects 5 and 6.

**4    Status Bar Controls**

The 3ds Max 2010 window contains an area at the bottom for prompt and status information about your scene and the active command. To its right/left is the coordinate display area, in which you can manually enter transform values. To its left, is the MAXScript listener window, where you input single-line scripts.

**5    Animation and Time Controls**

Between the status bar and the viewport navigation controls are the animation controls, along with the time controls for animation playback within viewports. Use these controls to affect your animation over time. We will discuss animation and the time controls further in Lesson 11, as well as Projects 5 and 6.

**6    Animation Playback Controls**

Use these buttons to see your scene in motion through time. We will discuss animation and the playback controls further in Lesson 11, as well as Projects 5 and 6.

**7    Viewport Navigation Controls**

Use these buttons to navigate your scene within the viewports. As we progress further in this lesson we will explore these features more.

**8    Viewport**

When you start 3ds Max 2010, the main screen contains four viewports showing the scene from different angles. By default you are looking at the Top, Front, Left, and Perspective views respectively. The Top, Front, and Left views are 2D representations of your scene, also referred to as Orthographic views. The Perspective viewport, by contrast, most closely resembles human vision in 3D. We will cover viewport navigation further in this lesson.

**9    Graphite modeling tools**

The graphite modeling tools menu is new with 3ds Max 2010, and it combines a wealth of new polygon-modeling features, including freeform sculpting and powerful loop-modeling tools, with the tried-and-true toolset in a dynamic, configurable new ribbon interface. By clicking the small arrow button at the end of the bar you can minimize and maximize the toolbar.

## Navigating the viewports, Interface, and 3D Space

Now that we have the very basics of what each element in the UI is, let's focus a little more on some specific tips for navigation and getting around.

### Menus, Features, and Moving Around

The menu bar along the top of the interface contains a large number of the most commonly used functions in 3ds Max. For almost every single button or icon you can click on, there is likely a menu function associated with it. As we move forward in the lessons, menu items are referenced as **Menu Name** → **Submenu** → **Menu Item**. For example, if you needed to create a cylinder, you could do so by **LMB** clicking **Create** → **Standard Primitives** → **Cylinder** in the menu bar.

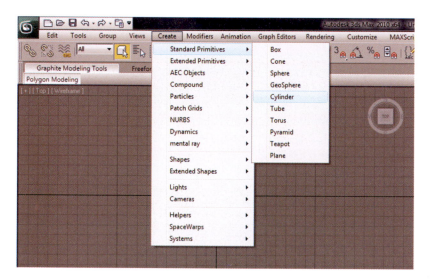

*Creating a cylinder using the menu bar.*

Directly underneath the menu bar is the Main toolbar. It is primarily a series of icons that take some memorizing to get used to, but handle a large number of the most commonly used 3ds Max functions. These functions are accessed by **LMB** clicking on them. Some of the buttons along the Main toolbar have additional functions by **RMB** clicking on them as well. We will discuss several of these additional features throughout this book.

*The default Main toolbar found under the menu bar.*

Directly underneath the Main toolbar are the graphite modeling tools. This new toolset contains a series of tools new to 3ds Max 2010, as well as a neatly organized collection of some of the most commonly used functions while creating 3D geometry. Without having created anything yet you will not see many options, but as you begin to build your assets these tools will come to life with all sorts of features and functions to improve your modeling speed and quality. To expand the menus, simply **LMB** click on any of the tabs to access their features.

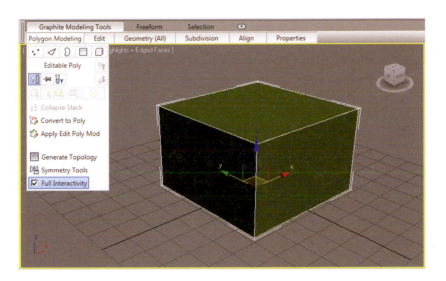

*A small example of the many features in the graphite modeling toolset.*

As you have already noticed, the predominant real estate on screen is four separate windows into 3D space, called viewports. These windows each represent a different view of your scene or asset. To access any of the viewports individually, you do so by **LMB**, **RMB**, or **MMB** clicking the desired viewport. You will see a yellow highlight along the border of the viewport you currently have selected.

If you would like to maximize any of the views on your screen, rather than working with all four of them open, you can do so by first accessing your desired viewport and then pressing **Alt + W** on your keyboard. Alternatively, at the very bottom right corner of the UI you can also press the **Maximize Viewport Toggle** to maximize or minimize the currently accessed viewport.

*Press Alt + W or use the Maximize Viewport Toggle to maximize your selected viewport.*

Working with a maximized viewport is a personal preference, but it definitely increases the visual workspace of your scene or asset. To quickly move back and forth between the various viewport options, you have more than one way to do it. **RMB** clicking on the Perspective title in the upper right-hand corner of your viewport can allow you to **LMB** click any of the desired views to choose them. Alternatively, using the hotkeys can be a quick option as well.

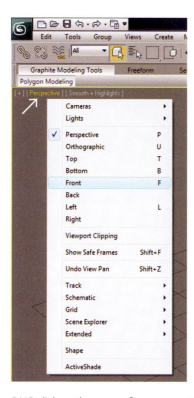

*RMB click on the name of your current viewport to bring up additional view choices.*

**Tip:** *If you want to work with multiple viewport windows, there are a couple options to customize the look of them. **LMB** click on the very center of the four viewports and you will see the icon change, allowing you to drag the windows to the size you deisre. Also, you can access preset configurations by clicking the + button at the top of any of the viewport windows and choosing **Configure**, and choosing the **Layout** tab. Here you can choose any of the premade layouts and then click OK. You can also access this window under **Views → Viewport Configuration**.*

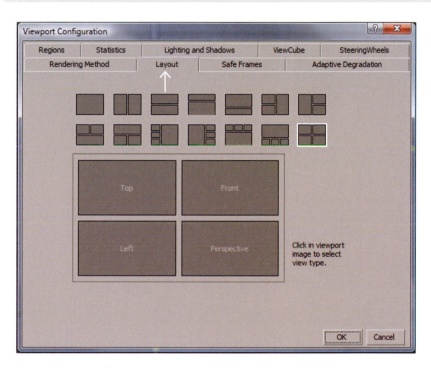

*The Viewport Configuration window with the Layout tab selected.*

In any viewport, to drag the camera around freely, **MMB** click and hold anywhere in any of the viewports left, right, or up and down, and you will drag the camera in that direction. Keep in mind that this does not actually move anything in your scene, it simply moves the camera that is pointed at your scene.

Rolling the **MMB** up or down will cause your camera to zoom forward or back. Holding down the Alt button while rolling the **MMB** will slow the speed of zoom.

Holding down the **Alt** and the **MMB** simultaneously will cause your camera to roll around the object in 3D space.

If at any time during your camera movements you want to get back to the center of the grid (known as 0,0,0) or frame the camera on your selected object(s) you can either click the Zoom Extents to center in just one currently active viewport, or the Zoom Extents All option will frame all of the viewport windows you currently have open.

*Use the Zoom Extents or Zoom Extents All choices to frame your selection inside the current viewport.*

**Tip:** *The **Z** key is the default hotkey for **Zoom Extent All** Selected. Get used to quickly moving around in 3D Space and then tapping the Z hotkey to quickly reframe your scene.*

## Navigating the Command Panel

The **Command Panel** along the right side of the UI is where a large number of creation and adjustments are made to geometry. Aside from the new **graphite tools**, this is also where the majority of the polygonal mesh functions are found as well. While there are a large amount of tools to cover, for the first project we will focus on just a few.

To access the various tabs, pull-down, or objects from the **Command Panel**, simply hover your mouse over the desired selection and **LMB** click it.

The **Create** tab features the majority of objects to create, ranging from various 3D and 2D shapes, cameras, lights, and more. Under the Create tab there are many other subgroups as well as pull-down menus for all the different things you can create. Keep in mind that any of these shapes or objects are simply building blocks for the objects we will be creating.

The **Modify** tab is where specific adjustments are made to the specific selected objects, as well as the many modifiers we will use when working with 3D. If you have nothing selected it will be blank, because you have nothing selected to modify.

The **Hierarchy** tab is where adjustments to an object's pivot point can be made, or we can utilize the working pivot. We will dive further into this later.

The **Motion** tab is focused more for animation and trajectories.

The **Display** tab allows you to quickly filter what is being shown on screen with various category options.

*The Command Panel, with the Create tab selected, Geometry option chosen, and Box selected.*

The **Utilities** tab has a preset collection of various unique tools and functions.

As you may notice, there are several submenus in the Command Panel. In the example to create a Box, you can see **Object Type**, **Name and Color**, **Creation Method**, **Keyboard Entry**, and **Parameters** as the submenus. To expand or collapse submenus inside of the Command Panel, simply hover your mouse over the name of the submenu, and **LMB** click to expand or collapse.

*The Command Panel, with several of the submenus collapsed.*

## Creating and naming objects in 3ds Max 2010

Now that you understand the very basics of the interface as it pertains to game asset modeling, let's go ahead and create our first object in 3D space. Keep in mind that we will be exploring a large amount of the interface as we move forward, but hopefully you are starting to get familiar with it.

1    **Create a geometry box.**

For your first object, let's create a simple box.

- In the Command Panel, select the **Create** tab, the **Geometry** option, and the **Box** as the Object type.

- In the **Perspective** viewport, hold the **LMB** and drag it around anywhere in the viewport. As you are moving the box around in the viewport, you are identifying its length and width.

- Release the **LMB**, and move the mouse up or down in the viewport. This is identifying the object's height.

- When you get a height you are happy with, click the **LMB** again.

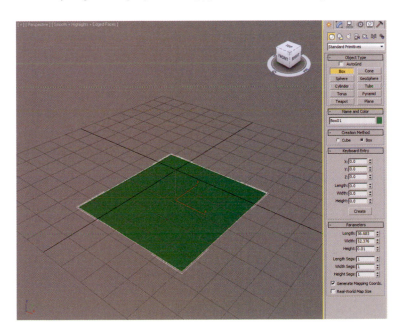

*Start by dragging the box in the Perspective viewport.*

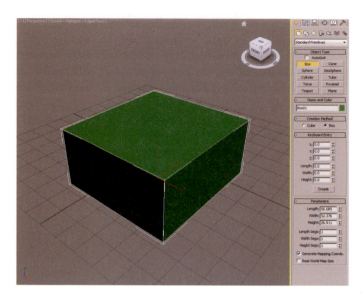

Move the mouse up to identify the box height.

2   **Name the box and change its color.**

Now that you have created your first box, let's name it something and change its color.

- Start by selecting your box. You do this by **LMB** clicking on the box in the viewport.

- In the Command Panel, under the **Name and Color** submenu, type in a new name for your box.

- Next to the name, you should see a color box. In my example you can see it as a green box. Yours might be a different color because by default 3ds Max will randomly choose a color for you when you create a new object.

- Click the color box using the **LMB** and a new window should appear.

- In the **Object Color** window, pick any color you want to change the color of your box.

**Tip**:   *In the **Object Color** window, you can turn off the random color generation by unchecking the box next to **Assign Random Colors**. Any color you choose will be the default color of all of your objects you create from now on.*

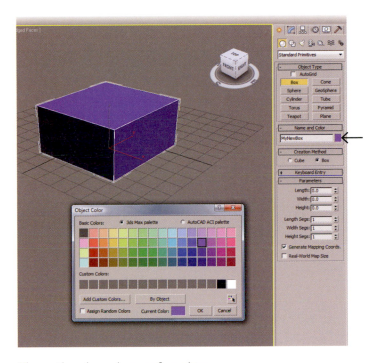

*Change the color and name of your box.*

## Changing the display of objects you create

Now that you have created your first object in 3D space, feel free to play around with other shapes. The creation method for many of them is very similar and we will further explore more primitives in the next chapter. Regardless of which shape you create, there are a few methods to adjusting how you view objects in 3D space.

For whichever viewport you are in, you will notice there are several different viewport options in the top left-hand corner of the viewport itself. By default when you start max, the setting should be **[Smooth + Highlights]**, as indicated between the two **[ ]** brackets. This setting is how the object inside the viewport is rendered, in this case, you can see smoothing on rounder or softer geometry, and there will be a lighting highlight. You can change this by **LMB** clicking on the [Smooth + Highlights] option and selecting a different view as you choose.

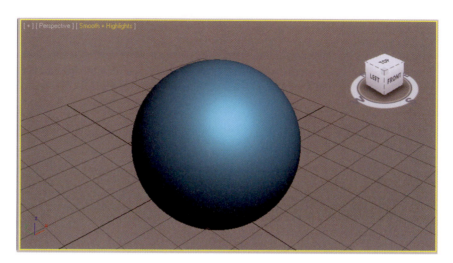

*The Default [Smooth + Highlights] viewport setting on a sphere.*

*The option changed to [Wireframe] viewport setting on a sphere.*

It is also possible to select **[Smooth + Highlights]** and **[Edged Faces]** at the same time as well.

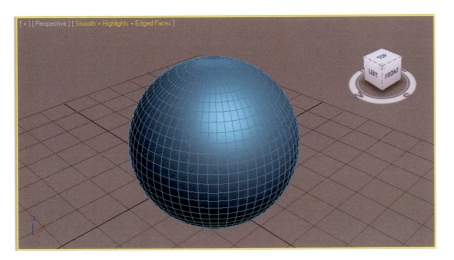

*The [Smooth + Highlights] and [Edged Faces] both selected in the viewport.*

> **Tip**: *While it is possible to change these visual choices in the drop-down menu, getting used to using the hotkeys for them will greatly speed up your workflow. As you start working with more complex scenes and objects, you will constantly be going back and forth between wireframe, flat shaded, and shaded + edge faces.*

- The default hotkey to toggle back and forth between **[Smooth and Highlights]** and **[Wireframe]** view modes is **F3**.

- The default hotkey to turn **[Edged Faces]** on and off is **F4**.

## Setting a project folder

When you start working with a scene in 3Ds Max, either through the course of this book or on your own, it is a good idea to start getting into the habit of setting up your project folders before you begin. While at first it is simply good to keep track of your 3ds Max files, as your scenes start to get bigger and bigger and contain multiple different assets, you will definitely want to keep track of all of them.

**1    Set your project path.**

To set up your project path, click the icon in the upper-left corner.

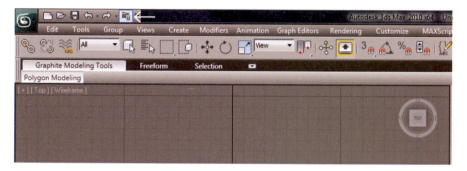

*Clicking this icon in the upper-left corner if your UI will allow you to set a path for your project.*

**2    Create a new folder for your project.**

After clicking this, the Browse For Folder window will pop up asking you for where you want to set the root of your project folder. Think of this as the place on your computer where you want to store everything associated with this project. Navigate to where you want to store your project, **LMB** click the Make New Folder button and rename the folder.

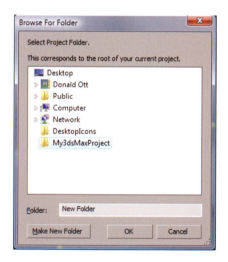

*Create a new project folder named My3dsMaxProject on the desktop.*

## Saving your scene

Few things are more important than saving and backing up your work. Since we set up a project folder, by default when you attempt to save your scene it will drop it under the *scenes* folder inside of your project.

**1    Click the 3ds Max icon to access your file options.**

To start with, click the **File** icon (which is the large 3ds Max icon) in the top-left corner of the menu bar to bring up your file options.

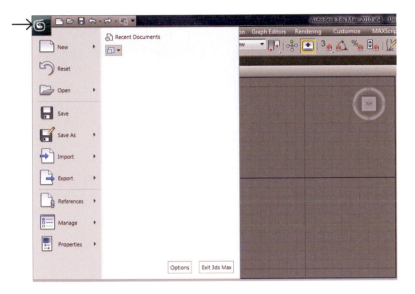

*Clicking the 3ds Max icon will bring up your file options.*

**2    Choose your file options.**

As you hover over the different menu items under the File Options, you will see additional options and explanations pop up in the right side of the menu. Some of the more common file options you should be familiar with are as follows.

- **New**—These options can maintain some of your current scene settings, but will create a new 3ds Max scene for you.

- **Reset**—Think of **Reset** as a whole fresh new scene. This is the same as restarting 3ds Max. You will lose all of your current settings and they will go back to the default.

- **Open**—As expected, this is the option to open previous 3ds Max files.

- **Save**—The default save. The first time you Save it will direct you to the scene folder of your project folder structure. You can, however, choose to save your scene anywhere you wish.

- **Save As**—Similar to the normal Save, but also includes the options to use an incremental save as well as saving only selected objects in your scene. The **Save As** → **Save Selected** option will take only what you currently have selected in your scene and save that as a completely unique file. The **Save Copy As** option will automatically add a numeric extension to the end of your file. For example, if your scene is called MyScene, using the **File** → **Save As** → **Save Copy As** will automatically attempt to save your scene as MyScene01. This is optional, but it is definitely helpful when you want to be able to save your scenes in chronological order or have a safe point to go back to later.

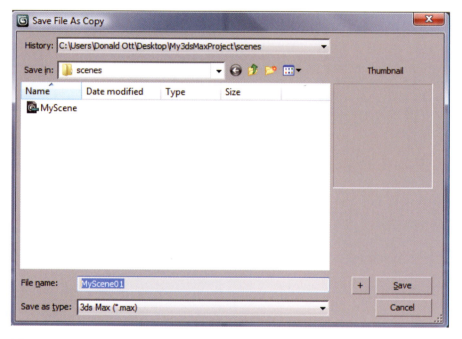

*File → Save As → Save Copy As will automatically add a numeric extension to your file name.*

- **Import / Export**—The **Import** and **Export** options are useful when working with various file types that may have been exported from other software packages, as well as merging 3ds Max files together. We will cover this more in Chapter 6.

## Conclusion

Congratulations! You have completed your first introduction to 3ds Max. You should now be able to easily navigate the different views and change the basic display settings for objects you create. You should also be confident in setting up a project folder to begin saving your scenes, and you should understand some of the basic names and functions of the UI that will aid you in the following chapters.

In the next lesson, you will explore deeper into creating 3D objects and primitives, as we start by blocking out a basic prop and further explore navigating around in the viewports and in 3D space.

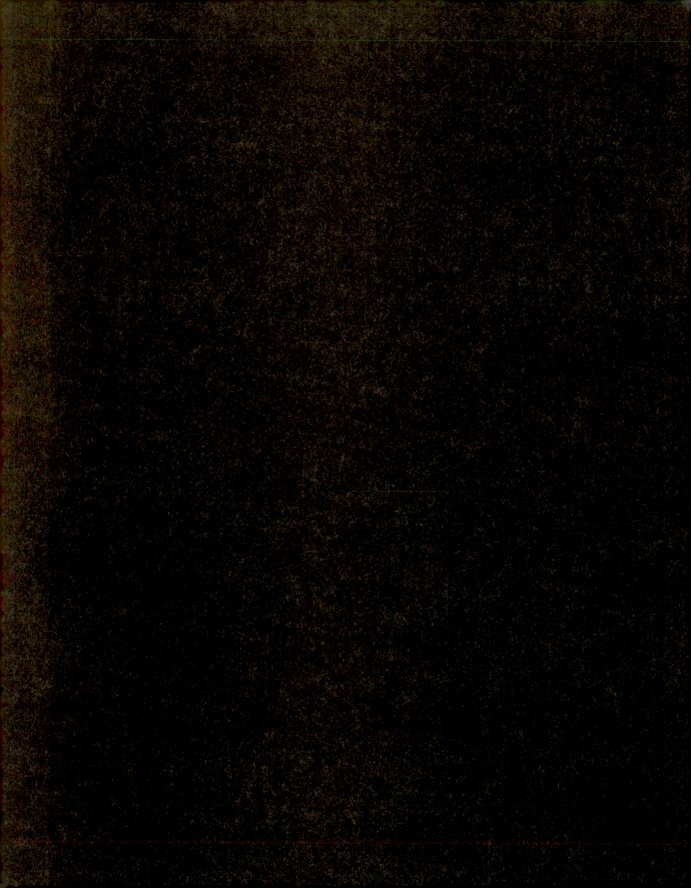

# Lesson 03
## Primitives

In this lesson, you will learn the basics of creating primitives using Autodesk® 3ds Max® 2010 software. We will cover the fundamentals you will need to start creating 3D art beginning with the basic primitive shapes. As you begin to explore and understand primitives and how they pertain to 3D, you will also be able to more easily navigate the viewport and construct basic shapes.

**In this lesson, you will learn the following:**

## What primitives are

Before you can start building the world's best game level, or the coolest game character anyone has ever seen, the forms and shapes to make those things almost always start with primitives. Primitives are the very basic 3D shapes that make up the foundations of more complex shapes. In 3D modeling, primitives are used as the rough first-pass shapes that an artist may create before adding to the model to make it more complex. For example, a skyscraper or a might start with a box. A fireman's pole might start as a cylinder. A bed sheet—a plane.

Look at the world around you. You are surrounded by boxes, cylinders, spheres, planes, and tubes. This very book you are holding is made up of a series of primitives! Whether you are creating props for a game or a game level, primitives are the building blocks that every artist must control before moving on to more complex 3D modeling. Even Michelangelo started with a box.

## Standard primitives

Let's take a look at some of the more commonly used primitives and a brief description of them. While this is not all of the primitives you can create in 3ds Max 2010, these are some of the more commonly used ones you will want to familiarize yourself with as you begin to work in 3D.

**Box**—The box is the simplest and most primitive of them all, but from which an enormous amount of shapes can ultimately emerge. Also known as a cube, the box is created with a default six sides.

**Cone**—The cone is a slightly tapered cylinder that can either have two flat ends, or one flat end and one sharp point.

*A box primitive.*

*A cone primitive.*

**Sphere**—The sphere is a round ball. By default, the sphere has a uniform circumference and radius.

**Cylinder**—The cylinder is a round primitive that extends along a height parameter, and the radius can be adjusted as well.

*A sphere primitive.*

*A cylinder primitive.*

**Tube**—The tube is a hollowed out cylinder that has geometry along the outside as well as the inside.

**Torus**—The torus primitive is a wheel or tube shape that forms a circle.

*A torus primitive.*

*A tube primitive.*

**Pyramid**—The pyramid is a simple five-sided shape, with four of the sides meeting at a point.

**Plane**—The plane is a very simple flat piece of geometry with no height or width. Think of it as a flat sheet of polygons.

*A plane primitive.*

*A pyramid primitive.*

## Extended Primitives

A bit more complex are the extended primitives. These shapes attempt to bridge the gap between the basic primitives and editable polygon objects, which we will discuss further in Lesson 5. We will not list all of them here, but there are a few shapes you might fight useful as you begin to use primitives.

**Chamfer Box**—The chamfer box is very similar to the regular box primitive, but you have the ability to round off the edges—also known as chamfering.

**Chamfer Cylinder**—The chamfer cylinder is very similar to the regular cylinder primitive, but just like the chamfer box, you can chamfer the edges as well.

*A chamfer box extended primitive.*

*A chamfer cylinder extended primitive.*

**Oil Tank**—The oil tank is a cylindrical shape with rounded caps on both ends.

**Capsule**—The capsule is similar to the oil tank, but fully rounds off the ends.

*An oil tank extended primitive.*

*A capsule extended primitive.*

**L-Extent**—The L-extent extended primitive creates an elbow joint shape similar to the letter L.

**C-Extent**—The C-extent extended primitive creates a corner joint shape similar to the letter C.

*A C-extent extended primitive.*

*An L-extent extended primitive.*

## Creating Standard Primitives

In the previous chapter we briefly discussed how to create your first box. Many other primitives are created in a very similar fashion. Let's discuss some of the more commonly used primitives and identify exactly how to create them.

1   **Create a primitive box.**

For our first primitive, let's create that simple box again.

- In the Command Panel, select the **Create tab**, the **Geometry** option, and choose the **Box** as the Object Type.

- In the **Perspective** viewport, hold the **LMB** and drag it around anywhere in the viewport. As you are moving the box around in the viewport, you are setting its length and width.

- Release the **LMB**, and move the mouse up or down in the viewport. This is setting the object's height.

- When you get a height you are happy with, click the **LMB** again.

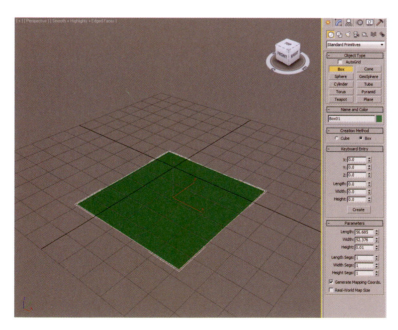

*Start by LMB dragging the box in the Perspective viewport.*

Project 01

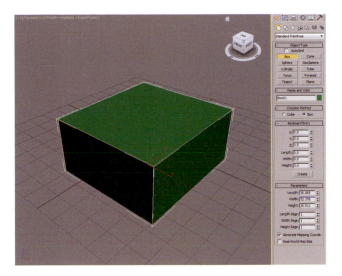

*Move the mouse up to set the box's height.*

**Tip:** *From the Creation Method submenu for the Box, you can choose the option of* **Cube** *instead of* **Box***, and when you* **LMB** *drag in the viewport, all of the parameters (length, width, height) will be uniform.*

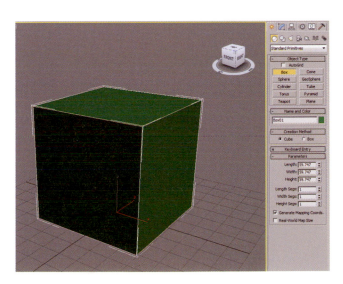

*Choosing Cube from the Creation Method submenu.*

## 2    Create a primitive sphere.

For our second primitive, let's create a sphere.

- Select the **Geometry** option and choose **Sphere** as the Object Type.

- In the **Perspective** viewport, hold the **LMB** and drag it around anywhere in the viewport. As you are moving your mouse around in the viewport, you are setting the sphere's radius.

- When you get a radius you are happy with, release the **LMB**.

*Creating the sphere in the Perspective viewport.*

## 3    Create a primitive cylinder.

For our next primitive, let's create a cylinder.

- Select the **Geometry** option and choose **Cylinder** as the Object Type.

- In the **Perspective** viewport, hold the **LMB** and drag it around anywhere in the viewport. As you are moving the shape around in the viewport, you are setting the cylinder's radius.

- Release the **LMB**, and move the mouse up or down in the viewport. This is setting the cylinder's height.

- When you get a height you are happy with, click the **LMB** again.

*Start by LMB dragging the cylinder in the Perspective viewport.*

*Move the mouse up to set the cylinder's height.*

4    **Create a primitive tube.**

For our next primitive, let's create a tube.

• Select the **Geometry** option and choose **Tube** as the Object Type.

• In the **Perspective** viewport, hold the **LMB** and drag it around anywhere in the viewport. As you are moving the shape around in the viewport, you are setting the tube's **Radius 1**, which ultimately can be either the inner or outer radius.

• Release the **LMB**, and then move the mouse left or right in the viewport. This will determine the tube's **Radius 2** parameter, which is either the inner or outer radius.

• When you get a radius you are happy with, click the **LMB** again.

• Move the mouse up or down in the viewport to determine the tube's height.

• When you get a height you are happy with, click the **LMB** again.

*Start by LMB dragging the tube in the Perspective viewport to set the Radius 1.*

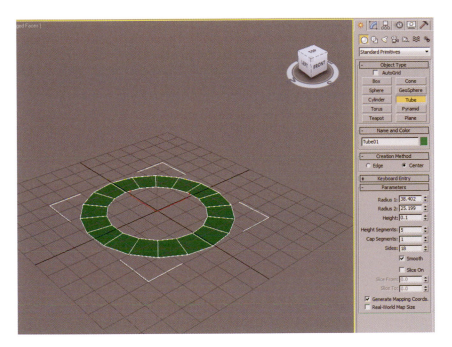

*Move the mouse left or right to set the tube's Radius 2.*

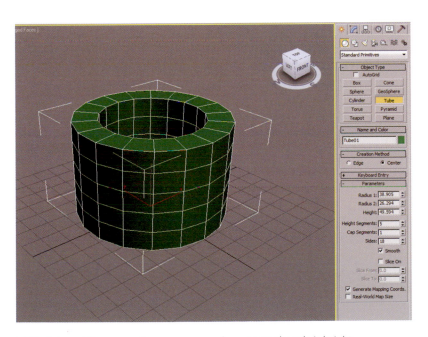

*LMB click, and then move the mouse up or down to set the tube's height.*

5    **Create a primitive plane.**

For our next primitive, let's create a plane.

- Select the **Geometry** option and choose **Plane** as the Object Type.

- In the **Perspective** viewport, hold the **LMB** and drag it around anywhere in the viewport. As you are moving your mouse around in the viewport, you are setting the plane's length and width.

- When you get a size you are happy with, release the **LMB**.

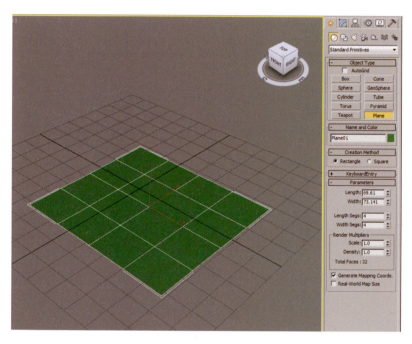

*Creating the plane in the Perspective viewport.*

**Tip:**    *From the Creation Method submenu for the Plane, you can choose the option of* **Square** *instead of* **Rectangle**, *and when you* **LMB** *drag in the viewport, both of the parameters (length and width) will be uniform.*

# Creating Extended Primitives

Creating extended primitives works very similarly to standard primitives. Like the standard ones, some of the parameters have specific creation requirements depending on the primitive you are trying to make.

As you may have noticed, the extended primitives are not in the same creation area as the standard primitives. To access the Extended Primitives, or other geometric shapes to create, in the Command Panel, select the Geometry option and **LMB** click on the drop-down menu. By default it should be set to **Standard Primitives**. Select **Extended Primitives** to change the different object types and reveal a new set of primitives.

*LMB click the drop-down menu and choose Extended Primitives.*

*A new list of primitives appears.*

1    **Create an extended primitive chamfer box.**

For our first extended primitive, let's create a chamfer box.

- From the Command Panel, select the **Create tab**, the **Geometry** option, **Extended Primitives** drop-down, and choose **ChamferBox** as the Object Type.

- In the **Perspective** viewport, hold the **LMB** and drag it around anywhere in the viewport. As you are moving the object around in the viewport, you are setting the chamfer box's length and width.

- Release the **LMB**, and move the mouse up or down in the viewport. This is setting the object's height.

- When you get a height you are happy with, click the **LMB** again.

- After clicking the **LMB** to get the height, move the mouse left-to-right to determine the Fillet amount, also known as the chamfer amount.

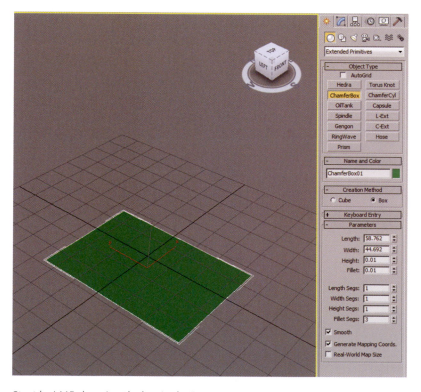

*Start by LMB dragging the box in the Perspective viewport.*

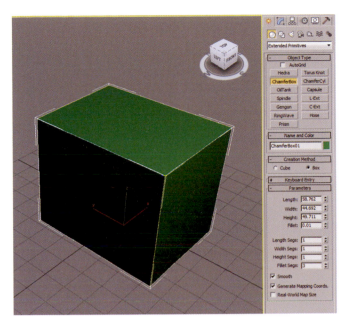

*Move the mouse up to set the box height.*

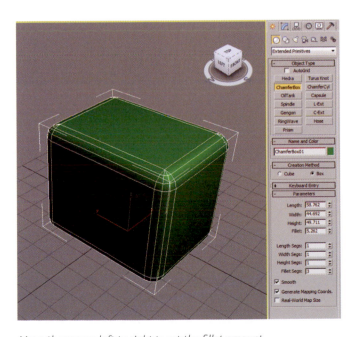

*Move the mouse left to right to set the fillet amount.*

**2    Create an extended primitive chamfer cylinder.**

For our next extended primitive, let's create a chamfer cylinder.

- Select the **Geometry** option and choose **ChamferCyl** as the Object Type.

- In the **Perspective** viewport, hold the **LMB** and drag it around anywhere in the viewport. As you are moving the object around in the viewport, you are setting the chamfer cylinder's radius.

- Release the **LMB**, and move the mouse up or down in the viewport. This is setting the object's height.

- When you get a height you are happy with, click the **LMB** again.

- After clicking the **LMB** to get the height, move the mouse left-to-right to determine the **Fillet** amount, also known as the chamfer amount.

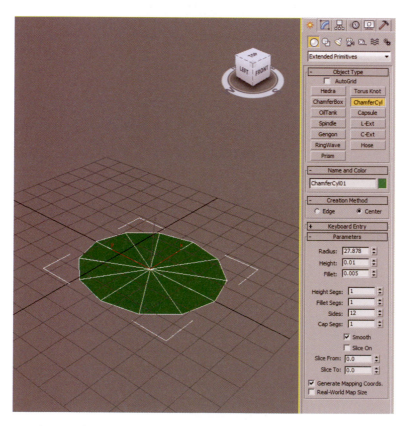

*Start by LMB dragging the chamfer cylinder in the Perspective viewport.*

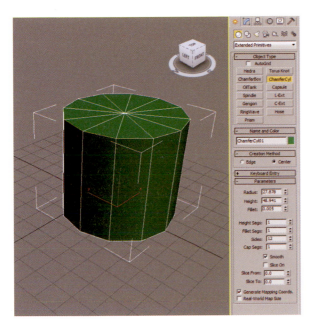

*Move the mouse up to set the chamfer cylinder's height.*

*Move the mouse left to right to set the fillet amount.*

**3**    **Create an extended primitive L-extent.**

For our next extended primitive, let's create an L-extent.

- Select the **Geometry** option and choose the L-Ext as the Object Type.

- In the **Perspective** viewport, hold the **LMB** and drag it around anywhere in the viewport. As you are moving the object around in the viewport, you are setting the L-Ext's Side and Front lengths.

- Release the **LMB**, and move the mouse up or down in the viewport. This is setting the object's height.

- When you get a height you are happy with, click the **LMB** again.

- After clicking the **LMB** to get the height, move the mouse left-to-right to determine the Side and Front widths.

- When you get a width you are happy with, click the **LMB** again.

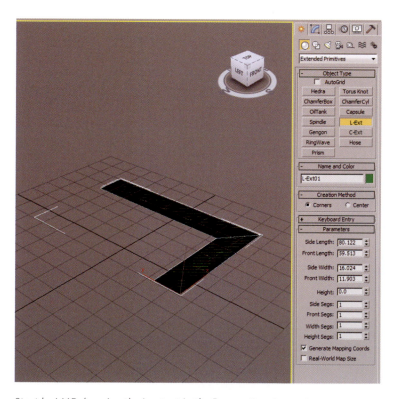

*Start by LMB dragging the L-extent in the Perspective viewport.*

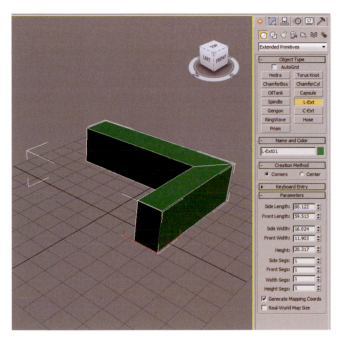

*Move the mouse up to set the L-extent's height.*

*Move the mouse left to right to set the L-extent's width.*

## How to alter the parameters of the primitives you create

Regardless of which primitive you create, all of them have parameters that you can adjust. As you can expect, not all of the parameters are going to be the same, but the method for changing various parameters is.

Whatever setting you create a primitive to begin with can be altered to reach your desired result. Adding additional polygons, changing the height or radius, or even the overall scale can all be done even after you have created the primitive. Let's look at how to adjust some of those parameters after you have created a primitive.

1   **Adjust parameters of a primitive box.**

For our first test, let's change some parameters of a basic box.

- Start by creating a standard primitive **Box** in the Perspective viewport.

- After you have created the box, **RMB** click anywhere in the viewport to end the creation process.  After you do this, you will notice that you no longer have any parameters under the **Create tab**. This is because the creation process is done. Now it is time to edit the object.

*After creating a box, RMB click in the viewport to end the creation process.*

- Next to the **Create tab** in the Command Panel is the **Modify tab**. If you have nothing selected you will not see much other than the Modifier List, but by **LMB** clicking on the box, many of the original parameters we saw when we created the box are back.

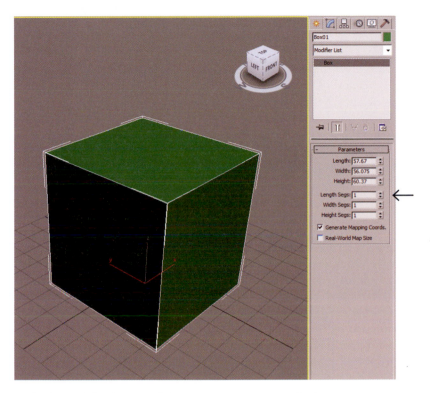

*Under the Modify tab, many of the creation parameters are back.*

- From the **Parameters** submenu, **LMB** click on any of the Parameter values and type in some numbers in the box, or use the small arrow icon next to the parameter numbers to drag the values up and down with the **LMB**. This is the same as typing the numbers in manually, but is obviously less accurate. You can also add numbers to the length, width, or height segments to change those values as well.

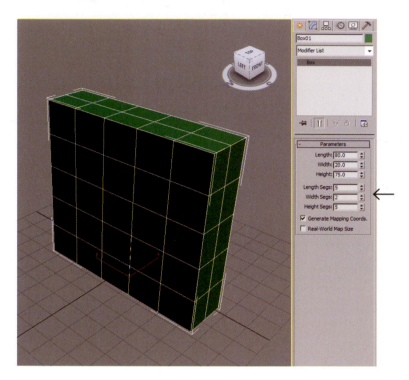

*Changing the parameters of the same box to create a customized shape.*

**2    Adjust parameters of a capsule.**

For our next object, let's change some parameters of an extended primitive **Capsule**.

- Start by creating an extended primitive **Capsule** in the Perspective viewport.

- After you have created the capsule, **RMB** click anywhere in the viewport to end the creation process.

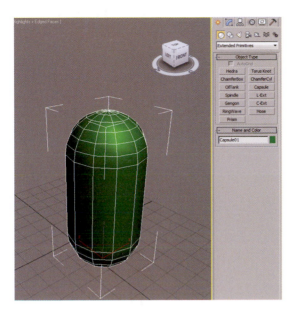

*After creating a capsule, RMB click in the viewport to end the creation process.*

- Switch to the **Modify tab** and randomly alter the Parameters to get a different shape. Yours might look different than mine, depending on what you type in.

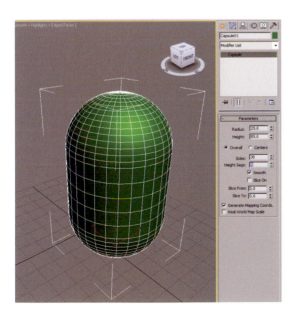

*Altering various parameters to get a different shape.*

## Moving, rotating, and scaling primitives in your scene

Now that you understand the basics of creating primitives, it is important that you understand how to manipulate them. Once you have created them, you will want to move and alter them around in 3D space, and you can do that with the **move**, **rotate**, and **scale** tools.

1    **Move a primitive.**

For our next exercise, let's **move** a primitive around in 3D space.

- Select the **Geometry** option, select and create any primitive you want to **move**.

- Ensuring you have the primitive selected, press the **Move** tool on the Main toolbar, or use the **W** hotkey on your keyboard. You will notice an icon appear on your primitive. This is known as the Move *gizmo* or *widget*.

*The Move tool selected on the Main toolbar.*

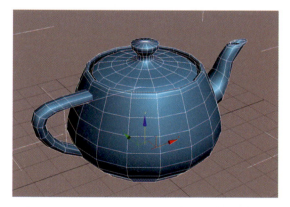

*The Move gizmo appears with our Teapot primitive selected.*

- **LMB** click and hold the **Move** gizmo on any of the small directional arrows.

- Move the mouse in the direction that the arrow is pointing to move your object in 3D space.

**2   Rotate a primitive.**

Next, let's **rotate** a primitive around in 3D space.

- Select the **Geometry** option, select and create any primitive you want to **rotate**, or use the same object as before.

- Ensuring you have the primitive selected, press the **Rotate** tool on the Main toolbar, or use the E hotkey on your keyboard. You will notice the icon change to the **Rotate** gizmo on your primitive.

*The Rotate tool selected on the Main toolbar.*

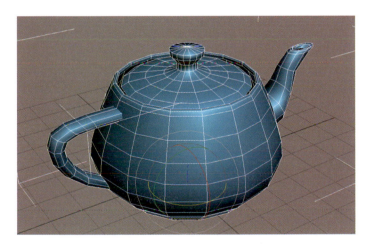

*The Rotate gizmo appears with our Teapot primitive selected.*

- **LMB** click and hold the **Rotate** gizmo on any of the colored lines to select that direction for rotation.

- Move the mouse in the direction that the arrow is pointing to move your object in 3D space.

3    **Scale a primitive.**

Next, let's **scale** a primitive.

- Select the **Geometry** option, select and create any primitive you want to **scale**, or use the same object as before.

- Ensuring you have the primitive selected, press the **Scale** tool on the main toolbar, or use the **R** hotkey on your keyboard. You will notice the icon change to the **Scale** gizmo on your primitive.

*The Scale tool selected on the main toolbar.*

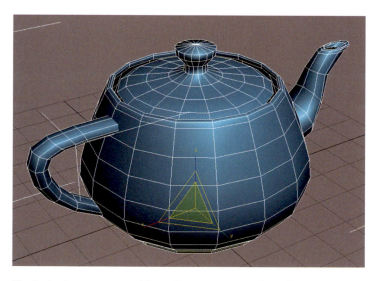

*The Scale gizmo appears with our Teapot primitive selected.*

- **LMB** click and hold on the **Scale** gizmo on any of the colored directional lines to select that direction for scaling.

- Move the mouse in the direction that the line is pointing to scale your object in 3D space.

- To do a Uniform scale, **LMB** click and hold on the yellow center of the gizmo and drag the mouse in any direction.

## Conclusion

Congratulations! You have completed your introduction to primitives in 3ds Max. You should now be able to quickly and easily create primitives and move them around in the viewport. You should be able to manipulate and alter the basic parameters to get the shapes you need, and create simple primitives in 3D space. This knowledge will aid you in the following chapters.

In the next lesson, you will explore methods used for copying and instancing your objects, as well as an introduction to layers and modifiers in 3ds Max.

# Lesson 04

## Modifiers, Layers, Copies, Instances and References

In this lesson, you will learn how to work with modifiers, layers, copies, instances, and references in Autodesk® 3ds Max® 2010 software. This lesson will focus primarily on several new 3ds Max 2010 tools and features that will greatly improve your workflow and save you time. As you begin to explore these tools, you will be able to quickly and effectively utilize them as you work with geometry in 3ds Max 2010.

**In this lesson, you will learn the following:**

- What modifiers are and how to apply them to your geometry

- What layers are and how to use them in your scene

- What instances, copies, and references are and when to use which

## What modifiers are

When you start to build geometry in 3D space, you may find yourself wanting to add a little more to the objects you create. You may also find that the default shapes are not exactly giving you the results that you want. Modifiers are tweaks and features that you can add to primitives or geometry in order to alter their original state, and give you a different result from the original.

For example, a Bend modifier may allow you to take a cylinder you made and put a curve into it. One of the FFD modifiers could allow you to stretch and skew your mesh all you want. The Symmetry modifier could save you a considerable amount of time by mirroring your geometry over to the other side so you only have to model half of it. These are just a few examples of the different results you can achieve with modifiers.

## How to apply a modifier

While the list of all the different modifiers is quite extensive and their results can be vastly different from each other, the way to apply any modifier to an object is the same. Let's start with a very simple shape, apply a modifier, and then adjust some parameters.

1   **Create a primitive box.**

For our first modifier, let's add one to a simple box with four length, width, and height segments. Start by creating that box.

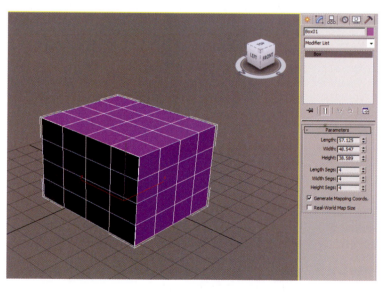

*Create a box primitive with four length, width, and height segments.*

Project 01

**2**  **Select the box, and then apply a modifier to it.**

As you may have noticed, at the top of the Command Panel in the **Modify tab** under the name of the object, there is a drop-down menu titled **Modifier List**. **LMB** clicking anywhere on the **Modifier List** will expand it, and the available modifiers will appear.

- With the box you created selected, **LMB** click the **Modifier List** to expand the available modifiers.

- From the available modifiers listed, scroll down until you find the **FFD 2x2x2** modifier and **LMB** click it to apply it to your box.

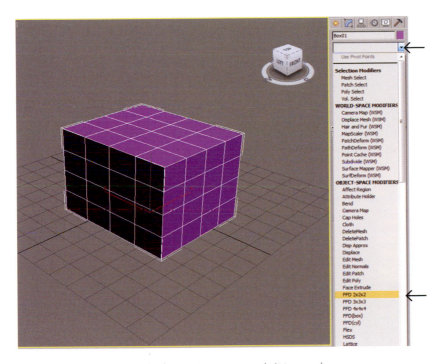

*Expand the modifier list and select FFD 2x2x2 to apply it to your box.*

- Now that you have applied the modifier to your box, there is a new set of available options. You will also notice that the name of the modifier FFD 2x2x2 has appeared above your object's name in the Command Panel.  This is known as the **modifier stack**. At the top of the stack we can see that we have the FFD 2x2x2 modifier, and underneath it is the original box. Think of modifiers as "extras" that we are adding to the original object, without losing any of the information of it unless we want to. The original box will stay exactly the same regardless of what we do to the modifier above the stack.

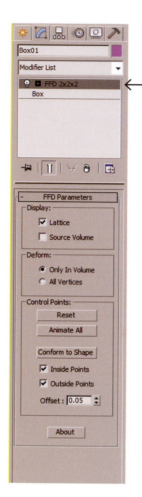

A modifier has been applied to the box,
creating a modifier stack.

Moving down the stack by
LMB clicking the original object
underneath the modifier.

- Currently the top level of the stack is selected, and as you can see the parameters in the Command Panel are specific for the FFD 2x2x2 modifier. However, if we would like to go back down and adjust the parameters of the original box, we can do that by **LMB** clicking the word Box under the FFD 2x2x2 modifier. This is called "Moving down the stack."

**3**    **Move down the modifier stack and adjust the parameters of the original box.**

Now that you know how to move down the stack, let's adjust the original box parameters.

- With the box you created selected, **LMB** click on the word Box in the Command Panel to move down the modifier stack.

- Change the Parameters to 20 length, width, and height segments.

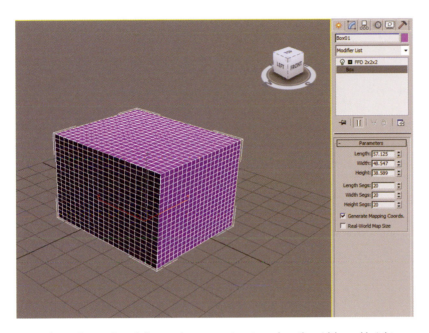

*Move down the stack and change the parameters to 20 length, width, and height segments.*

**4**    **Make some adjustments to the object with the FFD 2x2x2 modifier.**

After changing the original box's parameters, go back up to the top of the stack and let's change the shape of the box using the FFD 2x2x2 modifier.

- With the box selected, at the top of the modifier stack with FFD 2x2x2 selected, press the small plus sign next to the name of the modifier to expand the subobject options and select **Control Points**. This is a subobject mode selection of the modifier. We will discuss subobject modes extensively in future chapters.

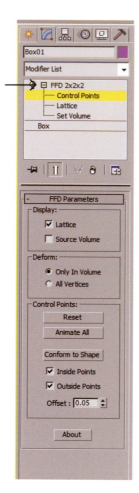

*Press the small plus sign next to the name of the modifier to expand its subobject selection modes. When expanded, it will change to a minus sign.*

- With **Control Points** option selected, hold the **LMB** and drag select a control point at any of the corners of your object to select them. The FFD modifier has added these control points to allow you to make changes to your object as you wish. Next, with a control point selected, use the **Move tool** to move the control point in any direction, changing the shape of the box entirely.

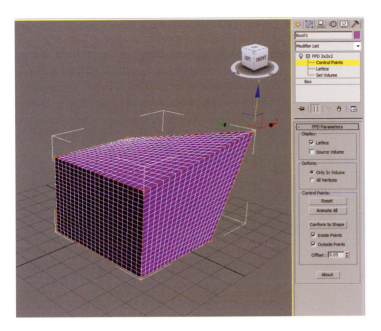

*Moving a control point to change the shape of the box.*

- Now that you have made an adjustment to your mesh with your first modifier, feel free to move other control points and adjust parameters of the original object and see what sort of results you get with the object.

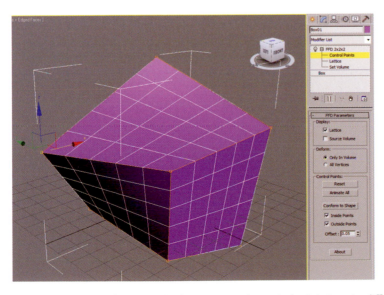

*Random parameter changes and adjustments to the control points to get a different shape.*

- If you decide you do not want to use the modifier anymore and wish to go back to the original object, you can delete the modifier by **RMB** clicking on the top of the modifier stack on the name of the modifier, and **LMB** clicking Delete. Alternatively, you can **LMB** select the modifier in the stack, and then **LMB** click on the small Trashcan icon under the modifier stack. Keep in mind that deleting the modifier will remove it forever, and you will not have your custom shape anymore.

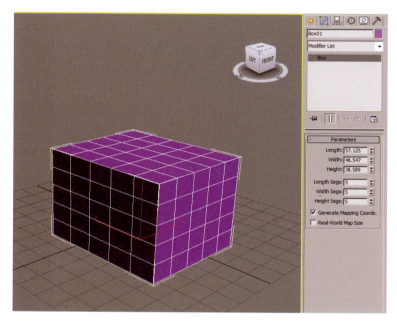

*Deleting the modifier; going back to the default primitive.*

## Using Modifiers in your workflow

While we will not cover every single modifier in this book, let's look at just a couple of the commonly used modifiers and a brief description of them.

1    **Apply the Bend modifier.**

For our next primitive, create a cylinder and add a **Bend** modifier. The Bend modifier attempts to do just like what it sounds like: bend your geometry any way you want it to.

- From Standard Primitives, create a Cylinder and set it to a radius of 20, height of 80, height segments 10, cap segments 1, and sides 18.

- **LMB** click the Modifier List drop-down and choose the **Bend** modifier.

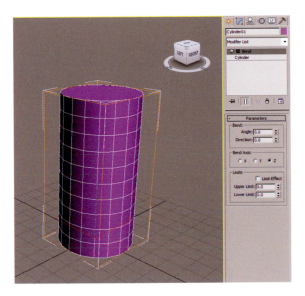

*Create a cylinder and apply the Bend modifier to it.*

- From the Parameters submenu select the Bend modifier, **LMB** click and hold the small spinners next to Angle and Direction and drag them up or down to randomly change the parameters of the Bend modifier. You can also type in parameters and see what your results are.

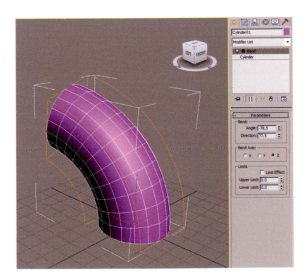

*Create a cylinder and apply the Bend modifier to it.*

2    **Apply the Symmetry modifier.**

Next, create a teapot and apply a **Symmetry** modifier. The Symmetry modifier works like a mirror along the axis of an object, copying what you have on one side over to the other.

- Select Standard Primitives and create a Teapot with `Radius` set to 40 and Segments set to 6.

- **LMB** click on the Modifier List drop-down and choose the **Symmetry** modifier.

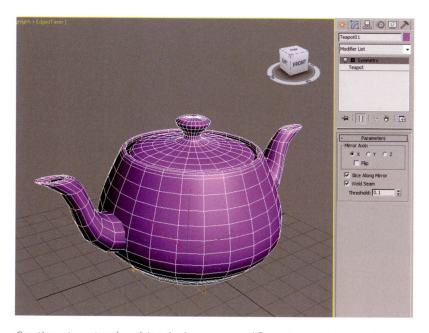

*Creating a teapot and applying the Symmetry modifier to it gives it two spouts.*

- By default, the Symmetry modifier is set to mirror along the axis of X, and your teapot should have two spouts and no handle. **LMB** click the Flip box under the Parameters to flip the symmetry to the other side, giving the teapot two handles instead.

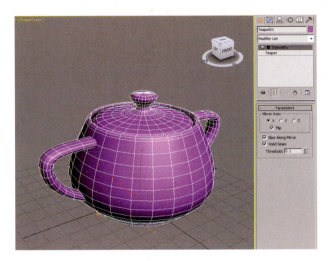

*Flipping the Symmetry modifier gives us a teapot with two handles.*

## Layers

Another important feature of working with 3ds Max 2010 is the built in Layer Manager. Layers play an important role in working with 3ds Max, because they allow you to work with multiple objects or pieces of your scene without having all of them visible all the time. The objects still exist in your scene, but layers allow you to quickly and easily hide or unhide objects in the scene as you wish.

The Layer Manager, available by **LMB** clicking the icon on the Main toolbar, is a tool where you can create and delete layers. You can also view and edit the settings for all of the layers in your scene, as well as the objects associated with them. You can specify the name, visibility, renderability, color, and more.

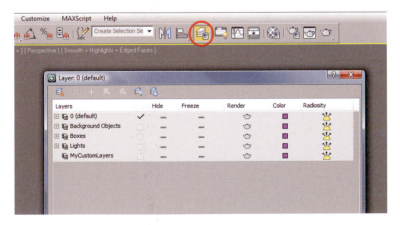

*Access the Layer Manager by LMB clicking the icon on the Main toolbar.*

## Layer Manager Interface Elements

**Create New Layer**—Creates a new layer containing any selected objects. The new layer's name is generated automatically (Layer01, Layer02, and so on) but you can change it by clicking the label. Note: The new layer becomes the current layer.

**Delete Highlighted Empty Layers**—Deletes highlighted layers if they are empty. Note: This button is unavailable if the highlighted set of layers contains any of the following: nothing (that is, no layers are highlighted), the active layer, objects, Layer 0, or nonempty layers.

**Add Selected Objects to Highlighted Layer**—Moves currently selected objects into the highlighted layer. Note: This button is unavailable if nothing is selected or if more than one layer is highlighted.

**Select Highlighted Objects and Layers**—Selects all of highlighted objects, as well as all objects contained in any highlighted layers. Note: This button is unavailable if nothing is highlighted.

**Highlight Selected Objects' Layers**—Highlights layers containing the currently selected objects and automatically scrolls so that highlighted layers are visible in the layer manager. Note: This button is unavailable if nothing is highlighted.

**Hide/Unhide All Layers**—Toggles the display of all layers.

**Tip:**	*This is most useful if you hide all layers and then display only the layers you want to work on.*

**Freeze/Unfreeze All Layers**—Toggles the frozen state of all layers.

**Tip:**	*This is most useful if you freeze all layers and then unfreeze only the layers you want to work on.*

**List of Layers**—Displays layers, their associated objects, and their properties. To expand or collapse the object list for each layer, click + (plus sign) or - (minus sign), respectively. To modify a property, click its icon. To select all layers quickly, **RMB** click and choose Highlight All. To open the Object/Layer Properties dialog box, **LMB** click on the icon next to the layer or object.

**Layers**—Displays the names of the layers/objects. Click a name to select the layer, or to rename the layer.

**Current Layer Toggle**—The unlabeled column to the right of the layer name indicates the current layer and lets you make a different layer current. A check mark appears next to the current layer. **LMB** click the check box next to another layer name to make it current.

**Hide**—Hides and unhides layers. When a layer is hidden, it is invisible. You might want to hide layers that contain construction or reference information.

**Freeze**—Freezes layers. You cannot select or edit objects on a frozen layer. Freezing a layer is useful if you want to view information on a layer for reference but do not want to edit objects on that layer.

**Render**—When on, objects appear in the rendered scene. Nonrendering objects do not cast shadows or affect the visual component of the rendered scene.

**Color**—Changes the color associated with the highlighted layers. You can select another color by **LMB** clicking the color swatch to display either the Object Color dialog box (for objects), or the Layer Color dialog box (for layers). You can set an object's color independently, or turn on ByLayer in the Object Color dialog box to use the associated layer's color.

**Radiosity**—When on, objects are included in the radiosity solution. Objects not included in the radiosity solution do not contribute to indirect illumination. If these objects are lights, only their direct contribution will be used for rendering.

## Working with layers

Now that we have looked at the interface of the Layer Manager, let's create a few pieces of geometry and add them to layers.

1   **Create a collection of geometry we will add to layers.**

   - Using what you have learned, create five standard primitive **Boxes**, **Cylinders**, and **Spheres** in the Perspective viewport.

   - **LMB** drag select the boxes in your scene, and bring up the Layer Manager by **LMB** clicking on the icon in the Main toolbar.

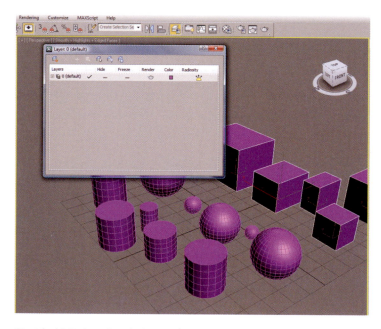

*Start by LMB dragging the box in the Perspective viewport.*

2   **Create a new layer and rename it.**

   Next, let's add the boxes to a new layer.

   - **LMB** click on the **Create New Layer** icon.

   - A new layer appears on the list, named *Layer01*. By default, since you had the boxes selected, the boxes are now added to this layer.

- **RMB** click on our new Layer01 layer, and then **LMB** click Rename.

- Rename the layer *BoxesLayer.*

- Repeat the same steps for the spheres and cylinders, and create new layers for them called *SpheresLayer* and *CylindersLayer.*

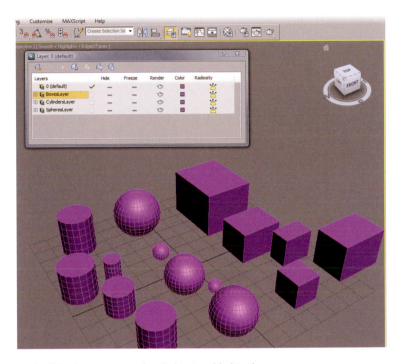

*Each of the layers renamed and objects added to them.*

3  **Adjust the settings of various objects in the layers.**

Lastly, let's adjust some parameters of the various layers and the objects inside of them.

- Under the *BoxesLayer* select the icon to hide the layer group. Notice that the layer group disappears. The objects are not lost, but will remain hidden from view until we unhide.

- For the *CylindersLayer*, select the icon to freeze the layer group. Notice that after we freeze this layer the color has changed to gray. This is indicating to us visually that the layer is frozen and we can no longer adjust it until we unfreeze that layer.

- Expand the *SpheresLayer* to reveal the objects in that layer, and change the colors of some of the spheres.

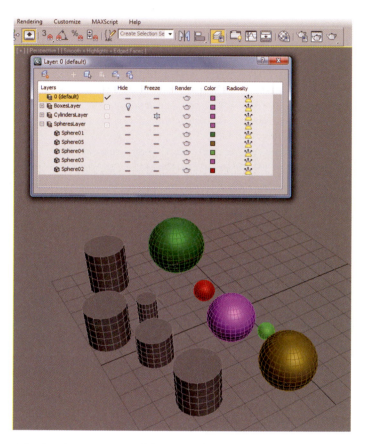

*Adjusting the parameters of the various layers and objects inside of them.*

## Copies, instances, and references

As you start to create more and more geometry, you may find yourself wanting to copy geometry, rather than having to create brand new geometry all the time and trying to match up the parameters. Trying to make 50 spheres one at a time could get rather frustrating! Aside from simply making a copy of an object, you can also create a version of the object that will allow you to adjust parameters of one and have it propagate to the other versions of itself. In 3ds Max 2010, these cloning methods are known as copies, instances, and references.

A **copy** is simply a duplicate of an object. The new version will only retain the original shape of the object when copied, but after that it is completely independent of any other object in the scene. Think of a copy just like you would with a copy machine in an office. Once you have that copied piece of paper, if you make changes to the original or the copy, it will not affect the other one.

An **instance** is a duplicate of the original object, but will simultaneously mirror any changes to either versions of the object. For example if I have a Box primitive, I make an instance of that box, and then change parameters of either object, both objects will change together at the same time. The exception to this is moving, rotating, and scaling with the gizmos.

A **reference** is almost identical to an instance in that any changes to one will be applied to both objects. The difference, however, is that a reference can have additional modifiers applied to it, without affecting the other versions of the object, and give you an idea of what the final result will be after those modifiers are applied further down the stack. For example, if I have a Box primitive, I make a reference of that box, I can then apply additional modifiers to that box without affecting the other versions of it.

1    **Make a copy of an object.**

Let's start with making a copy of an object.

- Start by creating a Standard Primitive **Sphere** in the Perspective viewport.

- After you have created the sphere, select the sphere and then select the **Move** tool, or use the **W** hotkey.

- With the sphere selected, choose any direction of the Move tool, and while holding down the Shift button on your keyboard, **LMB** drag that direction, and once you have a distance you are happy with, release the **LMB**.

- The **Clone Options** dialog box will pop up. Make sure that **Copy** is selected, type in **2** for **Number of Copies**, and then **LMB** click **OK** to create the copies.

*Hold down Shift and drag the Move tool to bring up the Clone Options.*

- You will now have three spheres in the scene—the original sphere you created, and the two copies you made. You should also notice how the spheres are spaced. However far you drug the sphere the first time before releasing the **LMB** is how far apart each of the copies will be from each other.

*Three spheres will now be in the scene, evenly spaced.*

**2    Make an instance of an object.**

Next, let's do the same method, but this time choose instance.

- Start by creating a standard primitive **teapot** in the Perspective viewport.

- With the teapot selected, hold down the **Shift** button on your keyboard, **LMB** drag that direction using the **Move** tool, and once you have a distance you are happy with, release the **LMB**.

- When the **Clone Options** dialog box pops up, choose **Instance**, and type in **2** for the **Number of Copies**.

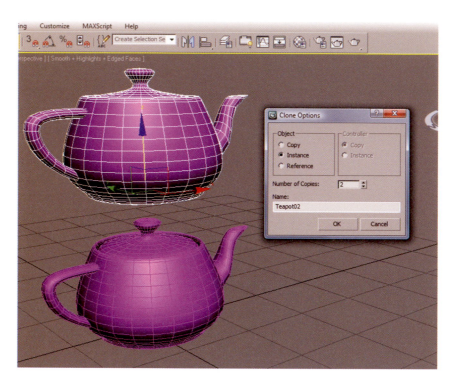

*Create a teapot and make two instances of it.*

- Several things will have changed as you will notice. The object name in the Command Panel under the Modifier List has been bolded, and any adjustments you make to the teapot's radius or segments will apply to all three of the teapots. If you were to add a modifier to any of the teapots, it too would affect all of the other instances.

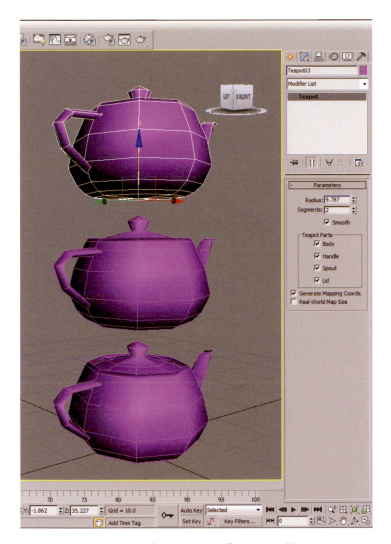

*Changing the parameters of one instance affects them all.*

## 3   Make a reference of an object.

Finally, let's create a reference. A reference will work almost exactly the same as an instance, but we can add modifiers to the reference and see what the final outcome will be as we adjust parameters of the other version of the object.

- Start by creating a standard primitive **Box** in the Perspective viewport, and give it **10** length, width, and height segments.

- With the box selected, hold down the **Shift** button on your keyboard, **LMB** drag that direction using the **Move** tool, and once you have a distance you are happy with, release the **LMB**.

- When the **Clone Options** dialog box pops up, choose **Reference**, and leave the **Number of Copies** at **1**.

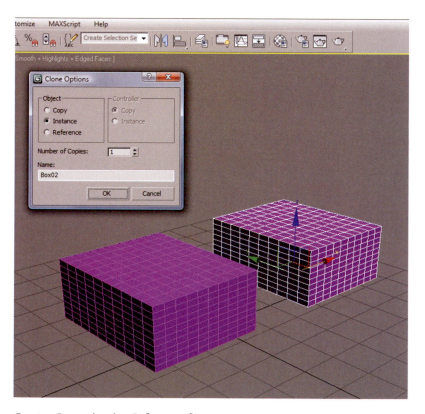

*Create a Box and make 1 Reference of it.*

- As you will notice, the object name in the Command Panel from the Modifier List has been bolded just like an Instance, and a new dark gray bar has appeared. This is where new modifiers will appear if you add them to either one of the two references. Add an **FFD 2x2x2** modifier to either of the references and adjust the control points. The gray bar will stay on the modifier stack as an indication that it is used in conjunction with the reference. But, as you notice, the modifier is only affecting one of the boxes.

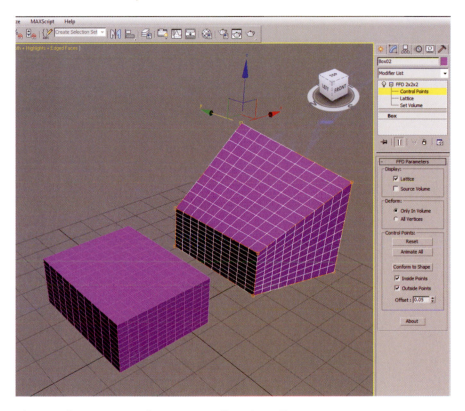

*Changing the parameters of one instance affects them all.*

- Lastly, go down the modifier stack by **LMB** clicking the Box in the modifier stack, and change the length, width, and height segments back down to 1. As you see, both of the objects' default settings change, but the version with the modifier on it also retains the effects of the modifier itself.

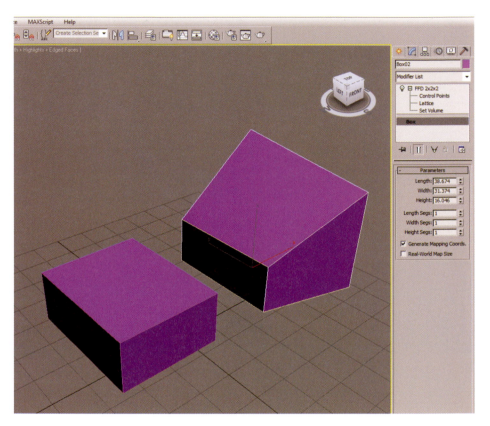

*Changing the parameters of one instance affects them all.*

Project 01

## Conclusion

Congratulations! You have completed your introduction to modifiers, layers, copies, instances, and references in 3ds Max. As you begin to create 3D objects and work with more complex scenes, working with layers can greatly improve your scene's organization and allow for a speedy workflow. Knowing when to use an instance instead of a copy can save you from a huge amount of repetition when modeling and we will definitely be using these methods moving forward. We have just barely started learning about modifiers, but as you move forward with modeling in Autodesk 3ds Max we will cover plenty of new ones.

In the next lesson, you will explore the basic fundamentals of editable polygon modeling which will open up an exciting new world for you when it comes to creating 3D geometry.

# Lesson 05
## Editable Polygon Objects

In this lesson, we will push beyond the standard primitives and start to introduce the tools for editable polygon objects in Autodesk® 3ds Max® 2010 software. Almost every object you create in 3ds Max for use in games is made up of vertices, edges, and polygons, and mastering these components is key to successful 3D modeling. As we begin to explore these essential parts of the 3D modeling workflow, you will begin to see the methods needed to create anything you can imagine, using editable polygon objects.

**In this lesson, you will learn the following:**

- What an editable polygon object is, and how it differs from primitives

## What editable polygon objects are

While each of the basic primitives are a great building block when working with geometry in 3D, even with modifiers they will never give you complete capabilities to create everything you could possibly think of. Editable polygon objects are objects that have been converted to take advantage of the subobject modes that make up those objects.

The five subobjects that make up an editable poly are vertices, edges, borders, polygons, and elements. While these subobjects exist on all 3D objects, you can only manipulate them individually by converting your object to a polygonal surface. Cutting up your geometry and adding to it beyond the basic primitives is realistically only achievable with a polygonal object, such as converting it to an editable polygon.

## How to convert a primitive to an editable polygon object

There are at least two quick and easy methods to converting your objects to an editable polygon object. Once you have converted them to an editable poly, you will notice the entire Command Panel will change to access new features for the new editable poly object.

1    **Access the Quad menu.**

The first method to converting an object to an editable polygon object is to use the **Quad** menu.

- Create a Box primitive in the Perspective viewport, and then **RMB** click it to bring up the Quad menu.

- At the bottom of the menu, move your mouse down to the **Convert To** option to extend that menu, and **LMB** click **Convert to Editable Poly**.

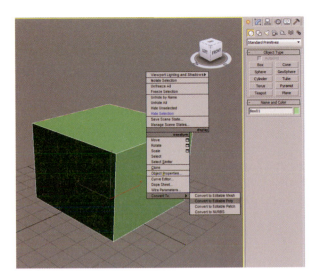

*RMB click on a primitive and choose Convert to Editable Poly.*

2 **Change it from within the Command Panel.**

Another method is to simply convert it in the Command Panel.

- From within the Command Panel, **RMB** click Object from the Modifier List and **LMB** click **Editable Poly** to convert it.

*RMB click the object mode from the Modifier List, then LMB click the Editable Poly option.*

## Navigating the newly changed command panel

You may have noticed a large amount of new menu items appear after converting your primitive to an editable poly. Do not worry—you will not have to master each and every single piece of information to be a decent 3D artist. But it is important to understand many of the features in order to successfully create the objects you set out to make. There are also several tips you will need to know about navigating this newly changed Command Panel.

**Minimize and maximize submenus**—We have mentioned this before, but it is important to remember that in order to expand or collapse the submenus in the Command Panel, all you need to do is **LMB** click the box that has the name of the submenu. You will find that when working with editable poly objects you will not need every single menu expanded, so it might be a good idea to collapse the ones you do not need.

*The Command Panel with all but one submenu collapsed.*

**Project 01**

**Increase the width of the Command Panel**—Another tip for maximizing the Command Panel is to expand the panel altogether. Along the edge of the Command Panel, where the panel meets the viewport, if you hover your mouse slightly you will see the mouse icon change. Holding down the **LMB** and dragging it to the left will allow you to "pull" the Command Panel out further to give more screen space to the different menu options.

*Holding the LMB and dragging left at the edge of the Command Panel allows you to stretch its width.*

**Put the submenus in your preferred order**—When it comes to modeling in 3D for games and working with subobject modes, there are some common submenus you will use more often than others. One feature to help with this is to **LMB** click and hold any of the submenu titles, and then drag it up or down to your preferred order. So whether you choose to have expanded the Command Panel or to keep it small, you can choose which order your menus are in.

**Drag the Command Panel up or down**—Lastly, it is important to know how to drag the Command Panel up or down if you choose not to expand it out. If you hover your mouse over any area that is not a button or a submenu, your icon will change to a small hand, allowing you to "grab" the panel and pull it up or down. Alternatively, there is a very small traditional scrollbar at the very furthest left side of the Command Panel. Either of these methods will drag the panel up or down.

*When hovering your mouse over the Command Panel, a small hand icon appears allowing you to drag the panel up or down.*

## How to change  between subobject modes

As you may have guessed, there are multiple ways to switch between the subobject modes. Depending on whether you are taking advantage of the vertex toolset or the polygon toolset, you will want to be able to quickly switch between the different subobjects to take advantage of specific tools available to each of the subobjects.

- Using your keyboard, pressing 1-5 will switch between each of the subobject modes.

- If you have an Editable Poly object selected, pressing the icon for any of the five subobjects under the Selection submenu will change between them.

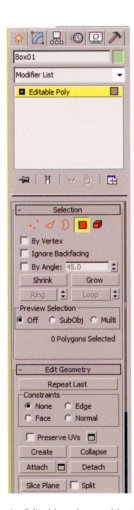

*An Editable polygon object with the Polygon subobject mode selected.*

- In the **Graphite Modeling Tools** menu, select the icons for the various subobject modes.

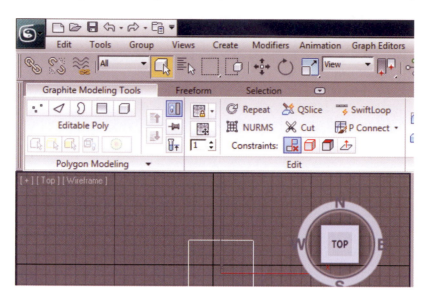

*The various subobject modes can be selected from within the Graphite Modeling Tools menu.*

## Subobject modes

There are literally hundreds of various tools associated with each of the subobject modes. If you have looked at the different submenus under each of them, it is easy to become somewhat confused at the vast amount of options. But do not worry—we will cover some of the basic and important tools you will want to know, and as you progress through this book you will learn more and more as you go along. It is not required to master them all, but feel free to experiment and see what you get! You can always utilize the powerful Help Menu by pressing **F1**, typing in the command you want to learn more about and experimenting on your own.

As you may have noticed as well, once you have converted an object to editable poly, the graphite modeling tools start to spring to life. This handy tool provides graphical icons and drop down menu descriptions that make understanding each of the functions of editable polygons that much easier. For many of the subobject tools, we will identify the name of the function and which submenu it falls under. Whether you choose to access it via the classic Command Panel or the new graphite tools is entirely up to you. The graphite tools do organize them a little more than the Command Panel does as well as provide a graphical icon for many of the functions, so it definitely makes a good learning tool for beginners and advanced modelers alike.

For this lesson, we will focus on three of the five subobject modes: Vertex, Edge, and Polygon. As we move throughout the book, we will utilize tools specific to the other subobject modes as well.

**Tip:** *When we describe the various functions, some of them also contain a dialog box that allows for additional functions or settings than the default function. The dialog box is brought up by clicking the small box icon next to the normal function's name.*

*To access a dialog box, LMB click on the small box next to the function you are using.*

## Features of the Edit Geometry submenu

The Edit Geometry rollout provides global controls for changing the geometry of the poly object, at either the top (object) level or the subobject levels. The controls are the same at all levels, except as noted in the descriptions below.

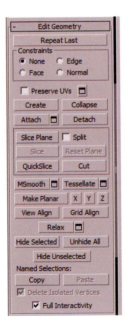

*The Edit Geometry options are available to all of the subobjects, and can change slightly depending on the subobject.*

**Repeat Last**—Repeats the most recently used command.

**Constraints**—Lets you use existing geometry to constrain subobject transformation. Choose the constraint type:

  **None**—No constraints. This is the default option.

  **Edge**—Constrains subobject transformations to edge boundaries.

  **Face**—Constrains subobject transformations to individual face surfaces.

  **Normal**—Constrains each subobject's transformations to its normal, or the average of its normals. In most cases, this causes subobjects to move perpendicular to the surface.

**Create**—Lets you create new geometry. How this button behaves depends on which level is active:

  **Object, Polygon, and Element**—Lets you add polygons in the active viewport. After you turn on Create, click three or more times in succession anywhere, including on existing vertices, to define the shape of the new polygon. To finish, **RMB** click. While creating a polygon at the Polygon or Element level, you can delete the most recently added vertex by pressing **Backspace**. You can do this repeatedly to remove added vertices in reverse order of placement. You can start creating polygons in any viewport, but all subsequent clicks must take place in the same viewport.

  **Vertex**—Lets you add vertices to a single selected poly object. After selecting the object and **LMB** clicking **Create**, **LMB** click anywhere in space to add free-floating (isolated) vertices to the object. The new vertices are placed on the active construction plane.

  **Edge and Border**—Lets you create an edge between a pair of nonadjacent vertices on the same polygon. **LMB** click **Create**, **LMB** click a vertex, and then move the mouse. A rubber-band line extends from the vertex to the mouse cursor. **LMB** click a second, nonadjacent vertex on the same polygon to connect them with an edge. Repeat, or, to exit, **RMB** click anywhere in the viewport or **LMB** click **Create** again.

**Collapse**— (Vertex, Edge, Border, and Polygon levels only) Collapses groups of contiguous selected subobjects by welding their vertices to a vertex at the selection center.

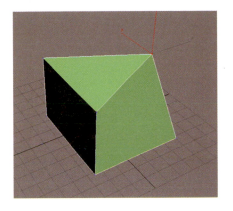

*Selecting two vertices for collapsing.*    *Two vertices collapsed down to one.*

**Attach**—Lets you attach other objects in the scene to the selected poly object. After activating **Attach**, **LMB** click on another object to attach it to the selected object. The **Attach** operation remains active, so you can continue clicking on other objects to attach them as well. To exit, **RMB** click anywhere in the active viewport or click the **Attach** button again. Attaching a non-mesh object automatically converts it to the editable-poly format.

**Detach**— (subobject levels only) Detaches the selected subobjects and the polygons attached to them as a separate object or element(s). With an editable poly object, when you **LMB** click **Detach**, 3ds Max prompts for those options in the **Detach Dialog**.

**Slice Plane**— (subobject levels only) Creates a gizmo for a slice plane that you can position and rotate to specify where to slice. Also enables the **Slice** and **Reset Plane** buttons. **LMB** click Slice to create new edges where the plane intersects the geometry. To perform the slice, **LMB** click the **Slice** button.

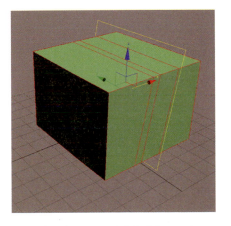

*Using the SlicePlane while in Edge mode.*

**Slice**—(subobject levels only) Performs the slice operation at the location of the slice plane.

**Reset Plane**—(subobject levels only) Returns the slice plane to its default position and orientation. Available only when Slice Plane is on.

**QuickSlice**—Lets you quickly slice the object without having to manipulate a gizmo. Make a selection, **LMB** click **QuickSlice**, and then **LMB** click once at the slice start point and again at its endpoint. You can continue slicing the selection while the command is active. To stop slicing, **RMB** click anywhere in the viewport, or click **QuickSlice** again to turn it off.

*Performing a QuickSlice in Object mode.*

**Cut**—Lets you create edges from one polygon to another or within polygons. **LMB** click at the start point, move the mouse and **LMB** click again, and continue moving and clicking to create new connected edges. **RMB** click once to exit the current cut, whereupon you can start a new one, or **RMB** click again to exit Cut mode. While cutting, the mouse cursor icon changes to show the type of subobject it is over, to which the cut will be made when you click.

**X/Y/Z**—Makes all selected subobjects planar and aligns the plane with the corresponding plane in the object's local coordinate system. The plane used is the one to which the button axis is perpendicular; so, for example, clicking the X button aligns the object with the local YZ axis. At the Object level, makes all vertices in the object planar.

*Aligning an edge of a cylinder using the Z align function.*

## Features of the Vertex subobject mode

Vertices are points in space. They define the structure of other subobjects (edges and polygons) that make up the polygon object. When you move or edit vertices, the connected geometry is affected as well. Vertices can also exist independently; such isolated vertices can be used to construct other geometry but are otherwise invisible when rendering. Some of the vertex-specific tools are as follows.

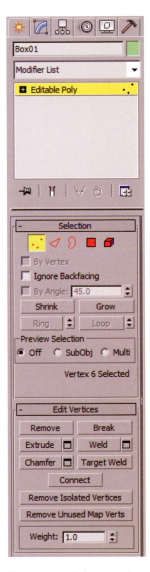

*The Vertex subobject mode.*

**Remove**—Deletes selected vertices and combines the polygons that use them. The keyboard shortcut is **Backspace**.

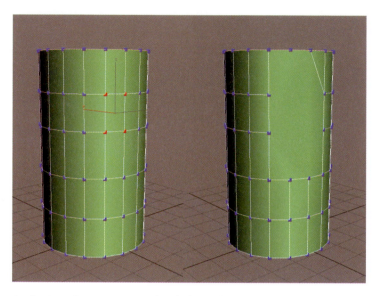

*A selection of vertices removed with the Backspace hotkey.*

**Break**—Creates a new vertex for each polygon attached to selected vertices, allowing the polygon corners to be moved away from each other where they were once joined at each original vertex. If a vertex is isolated or used by only one polygon, it is unaffected.

Weld—Combines contiguous, selected vertices that fall within the tolerance specified in the **Weld dialog** box.  All edges become connected to the resulting single vertex. Inside of the **Weld dialog box**, you can specify the weld threshold - a number that represents the distance between vertices. The smaller the number, the closer the vertices need to be in 3D space for the weld to work. Weld is best suited to automatically simplifying geometry that has areas with a number of vertices that are very close together. Before using **Weld**, set the Weld Threshold via the **Weld dialog box**.

Target Weld—Allows you to select a vertex and weld it to a neighboring target vertex.Target Weld works only with pairs of contiguous vertices; that is, vertices connected by a single edge. In **Target Weld** mode, the mouse cursor, when positioned over a vertex, changes to a + cursor. **LMB** click and then move the mouse; a dashed, rubber-band line connects the vertex to the mouse cursor. Position the cursor over another, neighboring vertex and when the + cursor appears again, click the mouse. The first vertex moves to the position of the second and the two are welded. Target Weld remains active until you click the button again or **RMB** click in the viewport.

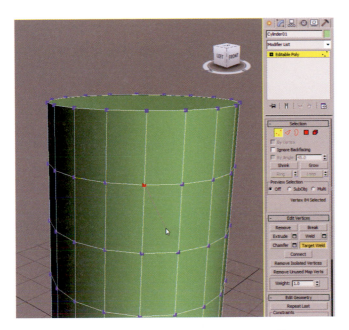

*Using the Target Weld to pick the original vertices to weld over.*

*Using Target Weld, the vertex is welded over to the vertex next to it.*

**Connect**—Creates new edges between pairs of selected vertices. Connect does not let the new edges cross. For example, if you select all four vertices of a four-sided polygon and then click **Connect**, only two of the vertices will be connected.

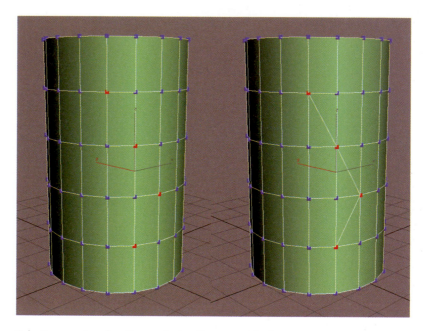

*Selecting a series of vertices and using the connect tool.*

## Features of the Edge subobject mode

An edge is a line connecting two vertices that forms the side of a polygon. An edge cannot be shared by more than two polygons. Some of the Edge subobject tools are as follows.

*The Edge subobject mode.*

**Remove**—Deletes the selected edges and combines the polygons that use them. Removing one edge is like making it invisible. The mesh is affected only when all or all but one of the edges depending on one vertex are removed. At that point, the vertex itself is deleted and the surface is retriangulated. To delete the associated vertices when you remove edges, press and hold **Ctrl** while using the **Remove** operation, either by mouse or with the **Backspace** key. This is called a Clean Remove, and it ensures that the remaining polygons are planar.

*Performing a clean remove of the edges with the Ctrl + Backspace hotkey.*

*Selecting a series of edges for removal.*

**Chamfer**—Click this button and then drag edges in the active object to execute a **Chamfer**. To chamfer edges numerically, **RMB** click the **Chamfer Dialog** button and change the **Chamfer Amount** value. If you chamfer multiple selected edges, all of them are chamfered identically. If you drag an unselected edge, any selected edges are first deselected.

 An edge chamfer "chops off" the selected edges, creating a new polygon connecting new points on all visible edges leading to the original vertex. The new edges are exactly *‹chamfer amount›* distance from the original edge along each of these edges. For example, if you chamfer one edge of a box, each corner vertex is replaced by two vertices moving along the visible edges that lead to the corner. Outside faces are rearranged and split to use these new vertices, and a new polygon is created at the corner.

*Chamfering the edge of a box.*

**Chamfer Settings**—Opens the **Chamfer Edges** dialog box, which lets you chamfer edges via interactive manipulation and toggle the **Open** option. If you click this button after performing a manual chamfer, the same chamfer is performed on the current selection as a preview and the dialog box opens with Chamfer Amount set to the amount of the last manual chamfer.

**Bridge**—Connects border edges on an object with a polygon "bridge." Bridge connects only border edges; that is, edges that have a polygon on only one side. This tool is particularly useful when creating edge loops or profiles.

*Using the bridge tool to connect two sets of disconnected edges.*

**Connect**—Creates new edges between pairs of selected edges using the current **Connect Edges** dialog box settings. **Connect** is particularly useful for creating or refining edge loops.

 **Note***: You can connect only edges on the same polygon. Also, Connect will not let the new edges cross. For example, if you select all four edges of a four-sided polygon and then click **Connect**, only neighboring edges are connected, resulting in a diamond pattern.*

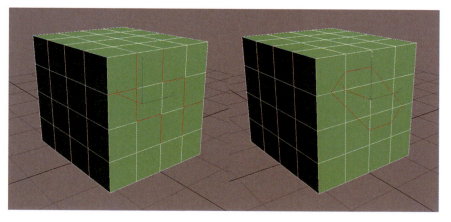

*Performing the Connect function on a series of selected edges.*

Project 01

## Features of the Polygon subobject mode

A polygon is a closed sequence of three or more edges connected by a surface. Polygons provide the renderable surface of editable poly objects. Some of the polygon subobject tools are as follows.

*The Polygon subobject mode.*

**Extrude**—Lets you perform manual extrusion via direct manipulation in the viewport. **LMB** click the button, and then drag vertically on any polygon to extrude it. Extruding polygons moves them along a normal and creates new polygons that form the sides of the extrusion, connecting the selection to the object. Following are important aspects of polygon extrusion:

- When hovering over a selected polygon, the mouse cursor changes to an **Extrude** cursor.

- Drag vertically to specify the extent of the extrusion, and horizontally to set the size of the base.

- With multiple polygons selected, dragging on any one extrudes all selected polygons equally.

- You can drag other polygons in turn to extrude them while the **Extrude** button is active. **LMB** click **Extrude** again, or **RMB** click anywhere in the active viewport to end the operation.

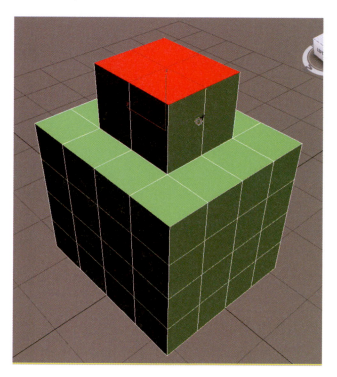

*Performing the Extrude function on a group of polygons.*

**Project 01**

**Bevel**—Lets you perform manual beveling via direct manipulation in the viewport. Click this button, and then drag vertically on any polygon to extrude it. Release the mouse button and then move the mouse vertically to outline the extrusion. **LMB** click again to finish.

- When over a selected polygon, the mouse cursor changes to a **Bevel** cursor.

- With multiple polygons selected, dragging on any one bevels all selected polygons equally.

- You can drag other polygons in turn to bevel them while the **Bevel** button is active. **LMB** click **Bevel** again or **RMB** click in the active viewport to end the operation.

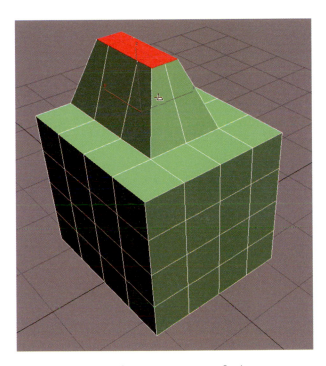

*Performing the Bevel function on a group of polygons.*

**Inset**—Performs a bevel with no height; that is, within the plane of the polygon selection. **LMB** click this button, and then drag vertically on any polygon to inset it.

- When over a selected polygon, the mouse cursor changes to an **Inset** cursor.

- With multiple polygons selected, dragging on any one insets all selected polygons equally.

- While the **Inset** button is active, you can drag other polygons in turn to inset them. To end the operation, **LMB** click Inset again, or right-click anywhere in the active viewport.

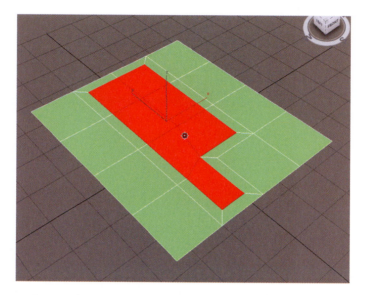

*Performing the Inset function on a group of polygons.*

**Bridge**—Connects two polygons or polygon selections on an object with a polygon "bridge." There are two ways to use Bridge in Direct Manipulation mode (that is, without opening the Bridge **Dialog Box.**)

- Make two separate polygon selections on an object, and then **LMB** click **Bridge**. This will create the bridge immediately, using the current **Bridge** settings, and then deactivates the **Bridge** operation.

- If no qualifying selection exists (that is, two or more discrete polygon selections), **LMB** clicking Bridge activates the button and places you in **Bridge** mode. First, **LMB** click a polygon and move the mouse; a rubber-band line connects the mouse cursor to the clicked polygon. Click a second polygon to bridge the two. This creates the bridge immediately using the current Bridge settings; the Bridge button remains active for connecting more pairs of polygons. To exit **Bridge** mode, **RMB** click anywhere in the active viewport or **LMB** click the **Bridge** button again.

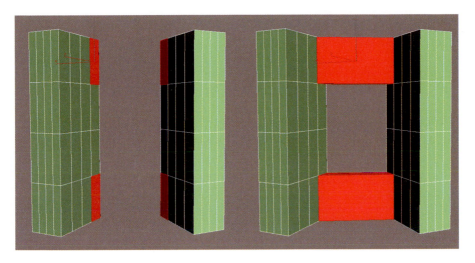

*Selecting a series of adjacent polygons and using the bridge tool to connect them.*

## Conclusion

Congratulations! You have completed your introduction to editable polygon objects in Autodesk 3ds Max. As you start to create more complex 3D objects and begin working with more complex scenes, it is very important that you familiarize yourself with the Editable Poly toolset. As the lessons in this book progress, we will explore plenty of new modeling tools and features that will propel you further as a 3D artist.

In the next lesson, you will explore the Material browser and begin to understand the basics of applying textures to your objects.

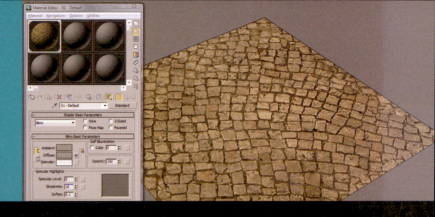

# Lesson 06

## Materials and Texture Maps

In this lesson, you will learn how to apply a material to an object. We will also define what a texture is, and show you the basics of how to give your objects a visual surface different than the default colors. Whether you want your object to be made of brick, stone, or water, you have to start with understanding how the Material Browser works.

**In this lesson, you will learn the following:**

- What a material and a texture are

- How to navigate and work with the Material Editor

- How to create your first material

## What materials and textures are

After creating an object in 3D, an important next step is to apply a material to an object to give it a visual surface and texture more closely related to the surface you are trying to generate. A material is used to create greater realism in a scene, and it describes how an object reflects or transmits light. The various maps and parameters that can make up a material work hand in hand with light properties, and when combined with shadows and rendering will simulate how an object might realistically look in a real-world setting.

Textures are flat 2D images, also known as maps that can be used in conjunction with numeric parameters to make a material. A common set of textures in the gaming world are color maps, specular maps, and normal maps that, when combined, can create a more realistic surface than simply making an object a flat color.

For an example of how texturing works, imagine a brick road and how that might look in 3D. Simply modeling each individual brick would likely be too time consuming and unrealistic given hardware limitations on game consoles, and even if you did, what would the surface look like? Simply making it red would not be enough to really sell the object so it looked believable. There are all sorts of tiny details that make surfaces more believable  dirt, grime, cracks, pores, and mud just to name a few. Actually modeling and coloring all of these surfaces could take quite a long time. This is where textures and materials come into play.

*Modeled red bricks.*

*An example brick diffuse map.*

Think of texturing your object as the art and skill of painting the surface to look more like what you want it to be and bridging the gap between simply modeling something and making it actually look like what you want it to with all the colors and nuances that surface has. Imagine a completely gray monster in your favorite game, or running down a city street that is just blue. It would not be a very interesting monster or street, would it? Now imagine that monster with slimy, scaly green skin and that road with hot black asphalt, a red curb, and graffiti along the walls. Textures and materials allow those otherwise drab and boring surfaces to really start to look like what you want them to.

## Working with the Material Editor

Let's start by opening the Material Browser. You can find the icon along the top of the Main toolbar, or use the keyboard hotkey **M**.

*The icon for the Material Browser along the Main toolbar.*

> **Tip:** It is easy to get lost with all the buttons and menus with the Material Browser when you are first getting started. When in doubt, you can always use the Go to Parent button to find your way back to the top of a material node. You can also simply delete the material and start over.

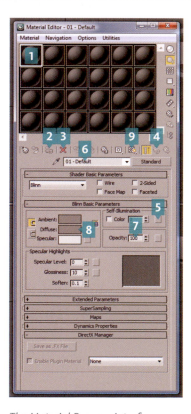

*The Material Browser interface.*

When you first open the Material Browser, there are plenty of new options and buttons to greet you. First, let's get familiar with some of the most important buttons as they apply to this book, and a description of their usage.

**1** **Material Node**—These are the icons that act as a visual representation of your material, with a small preview of what the material looks like. Double-clicking the **LMB** will bring up a scalable pop-up window that allows you a closer look at your material.

**2** **Assign Material to Selection**—Once you have a material created, this button will apply it to the object you have selected in your viewport.

**3** **Reset Map/Mtl to Default Settings**— This button will essentially delete your material and all of the setups in it back to the default state.

**4** **Go to Parent**—This button is basically the "go back to the beginning" button that will take you to the very top level of your material. As you begin to work with materials and textures, and the more complicated your materials are, you will want to remember this button to get back to the top level

**5** **Empty Box Input Nodes**—any of these empty boxes represent a map or input that can be used for that parameter. For example, if we have created a diffuse (also known as color) map, **LMB** clicking the small box next to Diffuse" will give us the ability to add that map. When you have a map or a parameter value plugged into these nodes, the letter **M** will appear over these otherwise empty boxes. You can also **RMB** click on these nodes and choose **Clear** to remove the maps completely. This is helpful if you have accidentally clicked a node and added something you did not intend to.

**6** **Material Name**—Each of the materials will have a number and the word Default next to it when you first begin work on your scene. If you wish to rename your material to something more relevant, simply replace the text in this box with the name of your choosing to replace it.

**7** **Opacity**—Adjusting this value will alter how see-through your material is. 100 is the default meaning it is not see-through at all, and the closer you get to 0 the less visible the material is.

**8** **Default Color Picker**—These gray boxes are color pickers. If you would like to create a material with just a color value, **LMB** click the gray box next to the word Diffuse to bring up the color picker and select a color of your choice.

**9** **Show Standard Map in Viewport**—Causes the material to show on the 3D object in the viewport. When rendered the material will generally always show up, but this button allows you to see it in 3D.

> **Tip:** *Remember that with any submenu in 3ds Max 2010, you can expand and collapse the menu by clicking anywhere on the box that has the name of the submenu. You can also "drag" the menu up and down by clicking anywhere in the gray area of the interface that is not a button and **LMB** click dragging it up or down. The icon will change to a hand when your mouse is anywhere that you can drag in a menu.*

## Creating your first material

For our first material, we will set up a simple ground texture that could be used as a ground or floor piece in a level. Before we can even begin to texture our object we need to think about the surface it is going to be. If I am making something out of stone, a marshmallow texture might not work! So, the first thing I might do is find a 2D image that looks close to what I am attempting to re-create. In future chapters we will discuss further some of the art involved with texture painting, but for now let's start with a simple image.

*A basic cobblestone ground texture.*

This texture works well because it is flat, does not have many sharp or harsh shadows on the surface, and is not warped by any sort of odd perspective problems. Looking at this image alone, you could almost imagine it being laid out flat on geometry to create a road. Quality texture maps do not need a lot of cleanup or fixing to start with. If the image had a sharp shadow in it, what would happen in your game if you shined a flashlight on that spot? The shadow would show up and that would spoil the sense of reality on the surface.

The next important step of texture maps is to ensure that the size remains relatively close to the size of the target geometry. If we took this square shaped picture and tried to squeeze it into a really long and thin picture frame, it would not look right at all.

Project 01

*The same brick tile stretched out of proportion.*

So for our first texture, we will take a square 2D image and put it onto a square shape in 3D.

1   **Set up a new material node.**

• Press the **M** hotkey on your keyboard to open the Material Browser, or **LMB** click the icon on the Main toolbar.

• On the very top-left blank material node, **LMB** click it to select it. A white outline appears over the material node to indicate it is your currently selected node.

• Rename this material *Ground_Floor*. After you have entered the new name, you should also see the name appear at the top of the Editor window, indicating it is the current material node selected.

*Select a new node and rename it.*

2    **Import your diffuse color map.**

- Under the submenu **Blinn Basic Parameters**, next to the diffuse, **LMB** click the empty node (the small empty box next to the gray color). This brings up a new window called the Material/Map Broswer.

*Select a new node and rename it.*

- The Material/Map Browser contains a multitude of various types of prebuilt maps, parameters, and input types; 2D texture maps are called bitmaps.

- Select Bitmap at the top of the Material/Map Browser by double-clicking the **LMB**.

- After you have clicked it, a browser pops up asking you where the image is.

- Navigate to *support_files/Project1/Lesson6/FG06_Ground.tif* on the DVD for this ground texture to select it.

- You should now see the surface of the ground replace the gray sphere in the Material Editor, giving you a small representation of what it looks like.

- You will also see that you are in a different set of menus than previously. This is because you are now looking at the exclusive parameters of that diffuse texture and not the material as a whole. You will also see that the icon changed from Standard to Bitmap, indicating that you are working with a 2D bitmap, and not a standard material.

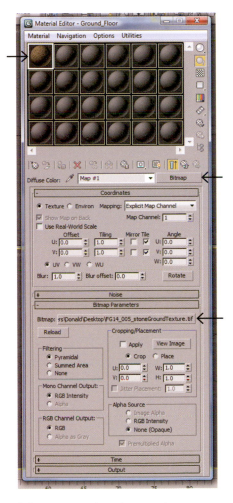

*Select a new node and rename it.*

- Under the Bitmap Parameters submenu, you also notice that the path to the image is listed here. If you want to change it to a different texture, you could do so by **LMB** clicking on the box and redirecting the path.

**3**    **Go back to the parent of the material.**

- Under the collection of material nodes, **LMB** click the **Go to Parent** icon to get back to the top of the material.

*Creating the sphere in the Perspective viewport.*

## How to apply a material to an object

Now that we have created our first material, let's create a simple plane apply the material to.

**1**    **Create a standard primitive plane.**

- In the Perspective viewport, create a plane and give it a length and width value of **100**.

- Set the length and width segments to **1**.

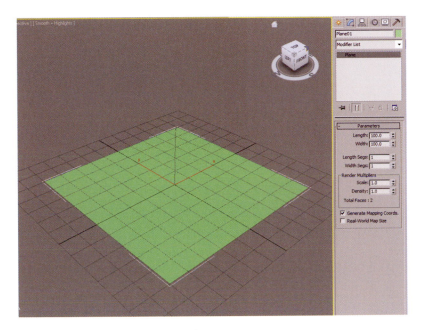

*Create a standard primitive plane in the Perspective viewport.*

**2** **Apply the material to the plane by dragging it.**

There are two quick methods for applying a material to an object. The first method is to drag the material node onto the object.

- Open the Material Editor window if you have closed it with the keyboard hotkey **M**.

- In the **Perspective** viewport, ensure that the plane primitive you created is in view.

- While holding the **LMB**, click and drag the *Ground_Floor* material onto the plane. When you do this, you will notice the icon change to a small square. Release the **LMB** to apply it.

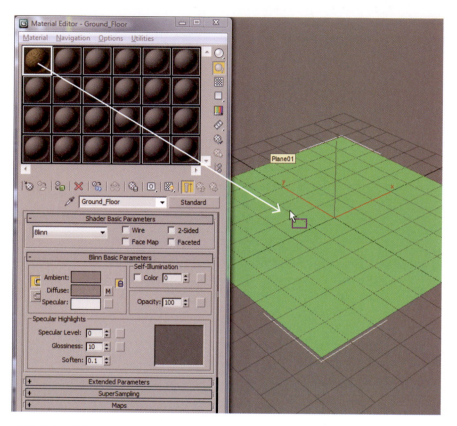

*LMB click and drag the material onto the plane.*

- After you drop the material onto the object, your plane should turn gray. This is because we have not turned the material on to show up in the viewport. We do that by **LMB** clicking on the **Show Standard Map in Viewport** icon. This works as sort of an on and off switch to show the texture in the scene.

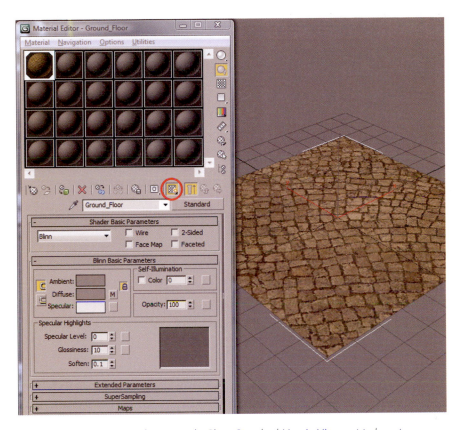

*After applying the material, turn on the Show Standard Map in Viewport to have to appear.*

**3**   **Apply the material to the plane with the Assign Material to Selection function.**

The second method to applying a material works almost exactly the same as the previous. The only difference is that you do not need to drag the material node at all, simply select the object and apply it.

- Open the material editor window if you have closed it with the keyboard hotkey **M**.

- In the **Perspective** viewport, ensure that the plane primitive you created is in view.

- With the plane selected, **LMB** click the **Assign Material to Selection** button to apply the material to the plane.

- If you have not already, make sure you turn **Show Standard Map in Viewport** on to see it.

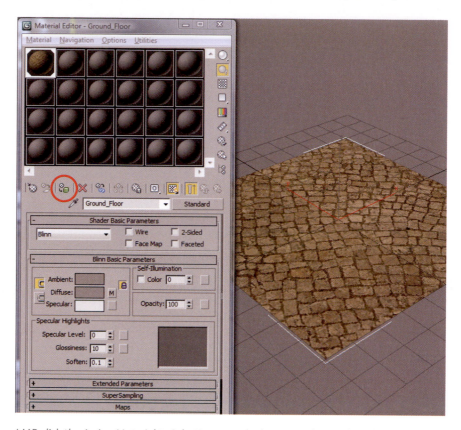

*LMB click the Assign Material to Selection to apply the material to a selected object.*

- Close the **Material Browser**. You have now correctly applied a material, composed of a diffuse color map, to an object.

- You can render the object with the keyboard hotkey **F9** to see what it would look like at its highest quality, but we will cover more on rendering and composition in later chapters.

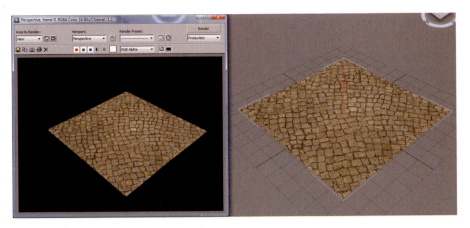

*A standard render of the plane, next to the viewport view of the object.*

## Conclusion

Congratulations! You have completed your introduction to materials and textures in 3ds Max! Having created your first material and texture map, you should have a basic understanding of how textures and materials work in 3D. In later chapters we will dive further into the world of texture painting and creating materials and maps.

This concludes Project 1, your first introduction to 3ds Max. In the next project and the lessons to follow, we will start with basic shapes and primitives, and work all the way toward creating your first finished game asset. We will expand on many of the principles you have learned in Project 1 and focus on a single project utilizing plenty of new tools and features contained in 3ds Max 2010.

# Project 02

Project 2 builds from the principles of Project 1 and covers the techniques needed to build a complete world prop from start to finish. In Lesson 7 we will begin by exploring the usage of 2D concept art and how it applies to creating 3D. Next, in Lesson 8, we will discuss the principles of polygonal modeling as we begin to model our first prop. From there, in Lesson 9, we will explore UVW unwrapping as we lay out the UVs of our asset. Lesson 10 will show you some of the methods used when texturing and applying surface detail to your asset. Lastly, in Lesson 11, we will discuss some of the basic rules for animation as we add motion to our prop. At the end of this project you should have a completed game prop, fully modeled, unwrapped, textured, and animated.

# Lesson 07
## Using 2D Concepts

In this lesson we will look at the principles behind using 2D concepts when creating 3D art; 2D concepts and references are the basic building blocks of generating 3D, as they provide you with the road map, giving you direction to what your object should look like. When working on video games, you are generally provided with concept art, references, or the direction to gather your own reference. Even the most abstract of video games will generally have some form of concept sketched out to give the 3D artist something to work with, even if there is a large reliance on personal creativity.

## Using 2D concepts as a guide for creating 3D

Before you begin to create that giant spectacular world you have always dreamt of, or model the next super car, it is a good idea to start with a 2D concept or a piece of reference.

Concepts or references are essentially 2D drawings or images that can be used as your guide for creating your piece of art. Imagine an architect who wanted to build a home, but never drew up any blueprints or had any sort of plans. He just showed up at the construction site with a big idea and told everyone what to do. Most likely, as you can imagine, the house would probably not turn out as it should! Concepts and references are the 3D artist's blueprint to help guide you in the direction of what you are going to create. A reference image is simply a picture of whatever it is you are trying to make.

Concept art and references can serve several purposes. For one, the lead artist on the project can channel his ideas directly to the 3D artist by utilizing a concept artist's skills of interpretation. The lead can potentially sit with a concept artist and say, "I want it to look more like this," and the concept artist will flesh out ideas in 2D. One benefit to this is that it saves a huge amount of time during the creation process of the actual 3D, because the better job the concept artist can do to translate what the lead artist wants, the less guess work is done by the 3D artists and level builders.

*A good concept image can lead to successful execution during the 3D modeling phase.*

*A screenshot from the game Demigod. While some proportions are slightly different, the overall theme of the concept is intact.*

One thing to consider is that concepts might not always be an exact blueprint. While you may be asked to create some objects as closely accurate as possible depending on the specific project, when you work in video games with fantastical worlds, sometimes you will not have such rigid guidelines. You might find that the concepts themselves might be missing some information, the perspective or scale might be a little off, or once you have the objects in the game you might discover the original dimensions are not going to work. These are all part of working on a team and working with concept. Obviously, the better the concept and direction are, the better you are going to be when it comes to executing the 3D, but sometimes creative liberties have to be made.

Another common practice is to start with some rough ideas in 3D space, quickly block in the basic shapes of the object, render that, and have a concept artist do paintovers. This is a term that can be used to describe when a concept artist or the lead artist takes either a 2D reference picture or an ingame screenshot and paints over the image to further direct the 3D artist to add more to the scene.

*The original ingame screenshot of the scene.*

*Adding additional concepts and ideas to an existing 3D space with a paintover.*

Project 02

*The final ingame shot with additional details and art added.*

Whether you are creating a full environment or a small prop for a scene, it is always good to start with concept or reference. Even the best artists in the business will start somewhere. Having an image next to you as you model will save you a lot of time in the end as a game artist. Nothing is worse than spending two days on something and having someone ask you what you were thinking!

One good practice is to take the concept or reference images, block out a rough version of it in 3D, and then identify any issues with the concept direction. If something is supposed to be animated or move around a certain way, you would want to identify that early on. Blocking in your asset or scene with very simple shapes before you get too far along is also a key to successful modeling. Think of it as a quick sketch before you commit. It is better to do a rough pass first!

Sometimes, seeing a complex piece of concept can be daunting, causing an artist to ask, "Where do I even begin?"

However, with some quick modeling you can easily block out the big shapes of the concept and immediately identify key parts of your model, proportion or scale issues, and consider how you will tackle the smaller details.

## Applying a concept image to your scene

In the following lessons, we are going to create a prop for the Demigod world using a piece of provided concept art. The image we will use as concept can be found on the provided disc in your *Project 2* folder, under *sceneassets/images/FG07_008_GoldMineConcept.tif*.

*For this project and throughout the following lessons, we will be building a Gold Mine prop.*

If you do not have a second monitor for your computer where you could keep the image up at all times, or if you do not want to constantly be maximizing and minimizing Autodesk® 3ds Max® software, a good alternative would be to add the concept image to your scene and have it as an object you could look at while you are working.

In Lesson 6 we covered the basics of setting up a simple material using a texture and applying it to a plane, so for now, let's start by doing just that with our concept image.

1    **Create a geometry plane the size of your image.**

First, create a plane with the same dimensions as the pixel dimensions of your concept image.

- In the Command Panel, select the **Create** tab, the **Geometry** option, and the Plane as the Object type.

- In the Front viewport, hold the **LMB** and drag it around to create a quick plane, and once you get a size you are happy with, release the **LMB**.

- One quick method of placing concept into your scene is to first identify the pixel dimensions of your actual concept image. Once you have identified the dimensions, you immediately know the size that the plane should be. Since our concept image is 1100x838 pixels, setting the plane's dimensions to that lets us immediately know it should be the correct size. Set the plane's dimensions to **838 length**, and **1100 width** by typing in those parameters under the **Modify** tab.

- Set the **length** and **width** segments to **1**.

- Center the plane in the world by **RMB** clicking the **Move** tool in the **Command Panel**, and entering **0** in each of the **X**, **Y**, and **Z** slots.

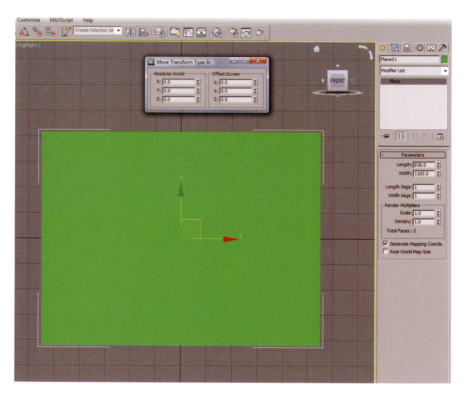

*Create a plane with the correct dimensions and the move it to the center of the world.*

**Tip:** *Depending on your computer's operating system, you should be able to find an image's dimensions by hovering your mouse over the image on your computer, or **RMB** clicking on the image and choosing **Properties**.*

**2**  **Create a material with your concept as the texture.**

- Press the **M** hotkey on your keyboard to open the Material Browser, or **LMB** click the icon on the Main toolbar. On the very top-left blank Material node, **LMB** click it to select it, and rename this material *Concept_Image*.

- Under the submenu **Blinn Basic Parameters**, next to the Diffuse, **LMB** click the empty node (the small empty box next to the gray color), and in the Material/Map Broswer window choose **Bitmap**. Navigate to the concept image in your *Project 2* folder, under *sceneassets/images/FG07_008_GoldMineConcept.tif*.

- Apply this material to the plane. If it does not show up immediately, do not forget to **LMB** click to turn on the **Show Standard Map in Viewport** button.

*Create a material with the concept image as the diffuse texture and apply it to the plane.*

3    **Rename, move, and resize the plane.**

- Under the Modify tab, rename the plane *Concept_Plane*.

- Move the concept image back and up from the grid in the world slightly with the **Move tool** (Hotkey **W**). This is so that any new objects we create and center in the world will always be directly in front of the concept.

- Since the actual parameters of the plane we created are somewhat large, go ahead and scale the image down slightly using the **Scale** tool (Hotkey **R**). If **Uniform Scale** is not selected (hover your mouse over the Scale tool to find out), **LMB** click and hold down the **Scale tool** button to reveal its rollout and select it. All three angles on the **Scale tool** should turn yellow for the Uniform scale.

*Move the concept image off of the center of the world and scale it down slightly.*

**4**    **Freeze the plane and put it into a new layer.**

- **RMB** click the plane to reveal its rollout menu, and **LMB** click **Object Properties**.

- This brings up the Object Properties window, where you can adjust parameters for specific objects in your scene. On the bottom-left side, uncheck the box for **Show Frozen in Gray**. This way when we freeze the object in the scene, the texture is still showing.

*RMB click the object and LMB choose Object Properties. Here, uncheck the option to Show Frozen in Gray.*

- **LMB** click the **Manage Layers** button to open the layers window.

- With the *Concept_Plane* selected, create a new layer by **LMB** clicking **Create New Layer**.

- **RMB** click the newly created *Layer01* and rename this *Concept Layer*.

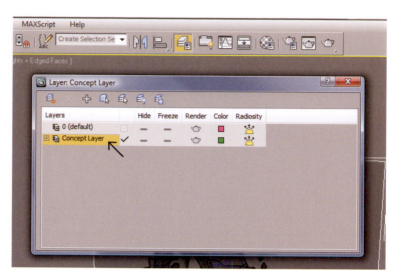

*Add the Concept_Plane to its own layer.*

- **RMB** click the plane and choose Freeze Selection. This does just as you would assume: it freezes the plane in place so that it cannot be altered in any way unless we Unfreeze it. To Unfreeze, **RMB** click anywhere in the scene and choose **Unfreeze All**. With the concept plane frozen in place, we can model all around it in the scene without messing it up, and since it has its own layer we can quickly hide or unhide it as needed for reference.

5    **Save your scene.**

- **LMB** click the 3ds Max icon in the upper-left corner of the UI and choose **Save**, or press the small disk icon.

- Save your scene as *PROP_GoldMine_01*.

*Save this scene as PROP_GoldMine_01.*

## Conclusion

Congratulations! You have successfully setup your scene and are ready to start modeling your first prop. In the next lesson we will cover the entire modeling process from beginning to end, and will look at several new tools and modifiers to reach our goal.

# Lesson 08

Polygonal Modeling
for Games

## Blocking out the prop

Continuing where we left off previously with our PROP_GoldMine_01 file, we will refer to the concept and begin to block in the basic shapes of the object using primitives and editable polygon tools.

A first step in blocking out the geometry is to spend a few minutes studying the concept art and imagining what primitives we can start with and then convert into an editable poly. With a clear idea in your head and thinking about the shapes ahead of time, you will find yourself over time deciphering any concept you are given and able to easily tackle even the most complex of shapes, simply by breaking them down ahead of time.

During this process, imagine the object in 3D, with no textures or surface detail. Imagine it completely bare and try to look at it as a flat and clean object. This will help you plan your modeling blockouts with primitives. Here are just a few ideas with our concept.

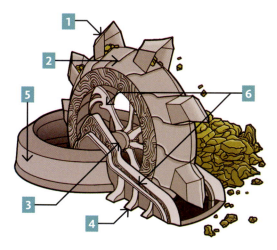

*Refer to the concept and try to imagine it completely untextured and barren.*

**1** Simple box with the insides cut out.

**2** Tube with outer edges pulled out.

**3** Simple cylinder.

**4** Boxes with the bottom extruded.

**5** Cylinder or tube with outer lip pulled up.

**6** Custom shapes.

Once you have a basic vision of what sort of shapes you could use, the next step is to go ahead and start blocking it in. After you have done this previsualizing a few hundred times, you may find yourself looking at the world as 3D shapes and objects trying to imagine just how you might model the world around you. This is a good thing!

When it comes to the actual creation of the objects, it is good practice to start with the largest shapes first, as this gives you a building block from which the rest of the objects can work from. Keep in mind, the goal of this is to quickly get the main shapes in and try to focus on having the majority of the geometry in the world for editing, even if it seems somewhat messy and unorganized.

1    **Block in and align two large tubes.**

Two of the larger shapes look like they could be done as tubes, so start by creating and aligning those.

- In the Perspective viewport, create a tube with the following parameters:

    **Radius 1**: 60

    **Radius 2**: 70

    **Height**: 25

    **Height/Cap Segments**: 1

    **Sides** 18

- Rename the first tube *GoldMineBase*.

- Move the tube to the center of the world by **RMB** clicking on the **Move tool** and set the **X**, **Y**, **Z** to **0**.

- Create a second tube anywhere in the Perspective view with the following parameters:

    **Radius 1**: 80

    **Radius 2**: 50

    **Height**: 30

    **Height/Cap Segments**: 1

    **Sides** 18

- Rename this second tube to *WheelBase*.

- Rotate the second tube 90 degrees by **RMB** clicking the **Rotate tool** and typing in **90** in the **X**.

- With the second tube you created selected, **LMB** click the **Align tool** on the Main toolbar and **LMB** click on the first tube. A new dialog box pops up. Under **Align Position (World)** check the boxes for **X**, **Y**, and **Z**, and under both **Current Object** and **Target Object**, choose **Center**.

*Create two tubes and use the align tool to line them up.*

- Move the WheelBase up and forward similar to the concept, imagining it will be the wheelbase for the scoops.

- Save your scene as *PROP_GoldMine_02*.

**2**   **Block in and align boxes for the scoops.**

Next we will use the align tool and adjust some boxes to block in the scoops.

- In the **Front** viewport, create a box with the following parameters:

   **Length**: 30

   **Width**: 30

   **Height**: 20

   **Length Segments**: 2

   **Width Segments**: 1

   **Height Segments**: 2

- Rename the box *WheelScoop*.

- With the box selected, **LMB** click the **Align tool** on the Main toolbar and **LMB** click the second tube, WheelBase. Similar to how we aligned the tubes, when the Align Selection pops up, under **Align Position (World)** check the boxes for **X**, **Y**, and **Z**, and under both **Current Object** and **Target Object**, choose **Center**.

- This will place the box at the very center of the tube. Using the **Move tool**, move the WheelScoop up so that it intersects with the tube at its top.

*Block in the WheelScoop with a box and align it to the tube.*

3   **Create a cylinder for the center of the wheel.**

- In the **Front viewport**, create a cylinder with the following parameters:

    **Radius**: 10

    **Height**: 50

    **Height**: 20

    **Height Segments**: 1

    **Cap Segments**: 1

    **Sides**: 10

- Rename the cylinder *WheelCenter.*

- Using what you have learned, use the Align tool to center the Wheel Center to WheelBase.

*Add the center cylinder for what will be the middle of the wheel. Do not worry if things are out of line or intersecting, the goal of the rough blockout is to get geometry down quickly so that we can edit it later.*

**4**   **Block out the side supports of the wheel.**

- In the Front viewport, create a box with the following parameters:

  **Length**: 40

  **Width**: 100

  **Height**: 10

  **Length Segments**: 1

  **Width Segments**: 5

  **Height Segments**: 1

- Rename the box *SideSupport1*.

- Convert the box to an **Editable Poly**. (**RMB** click on the object and select **Convert To Editable Poly** from the rollout menu.)

- Switch to **Vertex** mode (Hotkey **1**), and using the Move tool and the concept art as a guide, move the vertices up and down to block out the shape of the side support pieces outside of the wheel. If you need to, switch to **Edge** mode (Hotkey **2**) and use Editable Poly tools such as **Connect** to insert additional edges while in the Front view.

*After creating a box, move the verts up and down to block out the shape of the side support pieces of the wheel.*

- Once you have the basic shape completed, use the **Align** or the **Move** tools to place the Side Support along the outside of the wheel, similar to where it is in the concept.

*After creating the wheel support piece, use the Move tool to align it alongside the main wheel.*

5    **Add the small side supports.**

Next we will create the small support teeth that we see along the bottom of the main wheel support.

- In the **Front viewport**, create a Box with the following parameters:

    **Length**: 15

    **Width**: 8

    **Height**: 5

    **Length Segments**: 3

    **Width Segments**: 1

    **Height Segments**: 1

- Rename this small box *SmallSupport1*

- Convert the box to an **Editable Poly**.

- While in Vertex mode, select the various vertices along the outside face and use the Move tool to achieve a shape closer to the smaller support pieces.

- Once you have a shape you are happy with, use the Move tool to align it along the side of the bigger *SideSupport1*.

- Save your scene as *PROP_GoldMine_03*.

*Adding the small teeth support pieces.*

6    **Use shapes to create the wheel spokes.**

Similar to how a bicycle works, this would-be wheel has several large support spokes that connect it to the main base of the structure. These objects are a little more complex to create, so to do so we will not use standard geometry, but instead we will use a new object type called a Line.

- In the **Command Panel**, under the **Create** tab, choose **Shapes**. Under the Object Type, select **Line**.

- Under the Creation Method submenu, make sure Corner is selected for both **Initial Type** and **Drag Type**.

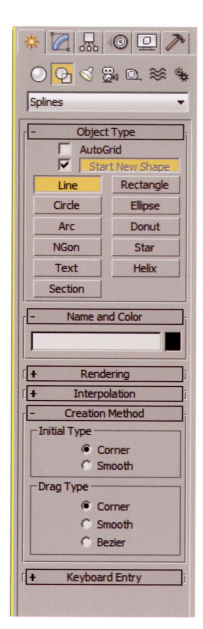

*For more complex shapes, starting with a line may be an easier choice than poly-modeling.*

- In the **Front** viewport, using a **Line**, **LMB** click and release to place your first point for the line, and continue to add points. Think of lines as tracing, and you are trying to match the outer most points of the shape. Each time you **LMB** click you are adding to the shape.

- Try to create a shape similar to the support spokes in the concept. When you come back around and complete the shape with a line, a pop-up will ask you if you want to **Close Spline**? Click **Yes** to complete the shape.

- Rename this object *MiddleSupport*.

- To add more vertex points to the Line, use the **Refine** tool while in Vertex subobject mode, under the Geometry submenu. **LMB** click anywhere along the line to add a vertex. **RMB** click anywhere in the viewport to exit **Refine** mode.

- If you have two vertices next to each other and want to collapse them together, the quickest way to do it is with the **Fuse** tool, also under the Geometry submenu. You can also use the **Weld** function with an adjustable threshold value (the numeric value next to the **Weld** tool).

- To remove a vertex point, simply select it and press **Delete** on your keyboard.

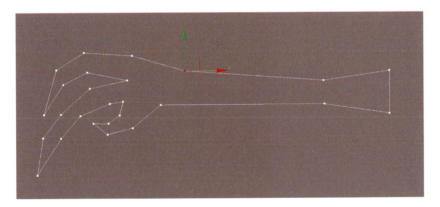

*Using the line tools, block out the shape of the supports for the main wheel.*

- Once you are happy with your shape, convert the object to an **Editable Poly**. Keep in mind you must have a closed shape, or the conversion will not work.

- You now have a single polygon object. Select the polygon and use the **Extrude** tool to give the object some depth. **RMB** click to end the **Extrude** operation.

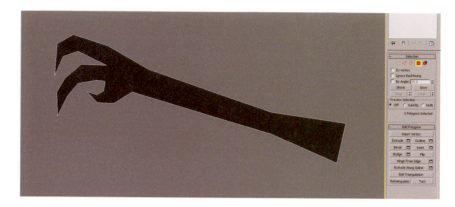

*Convert the shape to an Editable Poly.*

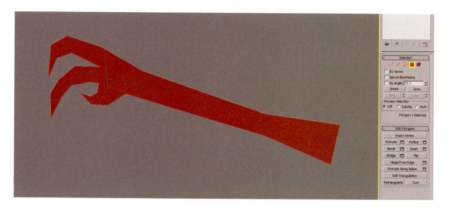

*Select the Face.*

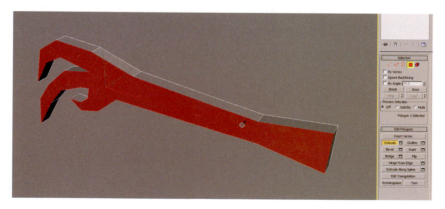

*Using the extrude tool, extrude the face out to give the object some depth.*

**Project 02**

- If you are happy with this shape, apply a **Symmetry** modifier, and set the **Mirror Axis** to **Z**.

- Collapse the object to **Editable Poly**.

- Once you have the shape completed, using the **Scale**, **Align**, **Rotate**, and **Move** tools, place this piece in the center of the wheel, similar to where it is in the concept.

- You may need to scale the object, or move vertices to get the object to fit within the wheel for now. Keep in mind we will be doing a polish pass again soon, but try to match the shape as close to the concept as possible.

*Making adjustments to the Middle Support piece. Do not forget to Hide/Unhide other pieces you do not need to see immediately when working with geometry.*

- Save your scene as *PROP_GoldMine_04*.

## Refining the prop

Now that we have blocked out the very basic shapes of what will be our finished prop, let's take advantage of a few Editable Poly tools and wrap the object up with a finish pass. We will also look at using instances and resetting pivot points to make things easier as we continue forward with completing our first prop.

As you are working with individual pieces, remember to take advantage of hiding and unhiding assets you do not need immediately, and remember to use the Layer Manager to reference back and forth with the concept image.

1    **Adjust GoldMineBase.**

Let's adjust the radius and the inner lip of the object using Editable Polygon tools.

• Convert the *GoldMineBase* to an Editable Poly object.

• Select any edge on the top of the inner circle of the tube, and use the **Loop** tool to select all of the edges in a loop around the top of the inner ring.

• Use the **Move** tool to move that edge selection up a bit, similar to the concept image

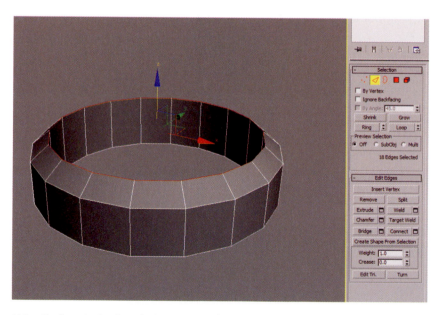

*Using the loop tool, select the inner ring and move it up slightly.*

• Switch to the Top view, and delete the 12 polygons closest to the wheel's center. Since these polygons are needed and we do not want to have interpenetration on the geometry, we want to clean them out.

*Switch to the Top view and select the three sets of inner most polygons.*

*Press Delete on your keyboard to remove them.*

2     **Refine and instance the WheelScoop.**

Next we will create refine the *WheelScoop* using **Editable Polygon** tools.

- Convert the *WheelScoop* box to an **Editable Poly** object.

- Using the **Vertex** subobject mode and the **Move**, **Rotate**, and **Scale** tools, refine the shape to closer match the scoops exterior shape. Do not worry about the interior of the scoop just yet, just get the outer shape first.

*Using the Vertex subobject mode, adjust the shape of the scoop to closer match the concept.*

- With the *WheelScoop* selected, select the front faces that would make up the interior of the scoop and delete them.

- Apply a **Shell** modifier, and under the Parameters submenu give it an **Inner Amount** of **1**, and an **Outer Amount** of **0**.

- Convert the object to an Editable Poly.

*Select the faces that would make up the inside of the scoop.*

*Delete the faces.*

*Apply a Shell modifer.*

*Collapse back to Editable Poly.*

- Ensuring that the *WheelScoop* is centered on the *WheelBaseObject*, and that you have the *WheelScoop* selected, switch to the **Hierarchy** tab, and select **Affect Pivot Only**.

- A new icon appears. This is the pivot point of the object, and by turning on **Affect Pivot Only**, any movements or rotations will affect only the pivot, and not the object. To recenter it to the object, press the **Center to Object** button, which centers the pivot onto itself.

- Next, use the **Align** tool and click the Wheel Base with X,Y,Z and Center/Center options on. Click **Apply**. We are now moving the pivot of the Scoop to the center of the WheelBase.

*Move the pivot of the Scoop to the center of the WheelBase.*

- To exit out of adjusting the pivot point, simply switch back to the Modify tab.

- With the *WheelScoop* selected, make sure you have turned **Angle Snap Toggle** turned **on**.

*The Angle Snap Toggle ensures that any rotations you do will snap to a default power of a 5-degree angle.*

- Holding down the **Shift** key, Rotate the *WheelScoop* **40** degrees along the **Y** axis, and when the option for Copy, Instance, or Reference pops up, create **8** instances.

*Create eight instances of the scoop after adjusting the pivot.*

3  **Refine the MiddleSupport.**

Using what you have learned, let's make some instances of the *MiddleSupportPiece*.

- Align the pivot of the *MiddleSupport* to the *WheelCenter* object. If the pivot is facing an odd direction and pressing **Center to Object** does not fix this, try using the **Reset: Transform** option under the **Adjust Transform** submenu.

- Make **7** instances of the *MiddleSupport*, and **Rotate** it **45** degrees.

*Create seven instances of the MiddleSupport after adjusting the pivot.*

- Using the **Loop** selection, remove any excess edges that are not defining the shape in the Edge subobject mode, with the **Ctrl+Backspace** hotkey.

4    **Refine the SmallSupport and the SideSupport.**

Next let's refine the *SmallSupport* and *SideSupport* objects.

- With the *SmallSupport 1* selected, holding down the **Shift** key and using the **Move** tool, move the object slightly to the left, and create **2** instances.

- Using the **Scale** and **Move** tools, adjust the sizes and positions of the *SmallSupport* instances to closer match the concept. Remember, scaling and moving will not affect the instances, but adjusting anything in the subobject mode will.

- Adjust the *SideSupport1* object and make any scale adjustments needed to refine the shape closer to the concept.

**Tip:**   *When working on your prop, do not be afraid to jump around from piece to piece and slowly refine the shapes so that they closer represent the shapes of the concept. There is no rigid guideline for making art, as it is all a creative process. Find the process that works best for you!*

- Select all three of the *SmallSupport* instances, as well as the *SideSupport* and switch to the **Hierarchy Tab**. This time, choose **Use Working Pivot**. The Working Pivot defaults a temporary pivot at 0,0,0 and allows for a quick Mirror without having to adjust the pivot points of the objects individually.

- Use the **Mirror tool** from the **Main toolbar** and select **Y** as the **Mirror Axis**, and choose **Instance**.

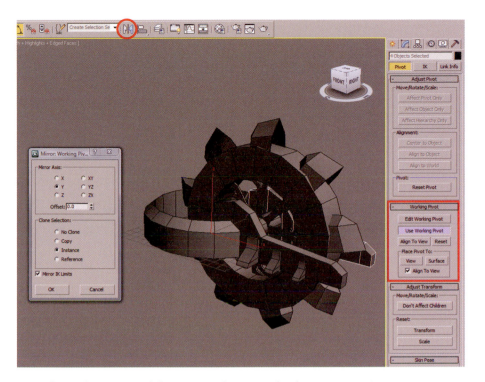

*Using the Working Pivot and the Mirror tool to mirror the objects across as instances.*

5    **Refine the WheelBase.**

Next let's refine the big *WheelBase* object.

- Convert the object to an Editable Poly.

- In Edge mode, select an edge along the outer and inner sides of the object, and use the Ring operation to select all of the edges in a Ring.

- Use the **Connect** tool to add one **Edge Segment** to the selection.

*Select an Edge on the Inner and Outer sides of the object.*

*Use the Ring selection tool to select all of the adjacent edges in a Ring around the object.*

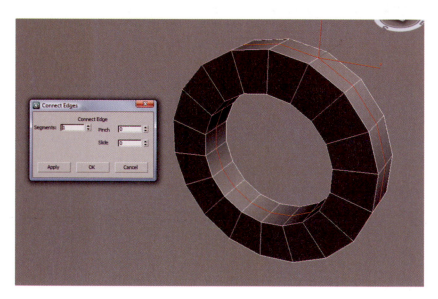

*Using the Connect tool while in Edge mode, add one segment to the selection.*

- With that same Edge selection highlighted, use the Uniform Scale tool to adjust the inside and outsides of the object, similar to the concept image.

*Use the Uniform Scale tool with your edge selection to push the inner and outer rings further.*

6    **Final cleanup.**

- Refer to the concept and all of your objects. Continue to make size and scale adjustments as needed.

- Select and delete any polygons that are embedded in other geometry or are facing the ground where they would normally not be seen if this object were placed in a world.

*Identify objects that have faces that are embedded into other geometry or would be pointed at the ground if this were in an environment. Here are just a few ideas of polygons that could get cleaned up.*

- Ensure that your meshes are at least made up of a four-sided polygon (aka Quads). When we created the *MiddleSupport* it was one giant polygon, which is bad for games. You want to do your best to avoid an object that has polygons with more than four vertices. You can clean the *MiddleSupport* object up easily by going to the **Front** viewport and selecting opposing sets of vertices and using the **Connect** tool to create edges between the vertices, thereby creating three- and four-sided polygons.

*In the Front viewport, select opposing vertices and use the Connect tool to connect edges between them while attempting to fix any polygons with more than four vertices.*

- When you are done making your adjustments, save the finished scene as *PROP_GoldMine_05*.

*The finished prop, with various scale and placement adjustments made as needed.*

## Conclusion

Congratulations! You have finished your first completed prop in 3Ds Max 2010. Hopefully you were able to follow along and learned several new tricks and tools for your modeling needs. As we move forward in the next couple of lessons we will be UVW unwrapping, texturing, and even animating our prop.

# Lesson 09
## UVW Unwrapping

In this lesson we will learn the fundamentals of UVW unwrapping. We will be laying out the faces of our object in the preparation of texturing, which we will cover in the next lesson. Before we can texture though, UVW unwrapping is a necessary step for any asset you might have to make in a game. Regardless of the size or level of importance of the object, doing a good job of UVW unwrapping is a skill any serious game artist should have.

**In this lesson, you will learn the following:**

• What UVW unwrapping is, and how it applies to game art

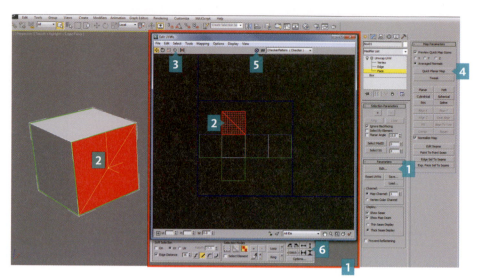

*The Unwrap UVW Interface*

## Unwrap UVW Key Interface Elements

The Unwrap UVW modifier works just like any other modifier to apply it. After you apply it, you are given three subobject modes **Vertex**, **Edge**, and **Face**. These are the three editable elements you will work with when it comes to UVs. Just like most all windows in Autodesk® 3ds Max® 2010 software, you can **LMB** click and hold along the border of the window to resize it as needed. You can also move the window to another monitor if you have that. Let's look at some of the key elements of the interface to get started.

**1    Edit UVW Window**

This is the primary window where you will be working with the UVs of your object. To bring up the window, click the **Edit...** button under the Parameters rollout.

**2    Currently Selected Subobject**

When working with UVs, the subobject you select in the Edit UVW window will also appear shaded on your geometry in the 3D viewport. Switching between subobject modes works the same as an editable poly using the **1**, **2**, and **3** hotkeys.

**3    Move, Rotate, Scale, Freeform, and Flip Tools**

These are some of the most commonly used tools in the set. As with many features in 3ds Max, **LMB** clicking them and holding down the button will reveal a rollout of various other tools as well. Similar to working in 3D, the hotkeys for **Move**, **Rotate**, and **Scale** are the same in the UV tools.

**4    Quick Planar Map**

We will be using this tool quite a bit when working with Unwrapping. Using the X, Y, or Z axis in 3D, we can use this tool to quickly lay out a selection of UVs.

**5    Show Map Toggle**

This toggle will show a selected image in the window, or a checkerboard pattern by default.

**6    Rotate and Align UV Tools**

Use these tools to rotate UV chunks, or align subobject selections. Hover over each of them for a description.

> **Tip:**    *While inside the Edit UVW window, hold down the **MMB** to drag the viewport around, and scroll the **MMB** up and down to zoom in and out .*

## UVW unwrapping explained

When working in 3D, UVW unwrapping is used to describe the process of laying your object's faces out flat into an informational 2D plane so that you can apply textures and materials to your object. The UVW coordinates of an object are basically a set of stored information inside of a piece of geometry that defines how a texture will look if applied to it.

The UVW coordinate system with regards to 3D is similar to the XYZ coordinate system you should be familiar with when modeling. However, when it comes to UVW unwrapping, the U and V axis of a texture map correspond to the X and Y axis, while the W axis correspond to the Z axis, and is generally only used for procedural maps, which we will not cover here. This is also why it is sometimes referred to as UV mapping or working with UVs and the W is omitted.

When unwrapping an object, you do not physically modify the actual geometry itself, you are simply modifying the UVW coordinates , which is what all of the object's faces might look like in 2D if they were rolled out flat. To illustrate, imagine a simple box made up of six polygons. To easily paint a texture map onto that box, imagine the box unfolding and laid out completely flat. Since texture painting is done in 2D, we could then take all six of those flattened faces of that box and paint them with the UVW coordinates of the box accurately, and then apply the texture to the box. This is the process of UVW unwrapping.

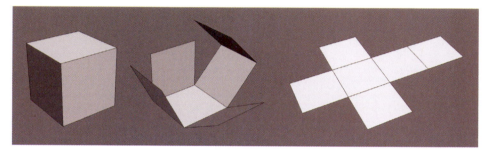

*When unwrapping, imagine a box being split apart and laid down flat. We will not actually change the original geometry, but when working with UVs, this is the goal in order to get a clean and easy surface to paint a texture on.*

## Create a checkerboard texture

As we begin to texture our assets, we will want to assign a checkerboard pattern to our objects to make sure that there is not any unusual stretching or skewing of our UVs. Imagine for a moment that you make that box again, but the UVs are stretched and not laid out flat. The texture of that object would also look skewed and stretched if the UVs are not relatively the same dimensions of the object itself. A checker pattern will allow you to visually ensure there is no unusual stretching or skewing of the UVs.

- Start by opening the Material Editor.

- Select an unused Material node, and **LMB** click on the box next to the Diffuse slot.

- When the **Material/Map Browser** window pops up, choose Checker as the map type by double-**LMB** clicking it.

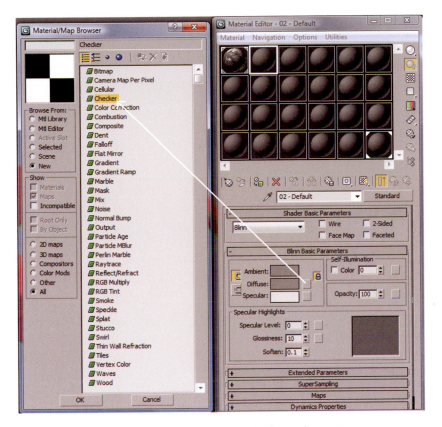

*Click the box next to the Diffuse slot and choose Checker as the map type.*

- By default, it is a black-and-white checker pattern with only a 1x1 tiling. The more you tile the texture, the smaller it will be repeated across the surface, which is fine for a checker pattern. So for now, change the tiling to 20x20. Under the **Checker Parameters** rollout, feel free to change the colors as you desire by **LMB** clicking the color box and choosing your own.

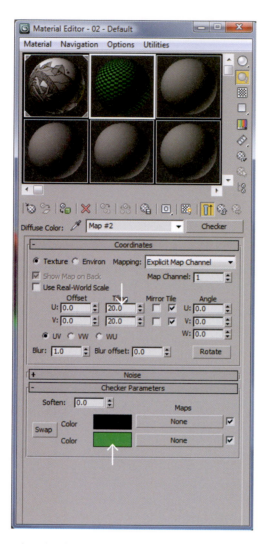

*Tiling the checker pattern 20x20 and changing the color.*

## Unwrapping our prop

Let's begin by opening our *PROP_GoldMine_05* file. Since we created several different instances of our objects, we luckily only have to unwrap those pieces. Start by selecting just one of the objects that we made instances of, and let's hide everything else. Remember, to hide something, simply **LMB** select it, and then **RMB** click in the viewport and select **Hide Selection**, or **Hide Unselected** to hide everything else.

**Project 02**

*Since we created a series of instances in our previous lesson, we only need to UVW unwrap those individual objects.*

Once we have the objects we want to work with, let's start unwrapping each piece individually.

> **Tip:** *Holding down the **Alt** button and pressing **Q** will allow you to isolate a selection. This works similarly to a fast Hide/Unhide. Once you have isolated a selection, simply click the Exit Isolation Mode button from the pop-up to exit.*

1 **Unwrap the GoldMineBase.**

Let's start with the large outer base and unwrap that first.

- Start by selecting the *GoldMineBase* by **LMB** clicking it.

- Apply the **Unwrap UVW** modifier in the **Modify** tab.

- Click the **Edit...** button under the Parameters rollout to launch the **Edit UVW** window.

- Let's start by hiding the checker pattern in the background by **LMB** clicking the Show Map toggle, and bring up the **Unwrap Options** by **LMB** clicking **Options → Preferences** in the Edit UVWs window. Here, uncheck the option for **Show Grid**, and press **OK**. (This is a personal visual preference only, and will have no bearing on the results of the unwrap. Feel free to alter any of these settings for yourself! Once you have some settings you prefer, save them as the default by **LMB** clicking on **Options → Save Current Settings As Default**.

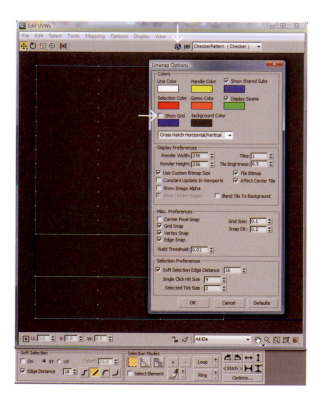

*Setting some personal preferences to how the Edit UVW window looks.*

- Start by selecting all of the faces of the *GoldMineBase*. You can do this by first switching to Face mode (hotkey is 3) or selecting it in the Modify panel, and then pressing **Control+A** on your keyboard to select all. You can also **LMB** drag select them all in the 3D viewport.

- Once you have all of the faces selected, choose the **Cylindrical** option under the Map Parameters. Click the **Align Z** button to make sure that the cylindrical calculation is done in the correct axis. This will cause the gizmo in the 3D viewport to change. To exit Cylindrical mapping, click the **Cylindrical** button again.

- Essentially what you have done is selected all the faces and attempted to lay their UVs out flat. We used a cylindrical "projection" because that is the closest representation of the original shape. The only downside to this method is that it lays out the faces on top of each other, so that the inside and the outside are both laid flat onto itself. This is fine sometimes, but for these faces we will want them to have different textures, so we should separate them.

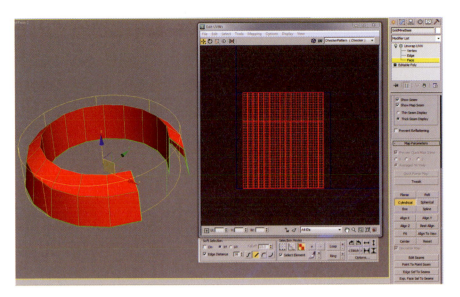

*Choosing the Cylindrical projection option for the UVs of the GoldMineBase.*

**Tip:** The default color of the UV lines in the Edit UVW window is going to be the color of the object itself, found next to the name of the object in the Modify tab. (Not the texture or material) Setting the color to white will cause the lines in the editor to be white as well, and may make them easier to see.

- Knowing that the faces are stacked on top of each other, go to the 3D Viewport and select only the faces on the inside. Remember, to select multiple faces, hold down the **Control** button and **LMB** select the faces.

- Once you have only the faces of the inside of the Base selected, back in the Edit UVW window, press the Break hotkey (**Control+B**) to break the selected faces off from the others, and move those faces off to the side.

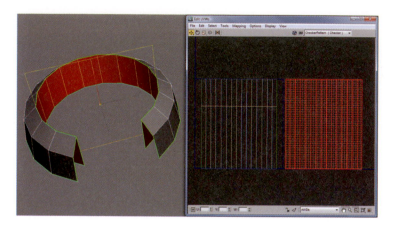

*Select the inside faces of the base, Break them off from the outer faces and move them over in the Edit UVW window.*

- After making these adjustments, apply the checkerboard material to the object. As you can tell from the pattern on the base, the squares are badly stretched and skewed. In order to fix this, we can go back into the Edit UVW window and resize the UV chunks so that they closer match the actual size and scale of what the 3D version of itself looks like.

- Using the various subobject modes, and the Move, Rotate, and Scale tools, adjust the UVs so that the checkerboard pattern squares are not stretched.

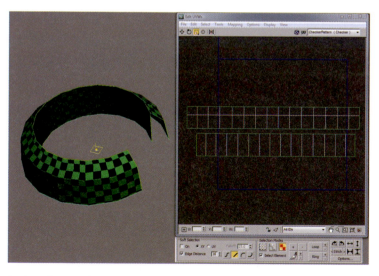

*Scaling the UVs down so that the checker pattern is less skewed. This is a closer representation of what the actual object would look like if it were laid out flat.*

- Since the UVs for this object are mostly done for now, collapse the modifier stack by **RMB** clicking anywhere in the viewport and choosing **Convert To → Convert to Editable Poly**.

**2   Unwrap the WheelCenter.**

- Select the *WheelCenter* and apply your checkerboard texture to it.

- You may notice that the checker pattern already looks pretty good, even without us having done anything. The reason for this is that some basic primitives when created already have UVs on them that closely represent the object.

- Apply the **Unwrap UVW** modifier in the **Modify** tab.

- Scale all of the UV faces down and move them off to the side. Later, when we attach all the objects together, this will help us to keep UV chunks off of each other.

- Collapse the modifier stack by converting it to an Editable Poly.

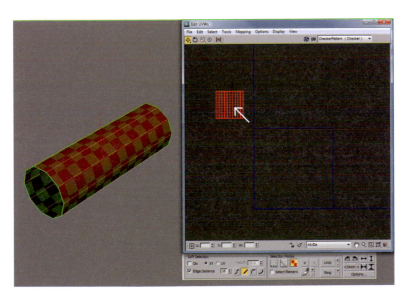

*Scale the UV chunk down a little and move it off to the side. Later, when we attach our objects together, this will help keep the UV chunks separated.*

3    **Unwrap the SideSupport.**

- Select the SideSupport object and apply your checkerboard texture to it.

- Apply the **Unwrap UVW** modifier in the **Modify** tab.

- Start by selecting all the faces of the object, and under the Unwrap UVW modifier and the Map Parameters rollout, choose the **Quick Planar Map** tool with the Y axis selected.

*Select all the faces and use the Quick Planar tool with the Y axis selected to do a quick projection on both sides of the object. This will do a flat projection of both sides of the object, which will ultimately share the same texture.*

- As you may notice, the sides of the object look correct, but along the top, the UVs are stretched pretty badly. To fix this, select all of the faces along the top in the 3D viewport, and in the Edit UVW window, **LMB** click **Mapping** → **Unfold Mapping**. When the dialog box pops up, choose the default settings by clicking **Ok**.

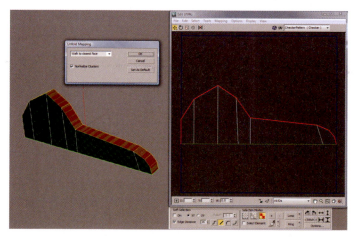

*Grab all the faces along the top and use the Unfold Mapping tool to fix the UVs along the top of the SideSupport object.*

- Since this is an Instanced object, we have to collapse the stack a little differently. To collapse the stack of an Instance, **RMB** click on the modifier at the top of the stack, (in this case the **Unwrap UVW** modifier) and choose **Collapse To**. If a dialog box pops up, choose yes to continue.

- Save your scene as *PROP_GoldMine_06.max*.

**4    Unwrap the SmallSupport.**

- Select the *SmallSupport* object and apply your checkerboard texture to it.

- Apply the **Unwrap UVW** modifier in the **Modify** tab.

- For this object, select all of the faces and in the Edit UVW window, choose **Mapping** → **Flatten Mapping** and the default settings.

- Starting with the large square chunk that is made of two faces, switch to Edge mode and select the outer edge that should connects to the other squares. You will know if you have the correct edge selected if the other edge turns blue in color. With that edge selected, **RMB** click anywhere in the window and select **Stitch Selected**. This will snap the floating face to the edge you originally selected. Continue to stitch the rest of the floating faces together.

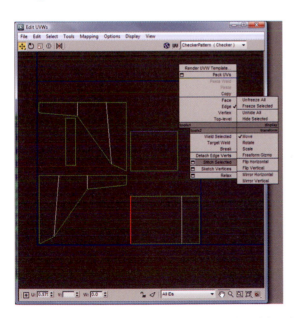

*Start by selecting an edge, as highlighted in red, and the edge that it should be attached to in 3D will be highlighted in blue. RMB click in the viewport and choose Stitch Selected to weld the two together.*

- Select the two side faces and use the **Quick Planar** tool with the **X** axis selected.

- **Collapse To** at the top of the Modifier Stack, since this is an Instance.

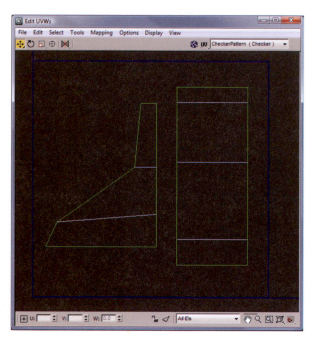

*The final UVs, after stitching and using the Quick Planar tool.*

5    **Unwrap the MiddleSupport.**

- Select the *MiddleSupport* object and apply your checkerboard texture to it.

- Apply the **Unwrap UVW** modifier, and start by selecting all the faces and applying a **Quick Planar Map** with the **Y** axis selected.

- Switch to the Top view in the 3D viewport and select all of the inside and outer faces of the object. If necessary, uncheck the **Ignore Backfacing** in the Command Panel under the **Selection Parameters** rollout.

- Choose **Mapping** → **Unfold Mapping** in the Edit UVW window to lay those UVs out flat.

- Resize and scale as necessary to fix any stretching.

- **Collapse To** at the top of the modifier stack, since this is an Instance.

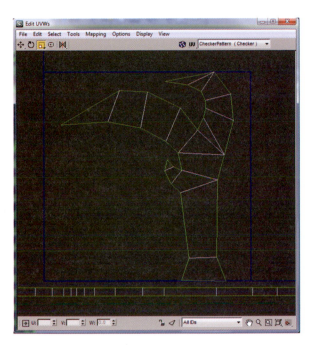

*The final UVs, after unfolding and using the Quick Planar tool.*

**6   Unwrap the WheelBase.**

- Apply the Checkerboard material and the **Unwrap UVW** modifier to the *WheelBase* object.

- Since we started with a primitive for the *WheelBase* object, it too should have some very basic UVs already laid out for us and make things a little easier. With everything laid out in strips, it will also make things easier when we get to the texturing phase. Start by grabbing just the inner most ring of the wheel, and **Break** those UVs off and move them to the side.

- Next, grab the outer most faces and move those over to the side. These UVs are going to be a little skewed, but this is an acceptable amount considering we will be eventually painting a somewhat abstract design along that side anyhow. Feel free to lay these UV chunks on top of each other as well, since they will have the same texture.

- Lastly, grab the outer most ring of UVs and move those aside.

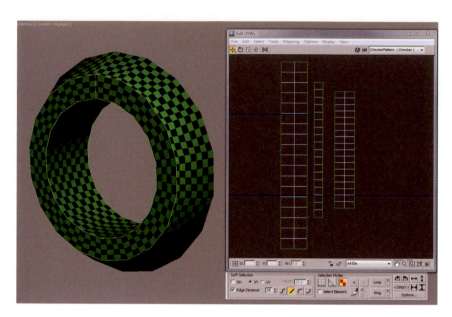

*The final UVs, broken into chunks. Sometimes, the gain from having your UVs cleanly laid out for texturing can override a little bit of UV stretching.*

**7**    **Unwrap the WheelScoop.**

- Apply the Checkerboard material and the **Unwrap UVW** modifier to the *WheelScoop* object.

- Select all of the faces of the WheelScoop and choose **Mapping** → **Flatten Mapping**, and choose **OK**. This will lay out all of the faces based on an angle numeric threshold.

- Using the **Stich Selected** tool and the Edge subobject mode, try to use what you have learned to stitch together the UV chunks of the inside and the outside of the object. The goal is to keep it in as few of UV chunks as possible.

- Save your scene as *PROP_GoldMine_07.max*.

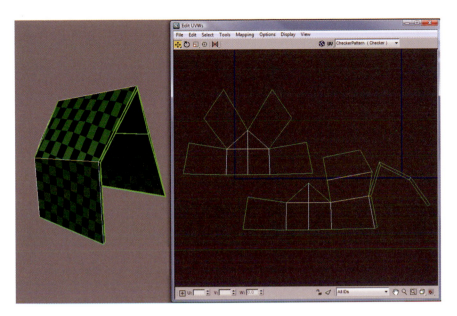

*The final UVs, broken into chunks after flattening and stitching.*

**Tip:** Sometimes when using the Stitch Selected tool, your stitching may cause a UV chunk to overlap over the top of your original UV chunk unintentionally. If this happens, try using the Mirror Horizontal tool on the target UV chunk first, and then try stitching.

## Wrapping up our prop and packing our UVs

Now that we have unwrapped all of our individual pieces, the final step is to go ahead and attach everything together and pack our UVs. Leaving everything as instances is a good practice before attaching, just in case we decide we need to change something individually later down the road. Now that we are happy with the mesh and the UVs, we will collapse everything together as one object.

- Start by selecting every object in the scene, and collapsing them by **RMB** clicking in the viewport and choosing **Convert To → Convert to Editable Poly**.

- Select the *GoldMineBase*, and in the Command Panel under the Modify tab, choose the dialog box next to **Attach**. From the Attach List, choose the Select All function to highlight all the objects in the scene, and press **Attach**. You now have one object, with all the pieces attached to it.

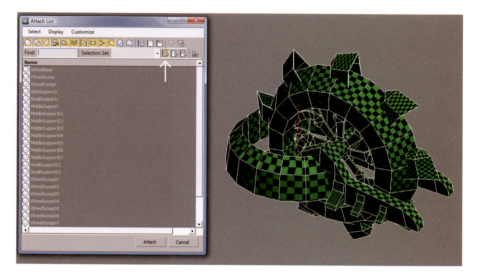

*Using the Attach List, choose Select All and press Attach to attach all of the pieces to the GoldMineBase.*

- Now that we have just one object, rename this to *Prop_GoldMine*, and apply a new Unwrap UVW modifier to it.

- As soon as we open the Edit UVW window we will notice a big mess with all of our UV chunks on top of each other. Don't worry, we can easily fix this by drag selecting the chunks and resizing and moving them off of each other.

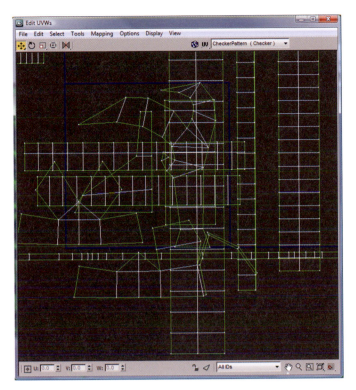

*By default, after attaching your objects together you may have a lot of UV chunks stacked on top of each other. Not to worry—with a little cleanup and resizing and adjusting, you can arrange the chunks with ease.*

- Try to move and arrange all of the UV chunks to fit into the blue square. This is the UV space you will be using for your texture map.

- You may need to **Break** a few faces off of the *MiddleSupport* UV chunks to get them to fit into the UV square and still be somewhat correct in scale.

- Once you are done with your unwrapping process, save your scene as *PROP_GoldMine_08.max.*

**Tip:** Fitting all of the UVs into the correct UV space is an art form all its own. The ultimate goal is to fit your UV chunks into the blue square as snug as possible. Moving, Rotating, and Resizing are the tools you will become very familiar with when UV mapping.

**Tip:** When using the Checkerboard pattern, another use of it is to ensure the scale of each UV chunk is relatively close to each other. This is known as Pixel Density. You do not want your smallest object to get more density than the bigger object, and vice versa. Try to resize your UV chunks so that they are somewhat uniform throughout. However, keep in mind that like many things, this is not a hard rule. Sometimes with obscure shapes or unusual UV chunks you may find yourself with a lot of unused UV space and more than enough room to resize your objects to get more space than what is uniform. The highest possible resolution from your texture is always going to win over whether you have perfect pixel density or not. Use your best judgement!

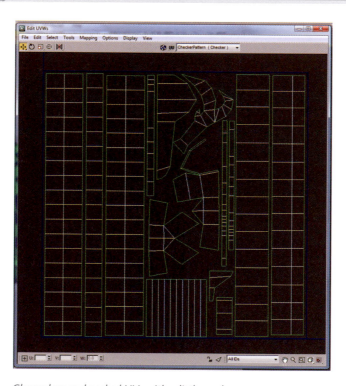

Cleaned up and packed UVs with a little work.

## Conclusion

Congratulations! You have completed your introduction to UVW Unwrapping. You should be somewhat familiar with the unwrap process, as well as the Edit UVW interface when working with UVs on an object. In later chapters we will discuss UV mapping other objects and characters as well, but for now you should know your way around.

In the next lesson, you will take that UV information from your object and dive into texture painting as we cover the steps of texturing this prop.

# Lesson 10
## Texturing Your First Prop

This lesson will cover the basic fundamentals of texturing as it applies to games, as we continue on with our gold mine prop and move on to the texturing phase. Taking the modeling and UVs we have created in the previous chapters will give us a good base to move right into covering the texturing basics.

Like UVW mapping, texture painting is a completely independent skill that can take quite awhile to get great at, and only through lots of practice will you improve. There are some game studios who hire people solely for the purpose of texturing! While this book can only scratch the surface on a handful of techniques needed to execute a successful texture, you should learn some of the basic tricks needed to get you started.

**In this lesson, you will learn the following:**

- How to export your UVW information to a texture you can paint onto

- Working in passes with your texturing

- Tips on creating quality texture maps

## Exporting your UVW information and getting ready for texturing

*After completing our UVW information from the previous lesson, it is time to move on to the texturing phase. A good texture is only going to be as good as the UVs of an object allow for, so the better you do on your UVs the easier time you will have when it comes to painting a good texture map.*

*To begin with, let's get the UVW map out of Autodesk® 3ds Max® software and into a 2D painting program.*

- Start by opening our *PROP_GoldMine_08.max* file, and select our collapsed and unwrapped *PROP_GoldMine* prop.

- Apply an **Unwrap UVW** modifier to our prop if there is not one already. If one is already applied, open the Edit UVWs window by clicking the **Edit...** button under the Parameters rollout.

- Once the Edit UVWs window is open, click **Tools** → **Render UVW Template...**

- This brings up a new popup window to Render UVs.

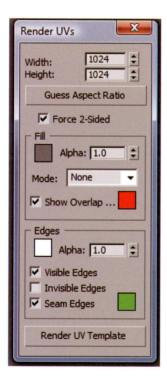

*The Render UVs window gives you the options needed to generate a 2D image of your UVW map.*

- In the Render UVs window you have several options to adjust if needed, but are mostly personal preferences. The default settings are mostly fine, but to make viewing in Photoshop easier, change the Seam Edges color to be white instead of green.

- Once you are happy with this, press the **Render UV Template**. A new window pops up. This is a 2D render of your UVW information. To save this image, **LMB** click the disk icon in the upper-left corner and navigate where you want to save this image. Save the image as *PROP_GoldMineUVW.pg*.

*Click the Disk icon in the upper-left corner of the rendered image to save your UVW map.*

*The rendered UVW image gives you the exact blueprint to paint a texture directly onto the surface of your object.*

- Once you have this image, whether you are using Photoshop or a different 2D image software, bring this image into your software of choice and save it as the native file format. On the software disk that comes with this book, we will be using the PSD format.

- Back in 3ds Max, apply this file to your 3D object as the Diffuse map, so that any changes we make to the original source file will be applied directly to our object.

- By default the texture quality may appear unrefined or jagged. (Even though for now the only thing we should have is a black-and-white image with our UV lines on it!) To improve the quality of your texture on screen, on the menu bar, select **Customize / Preferences...** and the **Viewports** tab. Select **Configure Driver**, and under the Appearance Preferences change both of the Texture Sizes to their highest setting, and check **Match Bitmap Size as Closely as Possible**.

- Once you have made these adjustments, press **OK**, close the menus, and under the menu bar choose **Save Custom UI Scheme...** and the default location and settings.

*Adjusting the 3D settings in 3ds Max will allow for a higher-quality viewport representation of your texturing.*

# Working in passes while texturing

As mentioned previously, texturing is an art form all into its own. What works for some people may be completely opposite for how someone else works. Either way, the final goal should always be the same: create an interesting or realistic texture to meet the demands of the game.

Similar to how we started planning out our modeling process, the texturing process should require some planning as well. What are the surfaces made of? Where are the natural seams and edges? Where are the high and low points on the object that correspond with our UVW map? These are all just a few of the sorts of questions you should ask yourself when texturing.

One last thing to consider: Your concept art is always going to be a guide, and may or may not be an exact blueprint of the object you want to create. Part of the creative fun of making 3D art on your own for practice is to see what you can come up with. When you are learning, nothing says you cannot take some creative liberty with your art. Be creative and explore the tools to see what sort of results you get.

1    **Start with the basic color pass.**

The first priority in texturing is to identify the major surfaces of your object either through color or texture. In the case of our gold mine, the concept is a little unclear, so we have to make that judgment ourselves. The first thing I will do is figure out what I want the main surfaces to be made of and apply a texture to that UV area in Photoshop. Since the majority of the surfaces in Demigod resemble concrete, stucco, steel, and earth, I know that I should stick with those surfaces only, and this particular object would be made mostly of metals. Remember, this is a rough pass to get the basic surfaces identified, nothing more.

*The very basic pass at texturing to identify some of the surfaces of the object.*

*With our texture applied, we have identified some of the basic surface colors and have a base to work with.*

**2**     **Adjust basic color parameters to a more uniform level.**

At this point in the texturing process, it is a good idea to refine the basic colors of the object to a more uniform level. Find the proper balance of brightness and contrast, and start to give a more cohesive look to your object by bringing the colors more in tune with each other and the environment where the object is going to go. Right now, the colors on our object are a bit too saturated and do not seem to blend with each other as well. The next step is to adjust that.

*Adjusting brightness, saturation, and contrast to get a more neutral feel for our texture.*

Project 02

*The more subtle tones allow for a better contrast between the various parts,*
*and should blend better with the environment we will place this in.*

**3**    **Paint your highs and lows.**

The next common step during the texturing phase is to identify the highs and lows of your object through good old-fashioned painting. Using a brush you are comfortable with in your paint program, go through along the edges where the high points are and accentuate those with a lighter color, and alternatively, where there are low points, those would get a darker color. Try to keep your painting somewhat imperfect and fluid, as nature and the world around you is never perfect.

When painting, consider that the lighter areas on the high points are where surfaces tend to get worn down or catch light along the edge. The darker lows are corners are where dirt and grime has built up, or a seam would be if the object were welded together. Keep these things in mind as you paint your highs and lows.

*Painting the edges with a scratchy brush where the high points are, and darkening the areas where the lowest points and crevices are.*

*Identifying the highs and lows adds a new level of realism to your 3D objects.*

4    **Custom line work**

Before we can wrap up the texture, we need to address some of the custom line work that the concept has, as well as any additional flair we want to add to the piece. On your texture map, paint out any of these custom areas and adjust the brightness and contrast of them to really make them pop off of the object. Do not forget the rule of highs and lows—be sure to add this sort of detail to custom painting as well to sell the idea of a 3D surface.

*Paint in some of the custom line work for yourself. It does not have to be perfect, but adding some of the ornate designs from the concept will help this to pop more.*

*Our gold mine machine with a little more ornate line work in the texture.*

5 **Final pass.**

The final pass is for any additional cleanup you need to do, as well as any extra detail you want to add to the prop, such as grunge, scratches, dirt, and so on. This is the part where you get in and add that little extra amount of detail to really make the texture sell. Remember, in Demigod, it is a dirty, dusty war out there!

*My final texture map, with color adjustments made to match a dirty environment, bricks added to the base, and various scratches in the metal.*

*Our final gold mine machine with a war torn scratchy pass to potentially fit in the Demigod environment.*

## Conclusion

Congratulations! You have finished your first introduction to texture painting. When working with whichever photo manipulation software you choose, remember that practice makes perfect. While this is just an introduction to texture painting, continue to hone your skills and work with painting and various types of 3D objects to improve. For now, you should have a basic understanding of working in passes with your texture maps, and hopefully have a better understanding of the thought process of creating textures.

# Lesson 11
## Animation Basics

In this lesson we will cover some of the basics of animation and making objects move in Autodesk® 3ds Max® 2010 software. We are going to introduce some of the concepts behind animation, identify some of the primary animation tools, as well as do a short animation with our gold mine prop.

**In this lesson, you will learn the following:**

## Animation concepts

Animation is based on a principle of human vision. If you view a series of related still images in quick succession, you perceive them as continuous motion. Each individual image is referred to as a frame.

Historically, the main difficulty in creating animation has been the effort required of the animator to produce a large number of frames. One minute of animation might require between 720 and 1800 separate images, depending on the quality of the animation. Creating images by hand is a big job. That is where the technique of keyframing comes in.

Most of the frames in an animation are routine, incremental changes from the previous frame directed toward some goal. Traditional animation studios realized they could increase the productivity of their master artists by having them draw only the important frames, called keyframes. Assistants could then figure out what belonged on the frames in between the keyframes. The in-between frames were called tweens.

Once all of the keyframes and tweens were drawn, the images had to be inked or rendered to produce the final images. Even today, production of a traditional animation usually requires hundreds of artists to generate the thousands of images needed.

## How it works in 3ds Max

3ds Max 2010 is your animation assistant! As the master animator, you create the keyframes that record the beginning and end of each animated sequence. The values at these keyframes are called **keys**. 3ds Max calculates the interpolated values between each key to produce the completed animation.

*In traditional animation, the master animator could determine the keyframes at the beginning and end of the ball rolling, and the assistant would fill in the frames with the tweens. In 3ds Max, you identify the keyframes and 3ds Max fills them in for you!*

Autodesk 3ds Max can animate just about any parameter in your scene. You can animate modifier parameters, such as a bend angle or a taper amount, material parameters, such as the color or transparency of an object, and much more. Once you have specified your animation parameters, the renderer takes over the job of shading and rendering each frame. The result is a high-quality animation.

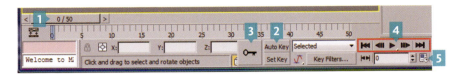

*The majority of the animation tools can be found along the bottom of the UI.*

## Key Interface Elements

Let's look at some of the main animation tools in 3ds Max 2010, and a brief explanation of them.

1 **Time Slider**

The Time Slider is along the top of the Track Bar, and shows the current frame of animation you are on. It also lets you move to any frame in the active time segment. To move the Time Slider along the Track Bar, **LMB** click it and hold, while moving left or right along the Track Bar. **RMB** clicking the slider bar opens the Create Key dialog box, which lets you create position, rotation, or scale keys without using the Auto Key button.

2 **Auto Key and Set Key Modes**

Auto Key mode toggles the keyframing method that when turned on, any changes made to the object's position, rotation, and scale are automatically keyframed (recorded). Set Key mode allows you to create keys only when you want. Unlike Auto Key, Set Key mode gives you control over what you key and when.

3 **Set Keys**

When in Set Key modes, use this button to create a keyframe with the selected object.

4 **Animation Controls**

These controls include **Go To Start**, **Previous Frame/Key**, **Play/Stop**, **Next Frame/Key**, and the **Go To End** functions respectively. Hover over each for their function.

5 **Time Configuration**

This will launch the Time Configuration window that will allow you to adjust the Frame Rate, Time Display, Playback options, and more. This is also where you can specify the animation Start, End, Length, and Frame counts.

## Animating our gold mine prop

Now that you are aware of some of the basis of the Animation interface, let's start by getting our hands dirty by completing a simple animation of our gold mine prop. Start by opening your latest version of the asset and then saving it as *PROP_GoldMine_Animated1*. Unhide any extra concept images or layers in the scene you might have and delete them, as we don't need them for this lesson.

**1**  **Start by detaching the main wheel.**

- To make the center wheel animate, first let's detach the main pieces in the center that will move. Start by selecting the gold mine itself, and then with the Element subobject mode select the individual elements.

- Once these elements are selected, use the Detach tool, and name the detached piece *GoldMine_Wheel*.

- Select the elements that make up the center of the wheel and detach them.

- Once the wheel is detached, go to the Hierarchy Tab, turn **Affect Pivot Only** on, press **Center to Object** to center the pivot to the object, and now use the **Move** tool to move the pivot to the middle of the centermost cylinder. (Keep in mind, that the center of the object might not be where it would rotate, which is why we are moving the pivot point even after centering it to the object.)

*wheel, adjust the pivot on it so that it is centered.*

2 **Create a full rotation animation.**

- For our first animation, select the *GoldMine_Wheel*, turn **Set Key** mode on, and press the big Key icon to set our first key. This is the starting, stationary position of our wheel.

- Next, drag the Time Slider all the way to the end of the Track Bar, and with the Wheel still selected, rotate it in the Y axis 360 degrees.

- After you have rotated it, press the Set Keys button again to set a new key at frame 100.

- Pressing the **Play** button will play the animation from start to finish, and continue to loop until you press Stop, or click the Track Bar again. Drag the Time Slider back and forth to watch the tweens for the animation.

- Save this file as *PROP_GoldMine_Animated2.max*.

*Rotate the wheel 360 degrees and create a second key at frame 100. You will notice the two markers appear where you created the keyframes on the Track Bar. Move the Time Slider left to right to see the tween frames between the two keyframes at 1 and 100.*

**3   3   Create a series of start and stop animations.**

- For our next animation, let's delete the animation we did previously and make a new one. Start by selecting the *GoldMine_Wheel*, then **LMB** drag select over the keyframes on the Track Bar and delete them. This will erase the keyframes we made in the previous animation.

- Next, with the *GoldMine_Wheel* selected, change the amount of frames on the Track Bar by **LMB** clicking the Time Configuration icon and changing the Animation Length to 300.

*Change the Time Configuration Animation Length to 300 to automatically increase the Frame Count, End Time, and number of frames listed on the Track Bar.*

- Turn **Auto Key** mode on, and create a keyframe for the *GoldMine_Wheel's* starting position. (Even when using Auto Key, it is a good idea to set a keyframe for the initial position of your object)

- Move the Time Slider to frame 50, and Rotate the wheel 200 degrees on the Y axis.

- Move the Time Slider to frame 80, and add a keyframe. This is so that for 30 frames, the wheel is motionless.

- Move the Time Slider to frame 120, and Rotate the wheel 160 degrees on the Y axis.

- Move the Time Slider to frame 180, and add a keyframe.

- Move the Time Slider to frame 300, and Rotate the wheel 360 degrees on the Y axis.

- Pressing the **Play** button will play the animation from start to finish, and continue to loop until you press **Stop**, or click the Track Bar again. Drag the Time Slider back and forth to watch the tweens for the animation.

- Save this file as *PROP_GoldMine_Animated3.max.*

*Create a series of start and stop animations using the Auto Key mode and rotating the wheel along the Y axis. When you are done, use the Time Slider or the Play button to watch the animation process.*

## Conclusion

Congratulations! This concludes Project 2, as well as the introduction to animation. Throughout this project we have covered the concept phase, all the way through the modeling, unwrapping, texturing, and even a little animation for our first asset. Hopefully you have learned the basic skills needed to explore these processes in 3ds Max 2010, and are ready to move on to even more advanced techniques in the coming lessons.

In the next few projects we will be exploring the world of environment modeling and texturing, as well as the process of creating characters for games.

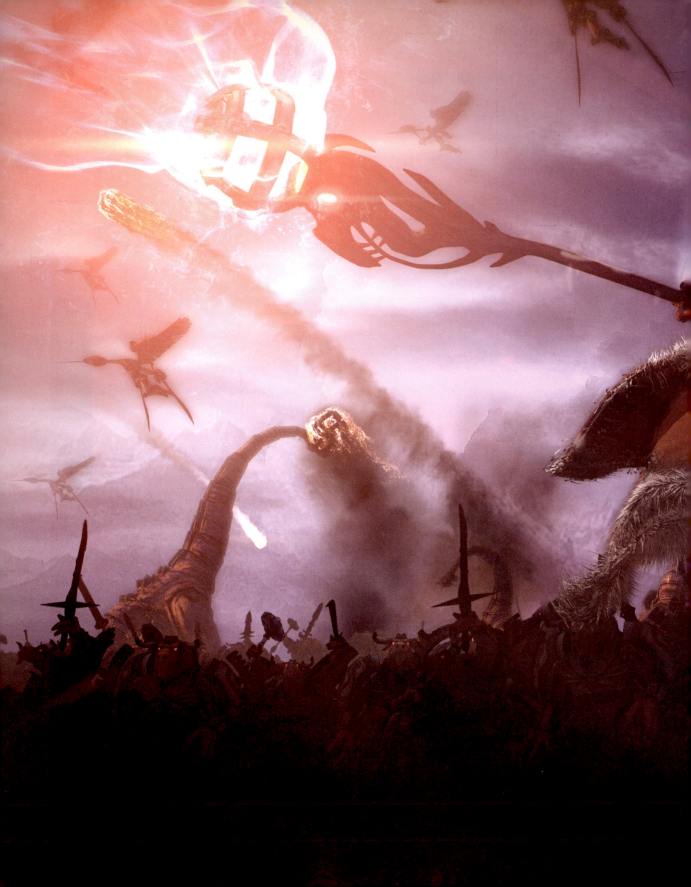

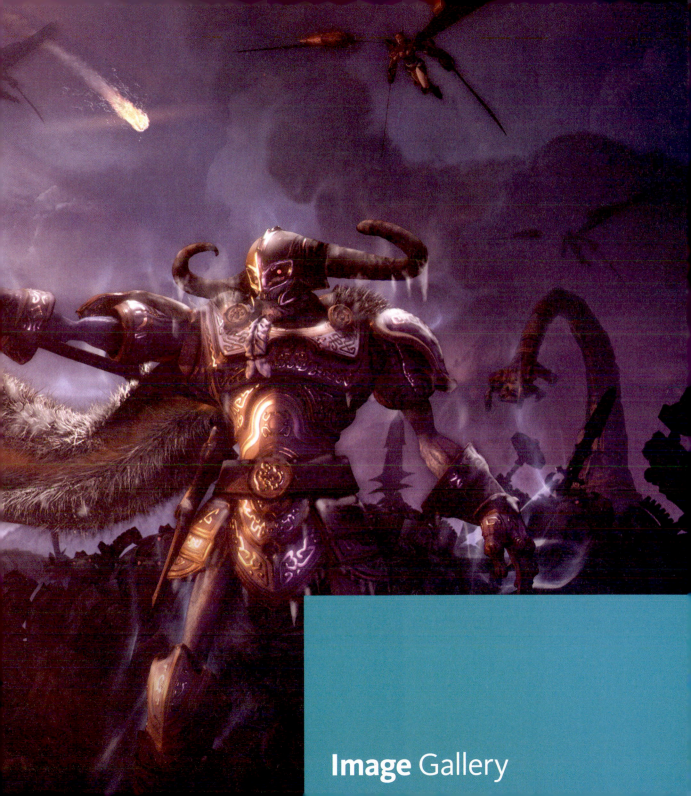

**Image** Gallery

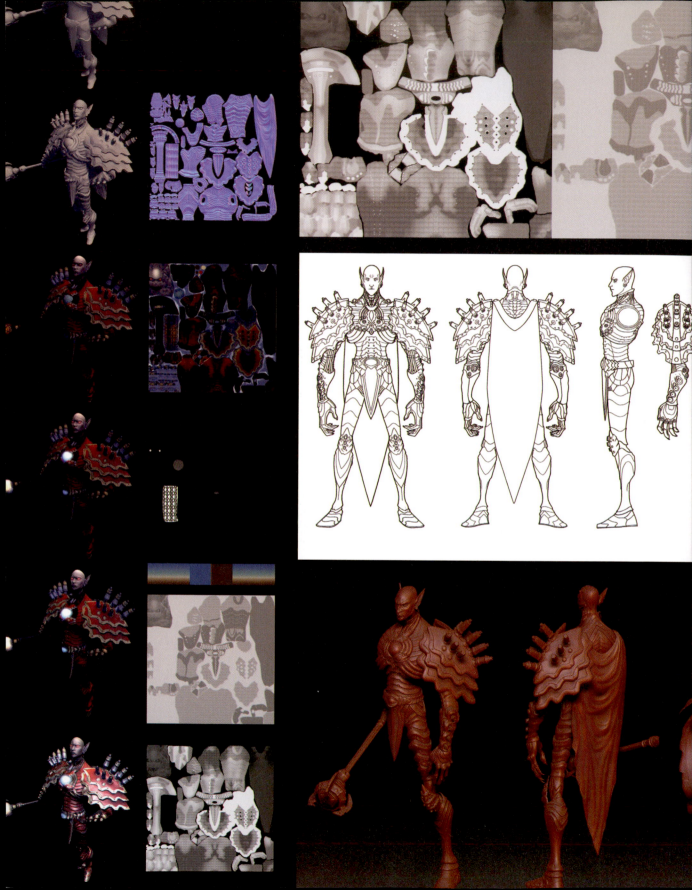

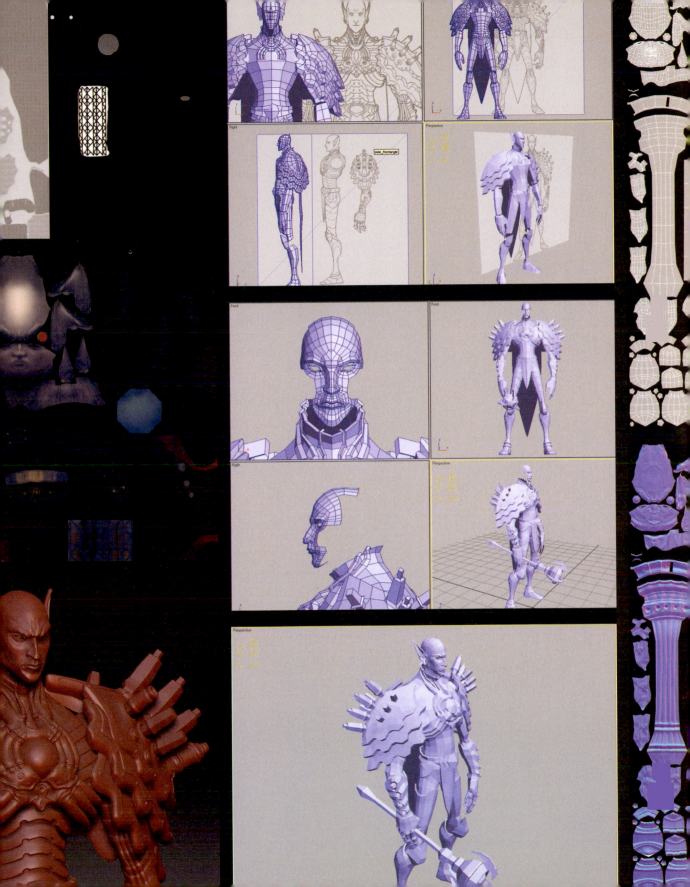

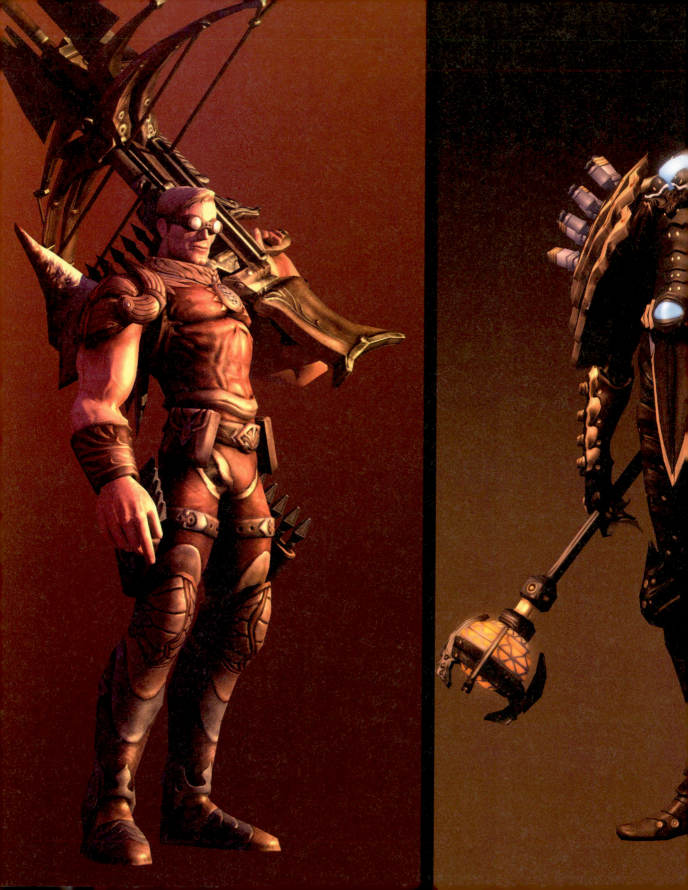

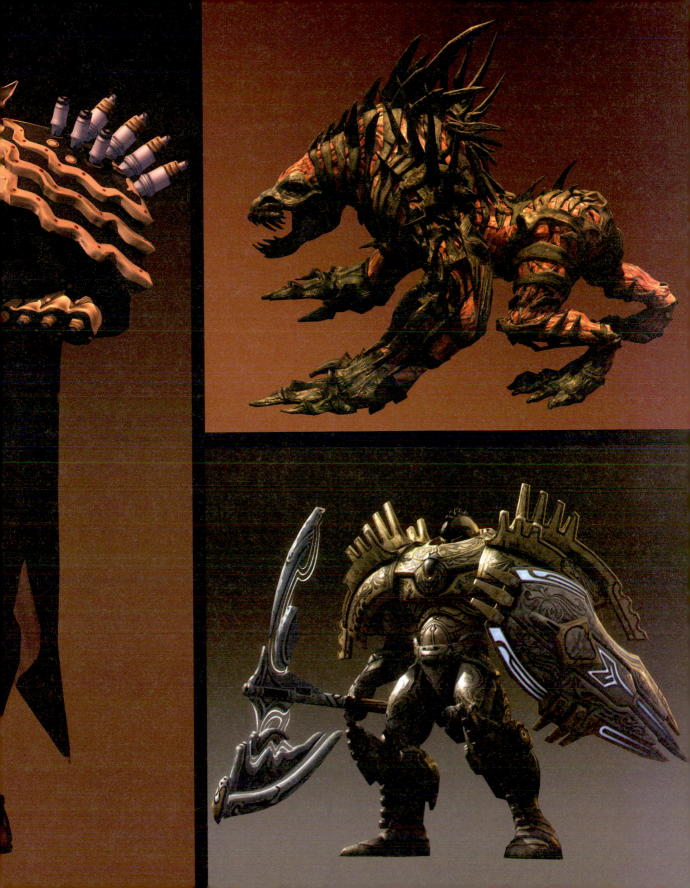

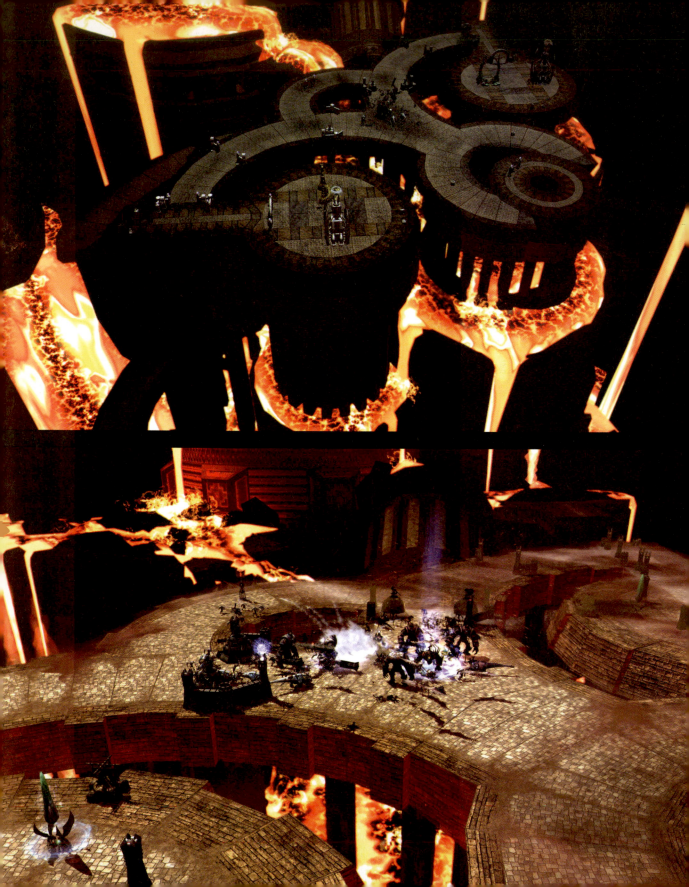

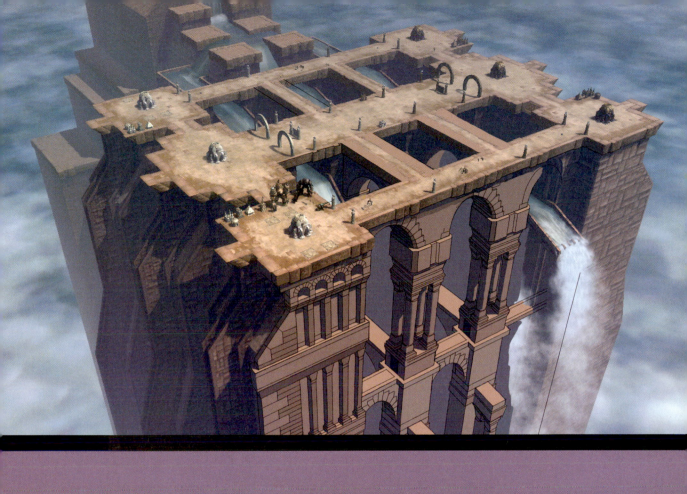

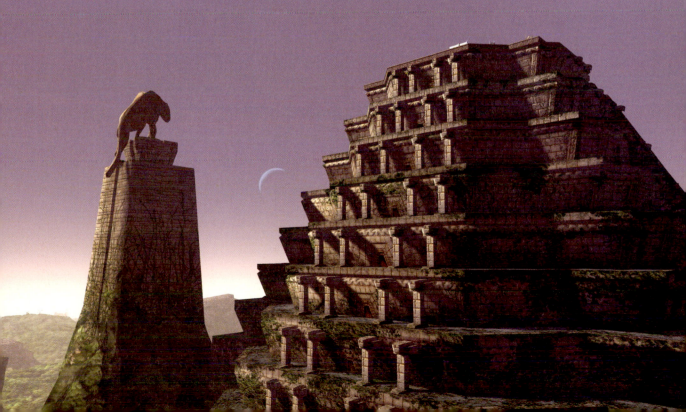

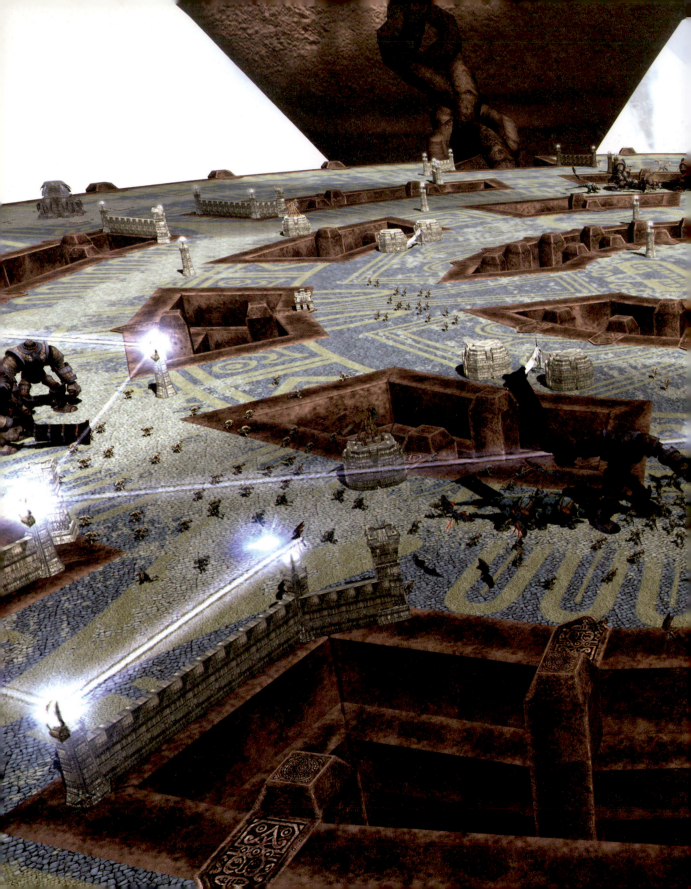

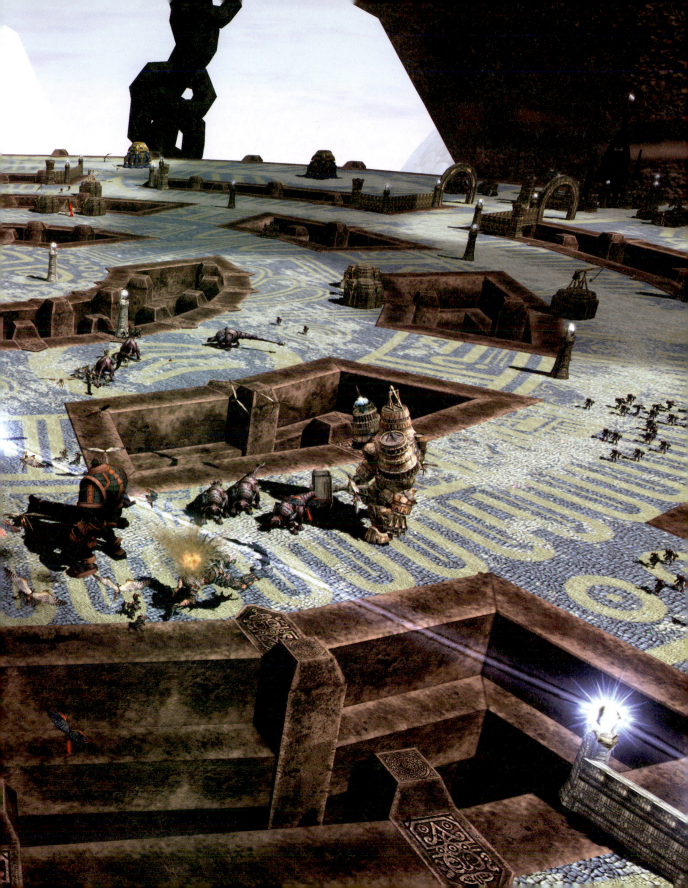

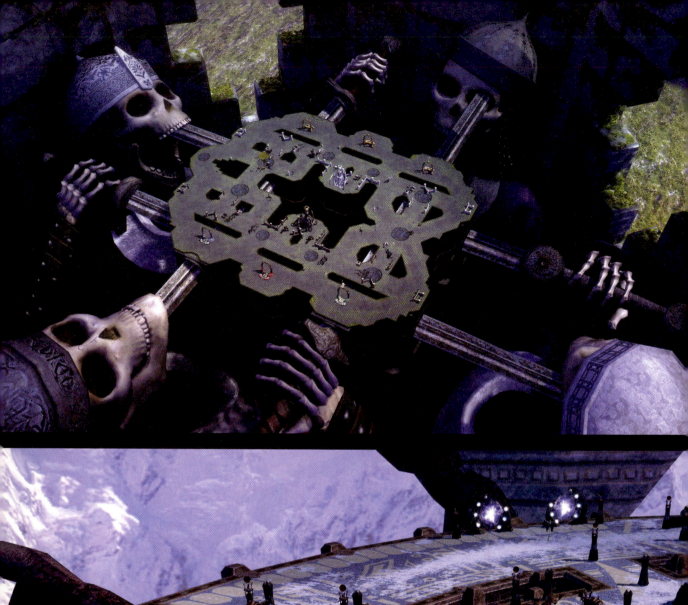

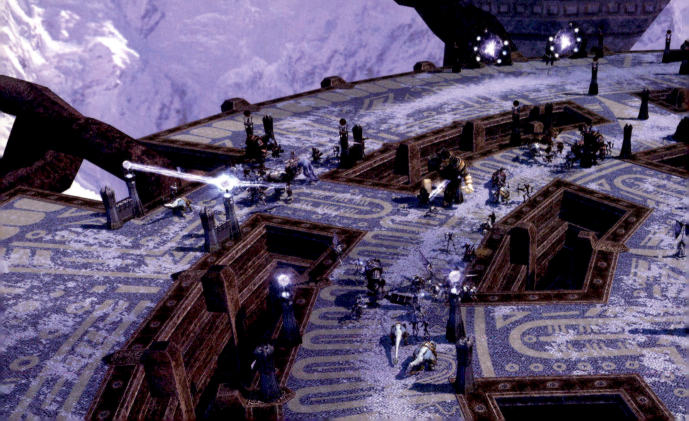

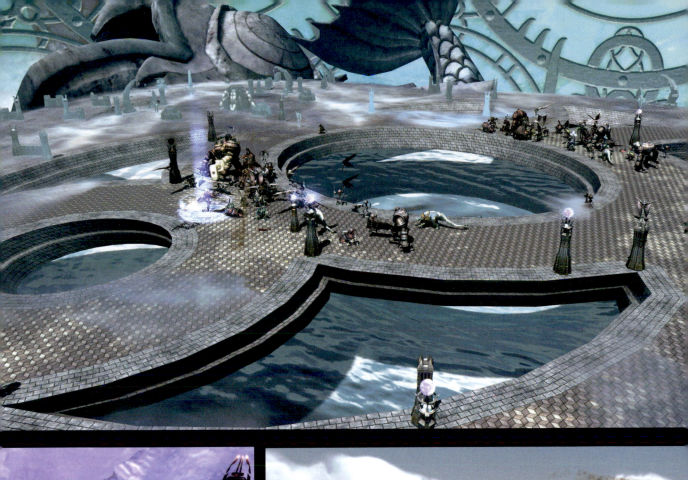

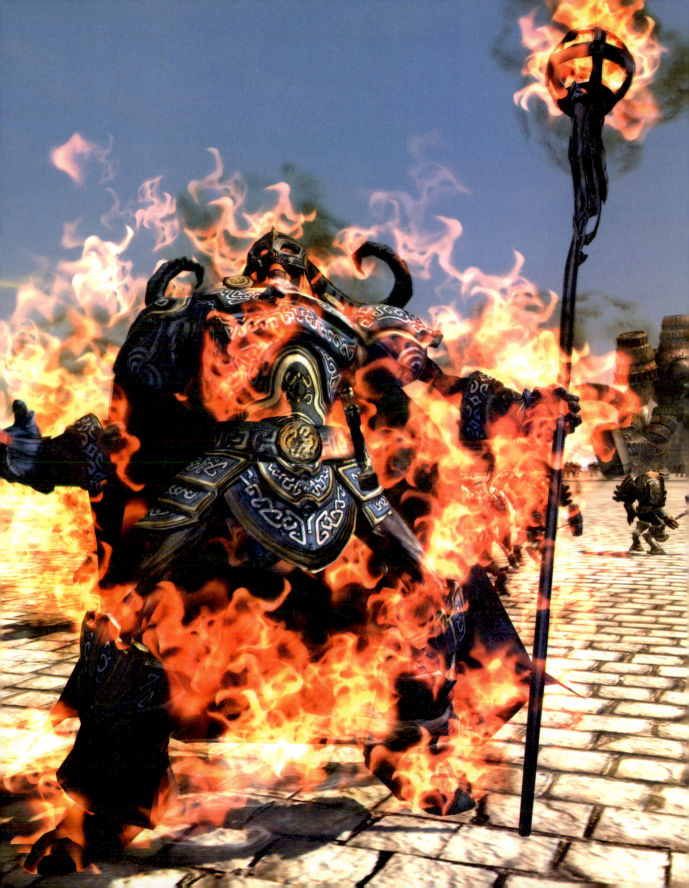

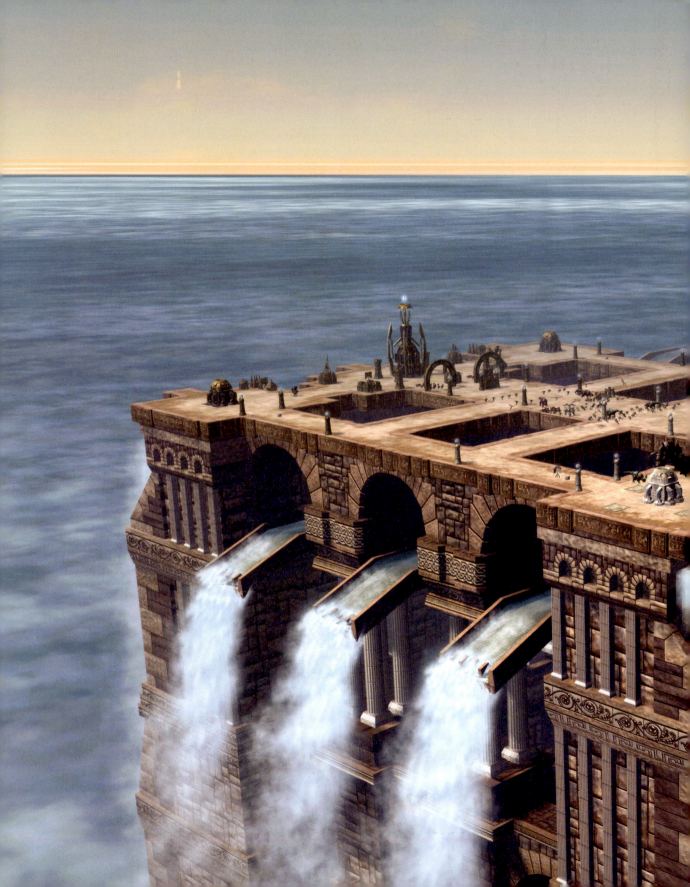

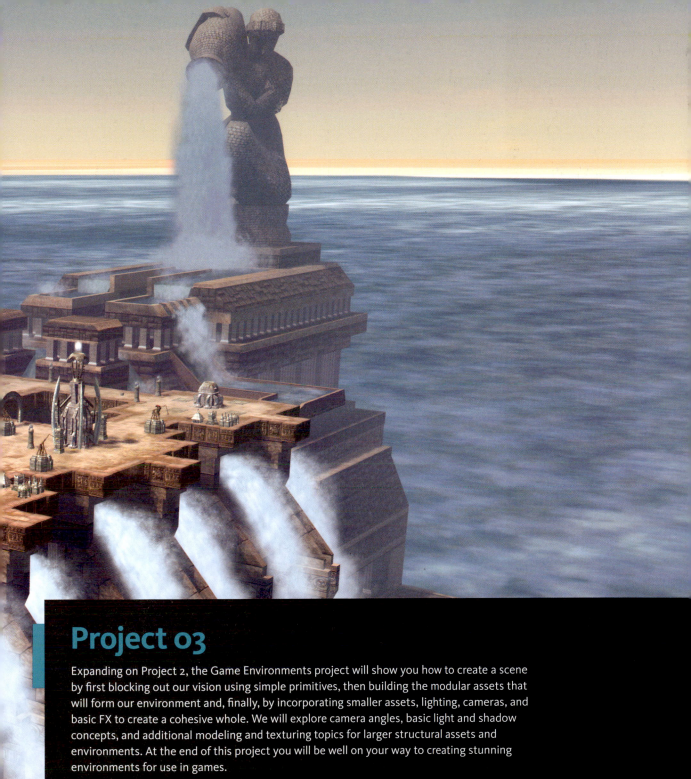

# Project 03

Expanding on Project 2, the Game Environments project will show you how to create a scene by first blocking out our vision using simple primitives, then building the modular assets that will form our environment and, finally, by incorporating smaller assets, lighting, cameras, and basic FX to create a cohesive whole. We will explore camera angles, basic light and shadow concepts, and additional modeling and texturing topics for larger structural assets and environments. At the end of this project you will be well on your way to creating stunning environments for use in games.

# Lesson 12

## Environment Planning and Organization

In this lesson we will prepare for building our scene. We will discuss some organization topics such as using the 3ds Max 2010 layer system, as well as how to merge our smaller assets from other 3ds Max files into our scene. We will then use our knowledge from the first two projects to create a simple block out of the space that will serve as our blueprints moving forward. And lastly, we will discuss why it is so important to work in a modular manner.

**In this lesson, you will learn the following:**

- Planning for environments

## Planning for environments

A little planning goes a long way when creating a new environment. Before you even open Autodesk® 3ds Max® 2010 software, it is important to start thinking about what the end goal is and how you'll go about achieving it. That said, our goal for this project is to create an open arena-style environment that would be suitable for a game such as Demigod. Most of the arenas in this game are other-worldly and exist in the sky or hovering above a great body of water.

Though this may sound like a rather large task, by planning ahead we can break up the arena into reusable chunks as well as think about the other elements we will need.

**1    Ground and Terrain**

This is what will cover a good percentage of the screen. The ground or terrain will be made out of large floating stone platforms. Some will feature large square holes in them that will bring both visual interest to scene as well as help make the theoretical gameplay more interesting by adding obstacles to players paths. For our ground we could simply create one large mesh. However, if we create a series of smaller more Lego®-like building blocks, we will have much more freedom to create new arenas quickly or make changes to our existing arena without having to edit our ground meshes. This type of workflow is considered much more modular and is something we will discuss in more depth later in this lesson.

**2    Large structures and Props**

Now that we know how we will go about constructing our ground we should begin to think about what other elements we can add to our scene. Larger structures like towers, walls, and so on, will bring life to our battle field. These sorts of things could be purely decorative or actual gameplay elements. In addition, we will also be importing the asset you created in Project 2. Smaller props and assets are integral in adding the bits of detail that will make our scene feel more complete. Both large and small assets can be included as rough primitives in our block out that we will cover later.

**3    Sky Dome**

One incredibly important element is going to be our sky dome. A sky dome is just what it sounds likes, a large dome mesh with a sky texture mapped on to it. Rather than a gray empty sky, our sky dome will help fake the illusion of clouds, a sun or moon, and atmosphere.

4    **Camera Angle and Scene Shot**

When creating environments for a game it is incredibly important to think about where a player can and cannot go. If a player can never reach a section of the environment because of an environmental hazard for example, there would be no need to add detail to this area. The same is true for our arena. For our environment we will be picking a few camera angles at the corner of our arena and focus on creating our scene there. We will not worry about areas that cannot be seen or reached. In addition to all of this, our camera angle is also very important. Our scene changes drastically when we move the camera to a top down view versus a three quarters view. We will take a cue from Demigod and use a slightly pulled out camera at a nice 45-degree angle. We discuss this more in depth in Lesson 15.

5    **Lighting**

Though we are still far from starting to light our scene, it is important to begin to thinking about the time of day, light sources, and general light conditions. Where our primary light source will be whether it is the sun or moon, can greatly affect the overall look of our environment. We will want to choose a location that creates interesting shadows and lighting for our scene and larger structures. We will be talking more in depth about how to actually light our scene in Lesson 16.

6    **Scale**

A correct sense of scale in an environment is incredibly important. Scale is what will let the player of our environment know where they fit in this world. For example, without the addition of small low level props (for example, a trash can or fire hydrant in the real world), a large building will not quite feel so large with out other smaller objects for us to compare it to. This is something to keep in mind when starting our block out.

Now that we are thinking about some of the larger elements that will comprise our environment we will be much better off when it comes time to start implementing these plans. These ideas should also be our guide when creating new assets and starting work on our lighting and cameras.

## Creating a block out for our environment

A block out is much like a rough 2D sketch, but in 3D. Certainly before we start creating final models and textures for our environment we should consider things such as layout, scale, and the number of assets we will need to create. This sort of thing is best done using simple primitives and basic materials. This process is really an extension of the simple planning we have done on paper for our environment. However, this will let us do some quick 3D sketching inside 3ds Max 2010 before committing to final models and textures. It is OK if things change, that is why we are starting simple.

1   **Tips to ensure your block out is a success:**

   • Keep the models simple by using only standard primitives (boxes, cylinders, spheres, and so forth).

   • Focus on scale and ensure the space feels right and is in proportion.

   • Think about asset reuse down the line. Though it is only a cube now, when you make your final model, if you can reuse it elsewhere in the environment and not have to make other unique assets you will save time.

   • Lastly, do not create your block out and forget about it. Refer to it until you are ready to let go and feel your environment is taking shape.

   Now that we know just how important our block out can be to the overall success of our environment, we should take what we have learned from our initial planning and assessment and begin one for our arena. As noted above, we will do so using simple primitives such as boxes.

2   **Using box primitives and our Move, Scale, and Rotate tools, we begin to block out the ground platform.**

   To start, we will take a simple box and then duplicate it, scale it, and arrange it to build our initial platform. We are not concerned about the boxes intersecting or overlapping. That is all part of the quick block out/sketch process.

*Starting our initial block out.*

**Tip:** *You can hold **Shift+LMB** and move a mesh using the translate tool to quickly duplicate objects.*

3   **Continue to refine the floor, adding more boxes and paths and begin to think about it as a whole.**

*Our ground platform is nearly complete.*

**4**     **We begin to build out the base of our platform.**

With our platform developed, we will begin to flesh out the base of our environment. Note that we are still keeping it really simple. Basic primitives are being used and scaled.

*Broad strokes are complete.*

**5**     **Now we can begin to work in some of the finer details .**

Lastly, we begin to think about the placement of some of our smaller detail objects such as the arches, a main building, large exterior water pipes, and the side support structures.

*Our block out is complete.*

**6    Save your work.**

- Save your scene as *Blockout01.max*.

Our block out is now fairly complete. With this we can now begin to think about how some of these mesh assets can be broken up and made more reuseable. As you can tell from our final image of the block out, our arena is largely symmetrical in both directions. This can be good for a few reasons:

- We only need to create essentially one quarter of the platform and then mirror in both directions for a complete platform Creating a block out for our environment.

- Symmetrical maps usually work well competitive team based games such as a Real-time Strategy game, or more precisely, a capture the flag mode in a First Person Shooter.

## Working modularly

With our environment roughly blocked out we will begin to break down the platform into reusable assets, or modular chunks. This step is incredibly important because it will save a lot of time later on in the process. Because much of our platform is simply mirrored, we will only need to create a small percentage of unique pieces that can then be used to build our entire platform. This is what working in a modular fashion is all about!

To start, we will identify a few sections of the platform that could be made in a reusable way. The first are the corner platforms that look like a puzzle piece. We will create this asset just once and then duplicate and reuse it.

*The two platforms are identical and could be made once to save time and then duplicated to create our platform.*

Additionally, the platform supports could be created in the same manner as could much of our arena.

*The two platforms are identical and could be made once to save time and then duplicated to create our platform.*

## Using layers and selection filters for environments

Autodesk 3ds Max 2010 gives us a few tools to really help better organize our scene and help us work smarter. This becomes incredibly important when we start to work on environments that are composed of several elements and generally much larger than the props or assets we created in Project 02. The first of such tools is the **Layer dialog box** that you learned about in Project 01. The second is the **Selection Filter** tool.

1    **Using layers.**

When we start work on our environment we will use layers to better organize:

- Our lights

- Cameras

- Particle effects

- Architectural meshes and

- Our props and smaller assets

**2**  **Using the selection filter.**

The second feature we will take advantage of is the **Selection Filter tool**. When it comes time to light our scene and add cameras this feature will be really useful. For example, when lighting you generally only want to work with lights. Setting the **Selection Filter to Lights** only will ensure that we can only select lights and not geometry, cameras or any other object in the scene.

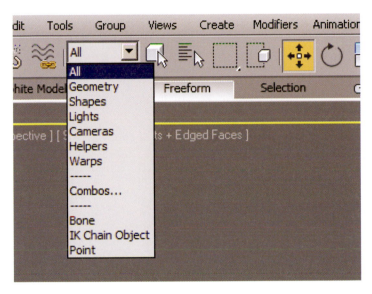

*The selection filter lets us work with a specific type of object in our scene without accidentally selecting other objects.*

## Conclusion

With this lesson complete you should now be well prepared to begin our environment. We learned how important a little planning up front can be. We created a block out of our environment to use as a guide for getting started on our scene. We learned about working in a more modular manor so that we can re-use assets. And lastly, we briefly talked about some tools you can use to better organize your growing scene!  In the next lesson we will get started on modeling our arena!

# Lesson 13
## Modeling a Game Environment

With our planning completed in the last lesson and a rough block out of our environment in hand, we can begin to start modeling our environment assets. In this lesson we will be primarily focused on polygonal modeling for games. We will create a portion of the ground platform that most of the action will take place on, a simple architectural arch, and a sky dome. We will also talk about how to add modular, reusable detail to platform and other meshes. With these skills in hand you will be able to add detail and build out the rest of environment as you see fit.

**In this lesson you will learn the following:**

• Working with the grid to snap pieces together

• Common box modeling techniques used in games

• Creating nice edges with the Chamfer tool

• Using edge loops and edge rings to add detail

• How to create a sky dome for our scene

• Merging assets together into one MAX file

## Grid snapping

To make things easier, we will use 3D Snaps to easily snap together our modular pieces and align pivot points to vertexes. This makes construction easy but also ensures that we do not have any seams or spaces between our pieces.

1    1    **Setup default units.**

We will setup our default units for use in 3ds Max 2010.

- From the top menu, select **Customize** → **Preferences** → **Unit Setup**.

- Set your units to **Generic**.

- Close the Unit Setup window.

*Corner Trim is placed at all four corners of our walkway.*

**2**    **Set up your grid and snap options.**

Next we will setup our grid and snap settings.

- From the top menu, select **Tools** → **Grids and Snaps** → **Grid and Snap Settings...**

- On the **Options** tab, ensure **Use Axis Center and Start Snap Point** is checked.

- Next, on the **Home Grid** tab set the following options:

    **Grid Spacing** to **8.0**

    **Major lines every Nth Grid Line** to **7**

*Corner Trim is placed at all four corners of our walkway*

---

**Tip:**    *You can **RMB** on the 3D Snaps icon on the Main toolbar to get to your snap settings quickly!*

## Modular raised platform

With our block out complete, we can quickly see that most of our platform is symmetrical. As well, if we start to break down the shapes that make up our platform, we can see that a small set of assets (Lego®-like building blocks) could be used to build it. We may need a few variants of these pieces, but those are relatively simple to create once our core set of building blocks is created. The pieces in color and numbered in the picture below, show the unique pieces needed to build our platform:

*The meshes highlighted represent the unique pieces needed to make our modular platform. Note that parts 3 and 4 are simply variants on pieces 2 and 1 respectively.*

## Platform walkway

We will start with a simple walkway piece 1 to begin the modeling of our raised platform for our environment.

1    **Create a new scene and save it.**

•   Save your as *13-Walkway_01.max*.

**2    Walkway primitive.**

You will now create the thin connecting walkway from our block out.

- Create a new box primitive.

- Set the following parameters in the **Create** panel:

    **Length**: 64

    **Width**: 32

    **Height**: 8

- Convert the box to an **Editable Poly**.

> **Note:**   *When building our walkway, we are using whole numbers easily divisible by 2. In games, this a very common thing as your texture sizes will follow the same conventions (256x256, 512x512, and so forth). Using these types of numbers for the length and width of our walkway means it will easily snap to other objects on the grid.*

**3    Walkway pivot point.**

Next we will set the pivot point to a bottom corner of the mesh for easy snapping.

- Select the **Hierarchy tab** → **Affect Pivot Only**.

- **RMB** on the **3D Snaps** icon on the main toolbar and use the following settings:

    On the **Snaps** tab, uncheck everything but Vertex and close the Grid Snap Settings window.

- Press **S** to toggle **On** our 3D Snaps.

- Using the **Move** tool and **3D Snaps**, drag the pivot point of the walkway to a lower corner vertex.

- Press **S** again to toggle **Off** our 3D Snaps.

- Rename our box *Walkway_1*.

*Pivot is now placed on the bottom corner of the mesh for easier snapping later on.*

**4    Snapping meshes together using the grid.**

With our simple walkway complete, we could easily snap together a series of these on the grid to make a longer walk way. Try it!

- Press **S** to toggle **On** 3D Snaps.

- Change your 3D Snap settings to affect only **Grid Points**.

- Duplicate the walk way and snap together a longer walkway.

**5    Walkway corner trim.**

Next we will build some trim to make our stone walkway more interesting. We will start with the corners.

- Create another new box primitive.

- Set the following parameters in the **Create** panel:

    **Length**: 8

    **Width**: 8

    **Height**: 11

- Convert the box to an **Editable Poly**.

- In **Edge Sub-Object** mode, select the top four edges of the box.

- Next, under the **Edit Edges** rollout, select **Chamfer** with the **option box**.

- Set the **Chamfer Amount** to **0.75**. Press **OK**.

- Select our new Corner Trim mesh and **instance** it three times, placing one at each corner of our walkway. We will want it to slightly overhang at the edges so that it transitions nicely to our other platform pieces.

*Corner Trim is placed at all four corners of our walkway to overlap onto transition pieces.*

**Note:** *Instancing now will help save time later because we will only have to UVW unwrap this corner trim piece once and our three other instaces will be done.*

6  **Walkway side trim.**

Using the same techniques as in step 3, we will create some side trim that will meet up with our corner trim pieces. The idea here is to block in our walkway a bit, even though most of our trim will be about step height.

- Start with a long box primitive.

- Set the following parameters in the **Create** panel:

    **Length**: 5

    **Width**: 60

    **Height**: 9

- Convert the box to an **Editable Poly**.

- Move this box to the side of our walkway, tucked between our corner trim pieces.

- In **Edge Sub-Object** mode, select the top two longest edges.

- Use the **Chamfer** tool to round off these edges much like the tops of our corner trim pieces.

*Base side trim.*

- Next, create five or so more box primitives to place along this newly created side trim piece. The lay out, shapes, and sizes are up to you. For some ideas see the image below.

- With one side trim complete, select it and duplicate it and move it to the opposite side for a complete walkway.

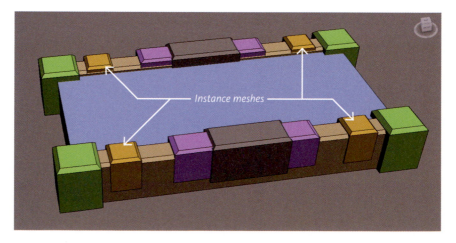

*Our walkway with all of the trim complete. Each color represents a separate mesh.*

Project 03

**Note:** *You will use the techniques outlined in this previous section to create the other walkway pieces and trim you will need for our enironment.*

7 **Save your work.**

- Save your scene as *13-Walkway_01.max*.

## Main platform corner

With piece 1, our thin walkway complete, we will move onto piece 5, or the main platform corner. This piece could serve as the main tower location, or team headquarters. Because it sits at each end of our platform, it is a little larger than the other walkways and could serve as a destination. Additionally, this is where we will be focusing most of our scene.

1 **Create a new scene and save it.**

- Save your scene as *13-Corner_01.max*.

2 **Platform corner primitive.**

We will start with a simple shape and add detail from there. Our initial box will serve as a thin connecting piece to the walkway we previously made.

- Create a new box primitive.

- Set the following parameters in the **Create** panel:

    **Length**: 16

    **Width**: 32

    **Height**: 8

- Convert the box to an **Editable Poly**.

- Set the Pivot point to the lower bottom corner.

- Rename our box *Corner_5*.

3    **Extrude to build out shape.**

Next we will use the Extrude tool and option box to build out the corner platform

- In **Polygon Sub-Object** mode, select the front/forward facing Polygon.

- Using the Extrude tool with the option box, set the following:

  **Extrusion Type**: **Local Polygon**

  **Extrusion Height**: **56**

4    **Extrude the sides.**

Next, select the side polygon faces.

- Using the Extrude tool with the option box, set the following:

  **Extrusion Type**: **Local Polygon**

  **Extrusion Height**: **26**

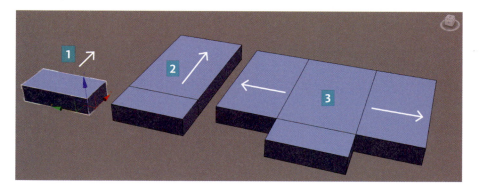

*Our walkway with all of the trim complete.*

5    **Add edge loops.**

We will use edge loops and edge rings in conjunction with the Connect tool to quickly tessellate or cut up our corner platform surface. This will then allow us to make more extrusions and add detail. Let's start by adding a small ledge to the front of our corner piece.

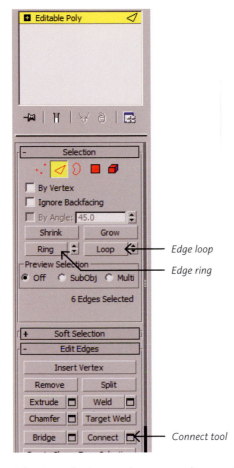

*Edge loop*

*Edge ring*

*Connect tool*

*Edge ring, edge loop, and connect tools are available in Edge Sub-Object mode.*

- In **Edge Sub-Object** mode, select any edge facing forward in the center of our corner piece.

- In the **Modify** panel, under the Selection rollout, select **Edge Ring**.

- To make a cut along the middle, select the **Connect** tool with the **option box** and set the following:

    **Segments**: 2

    **Pinch**: 26

    **Slide**: 0

- Press **OK** to apply these cuts.

## 6    Extrude ledge.

Next we will use the Extrude tool and option box to build out the corner platform.

- Select the newly created front Polygon face.

- Using the Extrude tool with the option box, set the following:

    **Extrusion Type: Local Polygon**

    **Extrusion Height: 16**

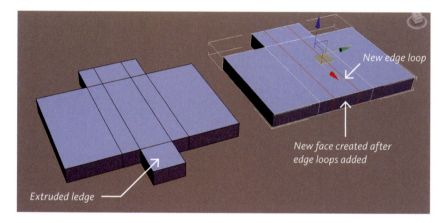

*Our walkway with all of the trim complete.*

## 7    More edge loops.

Next we will build the small connector piece to the rest of our corner platform using more edge loops that run across the surface this time.

- In Edge **Sub-Object** mode, select any edge going across (opposite direction of our first edge loop cuts) our corner piece.

- Select **Edge Ring**.

- Select the **Connect** tool with the **option box** and set the following:

    **Segments**: 1

    **Pinch**: 0

    **Slide**: 0

- Press **OK** to apply these cuts.

- Add one edge ring to each side of the last cut using the same **Connect** tool options.

**8    Extrude walkway connector.**

With our new edge loops in place, we will extrude one last time to create a connector piece that will join the corner platform to the middle section.

- Select the two inner side Polygon faces.

- Using the Extrude tool with the option box, and set the following:

    **Extrusion Type**: **Local Polygon**

    **Extrusion Height**: **28**

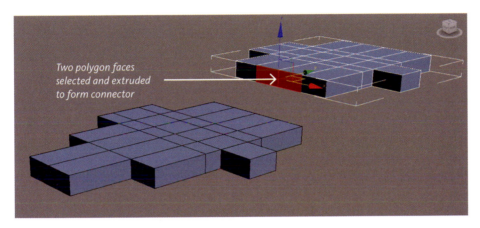

Two polygon faces selected and extruded to form connector

*Walkway connector extruded.*

**9    Cleanup.**

With our newly extruded connector piece done, we need to clean up the large middle edge loop. Doing this is easy.

- In **Edge Sub-Object** mode, select the middle edge.

- Select **Edge Loop** to select the entire edge.

- Use **Ctrl+Backspace** to remove the selected edge loop.

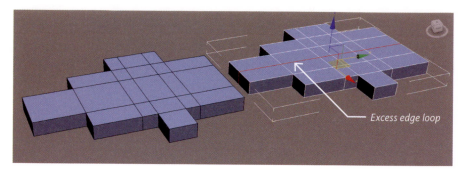

*Edge loop cleanup.*

10   **Adding trim detail.**

Now that our corner piece is nearly done, we can use the techniques and meshes we created earlier for our walkway to add trim detail to this piece.

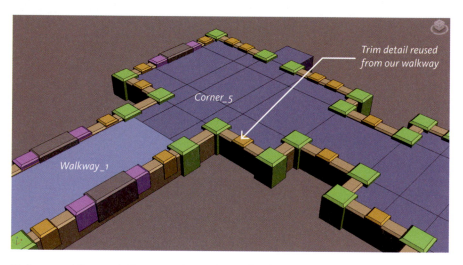

*Walkway and Corner platform together with trim detail.*

11   **Save your work.**

- Save your scene as *13-Corner_01.max.*

## Arch

Next, we will create a nice architectural arch to go under our walkway. This will serve as the basis for our platforms foundation. To make the arch, we will use the **Bridge** tool, and the **Make Planar** tools.

1    **Cylinder primitive.**

We will start with a simple cylinder primitive to create the actual curve of the arch and then cut out what we need.

- Create a new **cylinder primitive**.

- Set the following parameters in the **Create** panel:

    **Radius**: 20

    **Height**: 32

    **Height Segments**: 1

    **Cap Segments**: 1

    **Sides**: 15

    **Slice**: Checked

    **Slice From**: 0.0

    **Slice To**: 180.0

- Convert the cylinder to an **Editable Poly**.

- Name our half cylinder *Arch_1*.

- Press **A** to toggle **On** your **Angle Snaps**.

- Rotate the cylinder 90 degrees on the X axis.

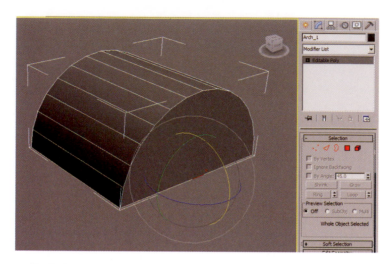

*Half cylinder rotated 90 degrees on the X axis.*

**2    Extrude out our arch.**

Next, we will extrude the outer polygon faces to begin making our arch.

- In **Polygon Sub-Object** mode, under the Selection rollout set the following:

   **Ignore Backfacing: On**

   **By Angle: On**

   **By Angle: 45**

- Select any outer face to select them all using the **By Angle** selection feature.

- Extrude the selected faces with the option box and these settings:

   **Extrusion Type: Local Polygon**

   **Extrusion Height: 10**

**3    Using Make Planar tool.**

We will use the Make Planar tool to quickly shape our arch.

- Select the bottom faces of our arch and use **Make Planar** tool on the Y axis.

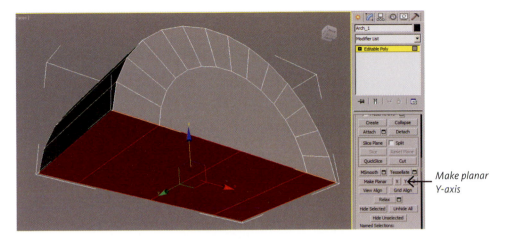

*Bottom of Arch flattened using Make Planar on the Y axis.*

- Turn **Off By Angle** in the **Polygon Sub-Object** mode Selection rollout.

- Select the top most six polygon faces of our arch and use **Make Planar** on the **Y** axis.

- With the remaining polygons on the sides (four on each side), select them and use **Make Planar** on the **X** Axis.

- Next, select our newly flat sides and use the **Extrude** tool with **option box** and these settings:

  **Extrusion Type: Local Polygon**

  **Extrusion Height: 6**

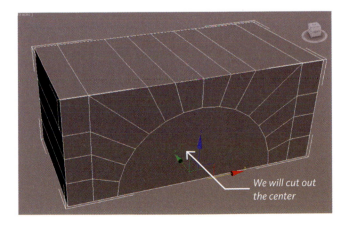

*complete. We just need to cut out the center now.*

4    **Cut out the center.**

All that is left is to cut out the center of our arch. We will delete these interior faces and then use the Bridge tool to create the inner ceiling.

- In **Polygon Sub-Object** mode, select and delete the center of our arch. Do not forget the bottom faces as well.

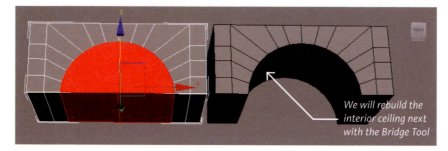

*Select and remove the center of the arch.*

>
>
> **Note:**    *The Bridge tool allows us to connect edges with a new polygon face when in Edge Sub-Object mode. When on, simply select two edges to bridge them.*

- In **Edge Sub-Object** mode, using the **Bridge** tool, build the interior ceiling of our arch by selecting an edge on one side and then selecting the matching edge on the opposite side.

- Select the bottom faces of our arch and **Extrude** them by **32**.

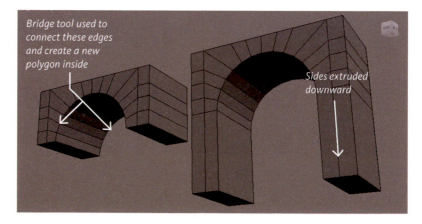

*Interior complete and side columns extruded downward.*

**5**    **Arch trim detail.**

With our arch complete, we could add additional detail much in the same way we did for our platform, though this is completely optional.

**6**    **Save your work.**

- Save your scene as *13-Arch_01.max*.

## Sky dome

The last step in this lesson will be to create a simple sky dome that we can use to encompass the environment but also fake the illusion of a sky and clouds. Creating a sky dome is quite simple but it will add a lot of life to our environment once we get to texturing it.

**1**    **Create a new scene and save it.**

- Save your scene as *13-SkyDome_01.max*.

**2**    **Create a half sphere .**

A sky dome is exactly what it sounds like—a large dome that will compass the entire scene. Rather than a full sphere however, we will cut it in half to simulate where a horizon might be.

- Create a new **sphere** primitive.

- Set the following parameters in the **Create** panel:

    **Radius: 800**

    **Segments: 32**

    **Hemisphere: 0.5**

    **Generate Mapping Coordinates: Checked**

- Convert to Editable Poly.

- Rename our sphere *SkyDome*.

- In Polygon Sub-Object mode select and delete the bottom.

> **Tip:**    *You can select all of the bottom faces by turning on Ignore Backfacing and By Angle (set to 45 degrees) in the Selection rollout.*

- In Vertex Sub-Object mode, select all vertices in the sphere by pressing **Ctrl+A**.

- In the Edit Vertices rollout, use the Weld tool. Default settings are fine. This will help us clean up some unneeded vertices.

**Note:** *Because we will only see the sky dome from inside, we will need to flip the Polygon faces so that they are visible from inside the sphere.*

- In Polygon Sub-Object mode, select all faces (**Ctrl+A**).

- Flip the selected faces by using the **Flip** tool under the **Edit Polygons** rollout.

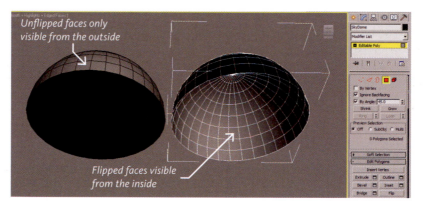

Unflipped faces only visible from the outside

Flipped faces visible from the inside

*Sky dome faces flipped to be visible from the interior.*

3   **Save your work.**

- Save your scene as *13-SkyDome_01.max*.

## Merging assets into a scene

Throughout this lesson we have created several smaller assets. On their own, they are only small parts of the puzzle. But together, they can create a scene or environment. To bring all of these assets together, we will need to merge multiple MAX files together into on complete scene.

1   **Create a new scene and save it.**

- Save your scene as *13-EnvironmentMerge_01.max*.

**2    Merging scene files.**

We will now merge all of our previous max files into this scene.

- Select **File → Import → Merge**.

- Select your first .max file to merge.

- In the **Merge** dialog, select all the meshes you would like to merge and press **OK**.

- Repeat this process for each asset you would like to merge into your scene.

*3ds Max 2010 Scene Merge dialog.*

**3    Save your work.**

- Save your scene as *13-EnvironmentMerge_01.max*.

## Conclusion

We have covered a lot in this past lesson. You should now be comfortable working with Editable Poly objects, using tools such as edge loops and edge rings, the Chamfer tool, and the Bridge tool. In learning these tools, you also learned many of the basic techniques used in modeling environments for games. You should also now have a basic understanding of 3D Snaps and their uses. And lastly, you should understand how to merge multiple scenes into a single scene file. Our next lesson will cover texturing for our game environment.

# Lesson 14
## Unwrapping and Texture Maps

In the previous lesson, we took a rough block out and made some sense of it. We created a detailed walkway and corner platform, as well as an arch to support our platform. We then created the sky dome for our environment. In this lesson, we will get rid of the flat shaded models and bring them to life with texture. In Project 2, you textured a smaller asset. Unlike props, larger environment assets share and reuse textures quite a bit. All walkable surfaces on our platform for example, will use a tileable ground stone texture that we will discuss in more depth.

**In this lesson you will learn the following:**

## Texture sheets and tileables

As mentioned in our intro to this lesson, environment and architectural objects are not always textured like small, unique assets. This is largely due to the number and size of textures that would be required to cover these larger surfaces. Instead texture sheets or atlases are used in conjunction with tileable textures. Texture sheets combine similar, smaller details that can be tiled in one or directions. They often also include small details that can be mapped to many objects. Tileable textures on the other hand are generally one large square texture that can tile in all directions, much like a checker pattern on a kitchen floor.

1    **Texture sheets and their applications.**

To show the use of texture sheets and tileables, we will take a look at our walkway that we created in Lesson 13 and illustrate how we will go about texturing it in the coming pages.

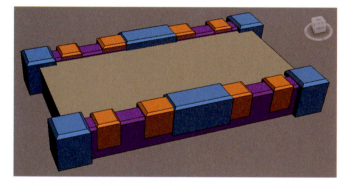

*Walkway trim. Each color represents a portion on our texture sheets.*

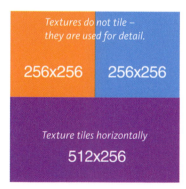

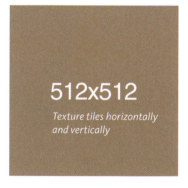

*Texture sheet or atlas. Contains some tiling elements and some detail elements.*

*Tileable texture tiles in both the X axis and Y axis.*

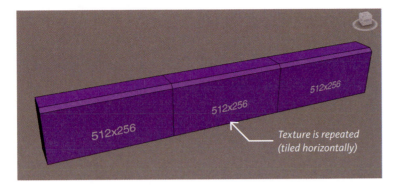

*Tileable texture applied to side trim piece. Texture is repeated horizontally.*

2    **Tileable texture for our walkway surface.**

The first part of our walkway we will texture will be our walkway surface. It is made up lots of tiny stones, dirty and worn over time. We will use a 512x512 tileable texture for this surface.

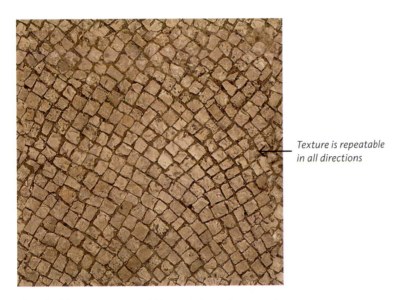

*This tileable stone texture will be used for walkway surface.*

- In the **Material** editor, create a new **Standard** material and name it *stoneGround_MAT*.

- In the current projects source images directory, locate the file *stoneGround_CLR.tga* and use as your Diffuse Color map.

- Ensure **Show Standard Map in Viewport** is enabled.

- Select the walkway surface mesh and Isolate your selection by pressing **Alt+Q**.

- With the walkway mesh selected, apply your newly created material to it.

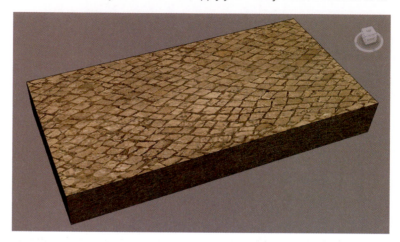

*Note the undesirable stretching on the surface and sides of the walkway.*

> **Tip:** *You can also create a new checker material and apply it to a mesh to quickly check for stretching while texture mapping an object. In an ideal situation, the checker map should be made up of perfect squres, not stretched rectangles or other skewed shapes.*

3    **UVW Mapping our walkway surface.**

Next, we will fix the stretching that we see on the surface of our walkway using the **Quick Planar Map** tool. We are not too concerned about the sides and bottom because they will never be seen in our environment. The sides for example, will be covered up the by the trim detail we created in Lesson 13.

- Select our walkway mesh and apply an **Unwrap UVW** modifier to it.

- Set our **Sub-Object mode** to **Face** and select the surface of our walkway.

- If your **Edit UVW's** window is not already open, you can press the **Edit** button in the Parameters rollout of the modifier.

- In the Map Parameters rollout, ensure **Averaged Normals** is chosen and then press the **Quick Planar Map** button.

- Our stretching is now resolved, however the stones are twice as large as we would like them to be.

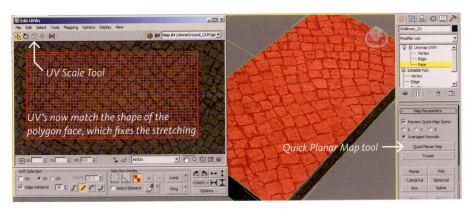

*Texture stretching has been fixed, the stones are now too large.*

- Select the UV Scale tool in the Edit UVW's window and scale up the surface face to make the stones about half the size or until it looks good. Scaling up the face means more texture or pixel density will be used, effectively making the stones smaller.

*UVs scaled up 50%.*

**4   UVW Mapping the details.**

With our walkway surface textured, we will now focus our attention on the trim details. For these pieces we will use a texture sheet or texture atlas, much like the example at the beginning of this lesson. To start, we will texture the long side trim mesh. However, we will have to make a small adjustment to illustrate a point:

*Trim will need to be subdivided to avoid texture stretching.*

*Detail texture sheet/atlas.*

- Using what we learned in the previous Lesson, use the Edge Ring tool to select all the edges around the trim mesh. Then, using the Connect tool, subdivide the trim piece evenly into three parts.

- We are now ready to UVW Map the trim. Apply an Unwrap UVW modifier to the mesh.

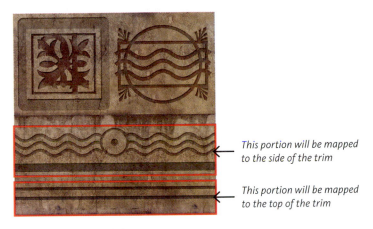

This portion will be mapped to the side of the trim

This portion will be mapped to the top of the trim

*Detail texture sheet/atlas.*

- We will use the same techniques we used to map the surface of our walkway to map this trim. Select all three faces along the side and use the **Quick Planar Map** tool.

- Position the three faces along the detail strip of the texture. Scale and fit as necessary.

- Use the same methods to texture map the top and sides of the trim mesh.

*Trim is textured using the texture sheet/atlas.*

- Using the same tools and techniques (Quick Planar Map, simple UV moving, and scaling) and the image below as a guide, texture map the rest of the trim.

*Completed textured trim pieces.*

- Because we instanced all our trim, it means we only have to unwrap one instance and the rest are done. Since we no longer need our instances, we can finally attach all of our pieces into one mesh. Our final result:

*Our complete walkway, 100% self-illuminated.*

5    **Save your work.**

- Save your scene as *14-WalkwayTextured_01.max.*

## Unwrap and texture the sky dome

Next we will unwrap the sky dome mesh we created previously with some help from the **UV Relax** tool.

1   **Unwrap the sky dome.**

- Open *13-SkyDome_01.max*.

- In the **Material editor**, create a new **Standard material** and name it *skyDome_MAT*.

- In the current projects source images directory, locate the file *skyDome_CLR.tga* and use it as your Diffuse Color map.

- Ensure **Show Standard Map in Viewport** is enabled for the material.

- Apply the newly created material to our Sky Dome.

- Apply an **Unwrap UVW modifier** to our Sky Dome.

- In **Face Sub-Object** mode, select all faces.

- Use the **Quick Planar Map** tool on the **Z** axis.

*Texture sky dome mesh—note the stretching near the bottom.*

- To alleviate the stretching near the bottom edge, we will use the **UV Relax** tool.

- In the Edit UVW's window, access the Relax tool **Tools → Relax...**

- With all faces selected (**Ctrl+A** in **Face Sub-Object** mode), leave the settings at their default and press **Start Relax**.

- Watch as 3ds Max 2010 relaxes your UVs in real time, flipping your UVs inside out and back to normal again.

- When the Relax beings to really slow, press **Stop Relax**.

- Scale and tweak your UVs to fit to the edges of *skyDome_CLR.tga*.

- Using the **Relax** tool, we have eliminated a majority of the stretching

*Texture sky dome mesh—note the stretching near the bottom.*

2   **Save your work.**

- Save your scene as *14-SkyDomeComplete_01.max*.

# Using the Viewport Canvas tool to add grunge detail

When texturing our walkway surface we made use of a tileable texture  our stone walkway surface texture. This tileable texture helped us cover a large surface without having to create a large unique texture that could only be used once. Though the use of tileable textures has its upsides, it too has one rather large downside. For a game like Demigod, the player will observe the game from a high camera angle. From this vantage point, the tileable texture looks tiled! But ist that not what we wanted? Tiled textures work well in say a First Person Shooter where it is rare that a player will ever see the ground or other large surfaces from far away. But in an RTS like Demigod, the tiled nature is very apparent. To remedy this, we will make use of the Viewport Canvas tool to add some unique detail. This method could be used on a one giant mesh to add grime to all our walkways. For now, we will focus on our singular walkway and break up the tiling.

1   **Prepare the surface for painting.**

   - In Polygon **Sub-Object** mode, select the top face and duplicate it as a new object. **Shift + Drag LMB** to this.

   - Select **Clone to Object** and name is *GrungePlane*.

   - This new Polygon face should sit just about the surface of our walkway.

   - N ext, we need to ensure the UVs are not tiled. Apply an **Unwrap UVW** modifier to the face, and do a **Quick Planar Map** on it.

2   **Viewport Canvas tool.**

   - To open the Viewport Canvas tool, from the top menu **Tools → Viewport Canvas**.

   - With our *GrungePlane* selected, press the Setup button in the **Viewport Canvas** tool and set the following settings:

      **Assign New Texture**: **Checked**

      **Width**: 512

      **Height**: 512

      **Color**: **White**

      **Save new texture to: Specify a name and location**

- Press the **Setup** button.

- We now have a paintable surface ready to go.

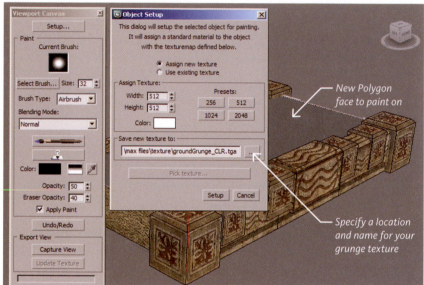

*Texture sky dome mesh—note the stretching near the bottom.*

3   **Paint our grunge alpha.**

Now that we are setup to paint, we will begin painting our grunge alpha. The idea here is that dirt and grunge build up along the sides of our walkway. Using the Viewport Canvas, we can paint directly onto the surface of our new polygon face. We will then take the image saved out by the Viewport Canvas tool and use this as an alpha or guide for where our dirt and grunge will be.

- Position your camera directly above our walkway.

- Select the paintbrush button when you are ready to start painting.

- Experiment with different brushes, sizes, and blend modes.

*Grunge alpha painted with Viewport Canvas tool. Black indicates where dirt and build up would occur.*

4    **Create grunge material with alpha.**

Now that we have generated our grunge alpha, we can use it in the alpha channel of a dirt texture. This texture can then be used to create a material that we can apply to our *GrungePlane* to complete the look.

- In the **Material** editor, create a new **Standard** material and name it *groundGrunge_MAT*.

- In the current projects source images directory, locate the file *groundGrunge_CLR.tga* and use it as your Diffuse Color map.

- In the Maps rollout of the **Material** Editor, drag and drop the *groundGrunge_CLR.tga* from our **Diffuse Color** slot to our **Opacity** slot as a **Copy**.

- Inside the **Opacity** slot parameters, under the **Bitmap** parameters rollout, set **Mono Channel Output** to **Alpha**.

- Return to the top level of the material and ensure **Show Standard Map in Viewport** is enabled for the material.

- Apply the newly created material to our *GrungePlane* mesh.

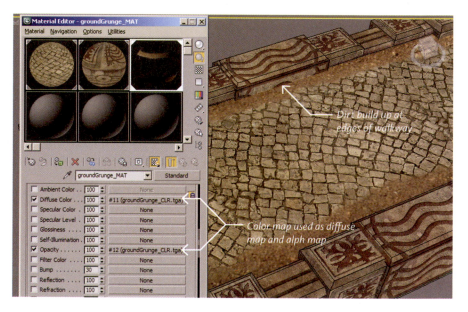

*groundGrunge_MAT applied to our floating polygon face to add the illusion of dirt and buildup at the edges of our walkway.*

5    **Save your work.**

- Save your scene as *14-WalkwayComplete_01.max*.

## Conclusion

In this lesson we have covered quite a bit about how to texture larger surfaces using only a small set of textures. You should be fairly comfortable with unwrapping and using the Edit UVW's window. As well, you should have a basic understanding of texture sheets/atlases and tileable textures. We then used the Relax tool to map our sky dome and lastly, you learned about a cool new tool called the Viewport Canvas, which lets you paint directly onto your models in 3D!

# Lesson 15
## The Camera

In this brief lesson we will learn how to use the camera and its settings to better frame our work. We will discuss free cameras as well as targeted cameras and their movement and rotation controls. We will discuss what makes one shot better than another and lastly we will touch on the Safe Frame viewport mode to ensure what we see will be visible in our renders in the next lesson.

**In this lesson you will learn the following:**

- The different types of cameras available in Autodesk® 3ds Max 2010® software

## Creating a new camera

In 3ds Max 2010, when creating a new camera there are two types for us to choose from. Each is best used in certain situations. The first option is the target camera. This camera allows you to easily focus on a particular object or set of objects. It is ideal for static shots or animated shots that will revolve around a central point. In Project 6 we will use an animated target camera to rotate around the focus of our scene. The second option is a free camera. As its name implies, the free camera does not have a target or focus. Though this type of camera could be used for still shots as well, it is particularly flexible when animated. Because it does not have a specific target, it can freely move around a scene and even more, can freely rotate up or down independent of a focal point. It is important to note that the target ability is the main difference between the two cameras. They function identically otherwise and because of this, we will learn about the target camera.

1    **Open sample scene.**

We will start with a sample scene that contains our walkway from the previous less as well as a simple cube to act as our target.

- Open *cameraStart_01.max*.

2    **Create a target camera.**

- Navigate to the Top view by using either the **ViewCube** or Pressing T.

- With the **Create** panel active, locate and select the **Cameras** button.

- Create a new **target camera** by **LMB**-clicking at the bottom of the screen and dragging toward our simple box target.

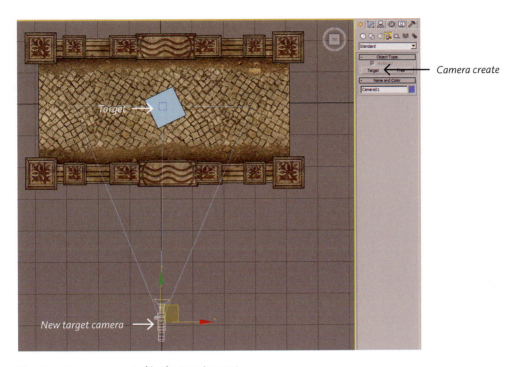

Camera create

Target

New target camera

New target camera created in the top viewport.

Dolly    Roll

Field of View    Truck    Orbit

Camera Viewport Controls

3    **Camera controls.**

Both target cameras and free cameras use the same view controls. These controls are very similar to the regular viewport controls you are already accustomed to. Now that we have a new camera in our scene, we will change our view to be through the lens of this camera.

- Ensure the viewport is active (noted by the yellow border) and Press C to enter the view of our new camera.

- Refer to the image on the previous page and experiment with the different camera controls in your scene.

- Using these new camera controls, position the camera so that our walkway and our box target are visible.

*Our scene through the lens of a camera.*

4    **Using the camera target and Quick Align.**

The camera target is incredibly useful in focusing the cameras view. We will quick align the camera target to our box target in Perspective view and move the camera around to illustrate its attachment.

- Ensure the viewport is active and Press **P** to enter **Perspective** view.

- Open the **Select By Name** dialog and select *Camera01.Target*.

- Press **Shift+A** to enter **Quick Align** mode and select our box target. Our camera target is now focused on the box.

- Using the **Move** tool, select the camera and move it around the viewport. Note how it always stays focused on our target.

- At any time, return to camera view by pressing **C**.

*Our camera orbits around its target.*

5   **Creating interesting camera shots.**

Simply placing a camera in a scene will not give you an interesting camera shot. High-budget films and games all labor over how a particular scene should be shot and presented to the viewer or player respectively. Changing something as simple as the camera angle can completely change what is being communicated to the audience. We will use this in practice in Project 6 when we bring together our entire scene. A few tips for creating an interesting shot:

- Three-quarter angles show more detail and depth than a straight on view.

- Low angles will make the subject appear to be larger and more menacing.

- High angles will have the opposite effect.

- Viewing an object from the same angle as the scenes main light source is less interesting as the lines created by this shot are going in the same direction.

- Think about where shadows and lights would be when planning your shot.

- Using objects to show scale such as doors, crates, or other objects that someone can relate to the size of, will help ground the viewer.

- In most cases, your target object should be the most interesting thing in view.

- Be aware of adding too much detail or noise in the background.

- Lastly, think about foreground, mid-ground, and background elements and how they can add interesting shapes to the scene.

*Camera angle lacks visual interest and is perfectly aligned with the camera.*

*Camera is more interesting. It is also not aligned to the camera.*

Project 03

**6    Using safe frame.**

Safe frames help you determine what will be visible and what will be hidden when your scene is rendered at a particular size, intended for a PC or TV for example. Television content and games are often presented in HD (high-definition format). On a standard square television, this means some of the content will be cut off at the edges. Using safe frame, we can see what content will be cut off and adjust our camera and scene accordingly. The safe frames will show us what to expect with our current render dimensions. We will discuss this in more detail in Lesson 17.

- In Camera View, press **Shift+F** to activate **Safe Frames**.

- Move your view around and note that some of the scene is cut off at the edges.

- Using your **Camera viewport** tools, **Zoom**, **Pan**, and **Orbit** to ensure all of our walkway is visible inside the safe frames.

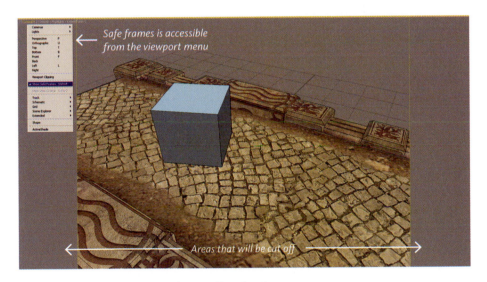

*Camera is more interesting. It is also not aligned to the camera.*

## Conclusion

In this brief lesson we learned the basics of using Cameras in 3ds Max 2010. We discussed the different types available, how to manipulate our view using the camera viewport controls, and how to align our camera target to other objects using the Quick Align tool. Lastly, we discussed what makes a good camera shot and how to use tools such as safe frames to our advantage. We will continue this in more depth in Project 6 as we bring our whole scene together.

# Lesson 16
## Introduction to Lighting and FX

Up until this point, we have dealt with Autodesk® 3ds Max® software's default lighting to view our models. However, adding our own custom lighting will greatly improve the look of our overall scene. Great lighting is the difference between making something look believable and having it look cheesy. In this Lesson we will talk about the different types of lights available in 3ds Max 2010 and how to use them together to get nice results. We will discuss rendered lighting versus real-time lighting. We will then build on all this by using some basic render effects before getting into detail on rendering in our next lesson.

**In this lesson you will learn the following:**

- The different types of lights available in 3ds Max 2010

- How to add lighting to your scene

- Enabling basic shadows for your lights

- Using real-time viewport soft shadows and ambient occlusion

- Tweaking your lights and shadows for better looking results

- Adding ambient environment light

- Using interactive post FX

## Adding lights and shadows

In 3ds Max, there any many standard light types, including the omni light, spotlight, direct light, and skylight. Because our scene is exterior we will mainly be dealing with the direct light (as our sun). Omni lights could also be used as a torch light, or special light glow for a magical portal. The spotlight works well for darker scene and could be used as a headlight from a car, a light fixture in a back alley, or anything similar. The skylight, however, is used to create a global amount of light everywhere. This light type can be very important because most scenes will rarely ever be pitch black in places and adding a skylight adds a small amount of bounce light to the whole scene. In the real world, light bounces off of surfaces into darker places solving the same issue as the skylight.

1    **Open sample scene.**

We will use the same sample scene as our last lesson but with a few tweaks.

- Open *lightingStart_01.max*.

2    **Add a directional light.**

- With the **Create** panel active, locate and select the **Lights** button.

- Ensure the drop down is set to **Standard** and not **Photometric**.

- Select and create a new **Target Direct light**.

- With the light still selected, position it up above our walkway. Much like the Target Camera from our previous lesson, the Target Direct light uses the same target to focus the light.

- Move the target of the light to the center of the walkway.

- Scale up the light to encompass the entire walkway.

- Render the scene by pressing **F9**.

*Position of the new Target Direct Light.*

**Tip:** *You can toggle between default light and custom lighting by pressing* **Ctrl+L**

3    **Enabling shadows.**

Our scene is still looking a bit bland, but we can fix this. Let's start by adding some shadows.

- Select the Target Directional light.

- In the General parameters under the Shadow group of our light, turn On Shadows. We will leave the shadow type to **Shadow Map**.

- Render the scene.

*Scene render with shadows enabled.*

4    **Enable hardware shading (if possible).**

Hardware shading will allow us to tweak the properties of our light and see results in real time. This is incredibly important if you are trying to achieve a certain look. Real-time feedback makes this process much quicker!

* Enable **Hardware Shading** by pressing **Shift+F3**.

* You should now be seeing the same results from our render directly inside your viewport.

* To speed up your viewport, we can disable Ambient Occlusion for now. We can do this from the **Viewport Label Menu**.

*Viewport Label Menu.*

*Real-time viewport shadows.*

**5**   **Tweaking our directional light.**

It is time to give our small scene some atmosphere and set a time of day—dusk. The easiest way to do this is to give our light some color. Pure white lights do not exist in the real world. Even artificial fluorescent lights will contain a hint of color.

- Select the Target Directional light.

- In the General parameters under the Intensity/Color/Attenuation group of our light, click on the color swatch to change the color of our light. The following RBG values look good for a late evening look:

  **Red**: 251

  **Green**: 217

  **Blue**: 162

- Next, adjust the brightness of our **light intensity** to **1.3**.

- Experiment with these values!

*Light color and intensity tweaked for a late evening look.*

6    **Tweaking our shadows.**

Now that our light color and intensity is starting to look much better, we need to tweak our shadows. Shadows in the real world are never completely black. In 3ds Max, the attribute that affects this is called Density. As well, most shadows contain some color, which we will add.

- With the Target Directional light still selected, scroll down to the Shadow Parameters rollout and set our Density to 0.5.

- Next, we will add a tiny bit of blue to our shadows to reflect the color of the sky. Select the color swatch next to Density and use the following RBG values:

  **Red**: 13

  **Green**: 37

  **Blue**: 72

- Experiment with these values!

*Shadow density set to 0.5 with some blue added for color.*

7    **Adding ambient light.**

Lastly, we still have a few black crevices that should be receiving some bounce light. The solution is to use global illumination, however it is quite costly and we cannot view it in real time in the viewport. One alternative is to simply turn up the ambient light in the scene.

•  Select **Rendering** → **Environment** to bring up the Environment and Effects dialog box.

•  In the Common parameters rollout, in the Global Lighting group, select the Ambient color swatch to change its value. Set the Value slider to 40 and press OK.

•  Experiment with these values!

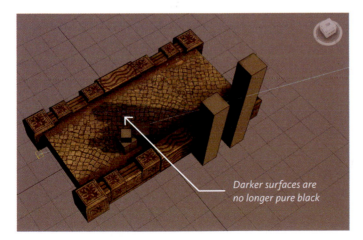

*Darker surfaces are no longer pure black*

*Shadow density set to 0.5 with some blue added for color.*

## Post effects

With our lighting near complete for this test scene, the last thing we will do is fine-tune the end result. This can be done using Effects. These changes tend to be minor tweaks that are much easier to do in post production. These same minor tweaks could be accomplished in other programs, such as Photoshop®; however, being able to make these changes in 3ds Max is much faster.

1    **Adjust contrast**

We will add a slight amount of contrast to our scene

- Select **Rendering** → Environment or press **8** to bring up the Environment and Effects dialog box.

- Select to the **Effects** tab.

- In the Effects rollout, click Add and select **Brightness and Contrast** from the Add Effect dialog box.

- In the Preview group, enable **Interactive**.

- In the Brightness and Contrast parameters, set Brightness to **0.55** and Contrast to **0.60**.

- Experiment with these values.

2    **Color balance.**

Now we will add a Color Balance effect.

- In the Effects rollout, click Add and select Color Balance from the Add Effect dialog box.

- Tweak the Color Balance parameters until you are satisfied.

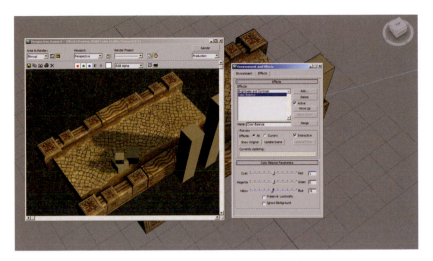

*Color balance and contrast were tweaked with Effects after the fact.*

## Conclusion

You should now be comfortable placing lights and tweaking parameters. We added a sun light source to our scene, tuned its color, and enabled shadows. You then learned about using Hardware Shading so that we could tune our shadows and lights in real time and why adding ambient light your scene is so important. You learned a bit about how to make our lighting and shadows more convincing by reducing the density of our shadows and adding some subtle color to them. And lastly, we used interactive post Effects to tune the contrast as well as the color balance of our final image.

In the next lesson we will cover more rendering topics in detail.

# Lesson 17
## Rendering

In previous lessons we have used Autodesk® 3ds Max® software's default scanline renderer to quickly view how our finished work will look once all lighting and effects have been applied. This process is slower than simply viewing our shadows and FX in real time in the viewport, but will allow us finer control over the final image, as well as allowing us to render out animations directly to a movie file. Though most games render in real time, 3ds Max software's scanline render is still used for marketing images and preproduction visualization.

**In this lesson you will learn the following:**

• How to render your scene

• How to quickly render only a specified region or asset

## Rendering your scene

Using the 3ds Max default scanline renderer, you can quickly preview your work such as lighting, shadows, FX, etc, all without needing a high graphics card. This is because the scanline renderer is not a real-time render and must pre-process your image. Once your image has been rendered you many options, including rendering only specified objects, a selected region of the screen, or even saving out your image!

1   **Open sample scene.**

We will use the same sample scene from Lesson 16 Introduction to Lighting and FX.

- Open *RenderingStart_01.max*.

2    **Using the Render Regions.**

The Rendered Frame Window provides several tools for iterating on our render. Using the Area to Render feature we can render only a small region of the screen to quickly check changes and iterate on our image.

- With our scene open, press F9 to produce a quick render which will open the **Rendered Frame Window**. You can also render your scene by going to **Rendering → Render**.

- In the **Rendered Frame Window** set the Area to Render to Region. Ensure that the **Edit Region** button is checked.

- Select the Target Direct light in our scene and change its color.

- Return to the Rendered Frame Window and press the **Render** button.

- Note that only the selected region was rendered allowing you to compare before and after with having to rerender the entire image!

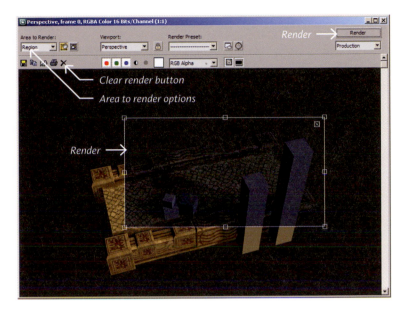

*A specific region of the scene was rerendered with changes made to the scene.*

**3** **Rendering selected objects.**

Using the same Area to Render feature, we can selectively render a certain object, or group of objects. This is useful if you are only tweaking a material or per object element and want to quickly make changes.

- First, select any object in the scene that you would like to selectively render.

- Make a change to our scene, such as changing the Target Direct Light's color.

- In the **Rendered Frame Window**, Set the Area to Render to Selected.

- Press the **Render** button.

> **Note** *You may notice that the whole scene is still being rendered. This is nott actually the case. 3ds Max will render regions or selected objects on top of the previous render. To clear the render, press the clear button (black x) in the upper right of the Rendered Frame Window and rerender to see the changes.*

4    **Rendering with a matte shadow.**

The matte shadow material will allow you to render your object with shadows as if it were on a green screen. When applied to a mesh, the matte shadow material will only render the shadows and not the object.

- Create a new plane primitive.

- In the **Material Editor**, select an empty material slot, and create a new **Matte/Shadow** material by clicking the **Standard** button.

- In the Matte/Shadow basic parameters rollout, you will find a shadow sub group where you can adjust things like the shadow color.

- Apply your new material to your plane mesh.

- Render your scene. Note that the plane mesh was not rendered, only the shadows that fell on the plane were.

5    **Saving your still image render.**

Once you have a render you are satisfied with, you can then save it out as a file.

- In the Rendered Frame Window, click the Save button (disk icon) just beneath the Area to Render dropdown.

- If you want to save the alpha channel as part of your image, choose the TGA format, and when prompted, choose 32-bits per pixel.

6    **Rendering a simple animated movie.**

Now that we know how to render a single frame, let's render a simple animation using a camera.

- With our scene in view, press **Ctrl+C** to create a new camera from your view.

- Press **N** to active animation mode. Your timeline at the bottom of the screen should now be red to indicate it is active.

- **RMB** on the time slider and press **OK** to create a key frame for position, rotation, and scale.

- Scrub the slider to frame 10.

- Using the camera tools, zoom, pan, or truck around the scene.

- **RMB** on the time slider again and press OK to create a key frame. Press **N** again to exit animation mode.

- With a very simple animated camera in place, it's time to setup our render. Press **F10** or go to **Render → Render Settings**.

- In the **Render Settings** dialog, on the Common tab, change **Time Output** to **Range**. Our range should be 0 to 10, since we only animated 10 frames.

- Next, in the Render Output group, select **Files** and choose a location to save your movie. Save your movie in the MOV format (QuickTime). Any quality settings will do.

- At the bottom of the **Render Settings** dialog, press the **Render** button.

- Your animation will be saved to the location you chose previously.

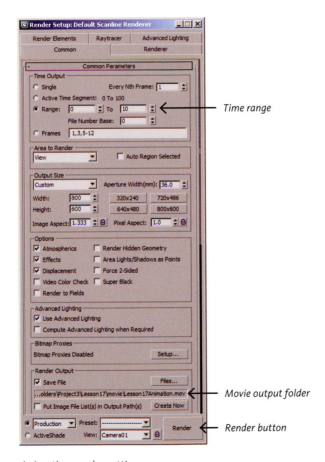

*Animation render settings.*

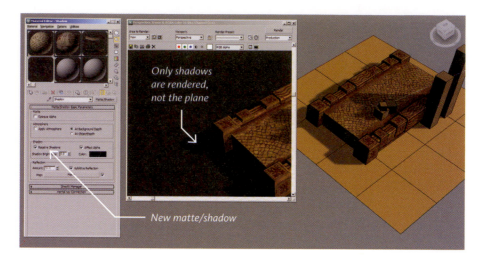

*A matte/shadow material was used to render only the shadows and not the ground plane.*

**7    Adjusting render settings
      for sharper images.**

Lastly, you can adjust which filters 3ds
Max uses when rendering your images. If
you prefer softer renders, the Area filter
is a good, standard choice. However, if
you want sharper, crisper renders, there
are other choices.

- Press **F10** or go to **Render →
  Render Settings**.

- Under the Render tab, under the
  Default Scanline Renderer rollout,
  there is a filter dropdown. For sharper
  renders, choose Catmull-Rom.

- Render your scene and compare.

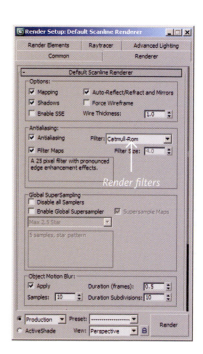

*Catmull-Rom is chosen for
shaper, rendered images.*

## Conclusion

In this lesson we covered some introductory topics in rendering with 3ds Max 2010. We learned how to render our scene, including just specific assets or regions using the Rendered Frame Window. We then talked about how to use the built in Matte/Shadow material to render just your shadows and not a background. We learned how to save our rendered images and movies and finally we saw how to sharpen our rendered images by using filters.

In addition to the material covered in this book on the DVD you will find Projects 4, 5 and 6 where you will learn to model the *Rook* character, animate the *Rook* and render the final scene for your portfolio or reel.

# Table of Bonus Content on DVD!

Continue learning even more including **character creation**, **animation** and **rendering** with over 200 pages of **Bonus Projects** that can be found on the DVD accompanying this book.

**Professional**
Interviews

### What is an average day at work like for a character artist?

My work as a character artist happens in phases:

**Phase One**—Receive concept art depicting the character to be created. This may also include spending an hour or so searching for additional reference photos/images if needed for particular details.

**Phase Two**—Start building a low-poly mesh. This is usually fairly rough in its early stages, and establishes the character's overall mass, proportions, and silhouette. In some cases, this untextured model will be quickly rigged and imported into the game to be evaluated. This helps in spotting weaknesses in the model's readability before any real heavy labor is spent. Once this model is approved by the art lead, the model is then refined to a final game-ready state.

**Phase Three**—Texture the model. The current typical pipeline involves developing a version of the model in much higher polygonal detail for the purpose of developing a normal map, and then establishing the surface color and detail.

### As a character artist what is the most interesting part of your job?

Creating characters that are eye-catching and believable is one of the things that drives me, but I think that the thing I always look forward to most is passing off a finished model to the animator and seeing how they bring it to life.

### What is the most challenging part of your job?

Creating compelling human characters is usually the most challenging task. Human characters in games tend to be the most scrutinized; and poorly executed proportions or features can really break the believability or immersiveness of a game.

### What do you feel are the most valuable skills for a character artist?

Having a solid foundation of drawing, visual design, and a good grasp of anatomy (people and animals) are vital. Familiarity with the current modeling techniques, software, and related tools is a must.

### What advice would you give to aspiring character artists?

Another important skill is having an eye for distinctive physical features and the roles they play in establishing character and personality. This is something that should be actively cultivated through observation.

### What is an average day at work like for an environment artist?

After I get in, I check my email to see what everybody else did the day before and make sure I am up to date. Then I get to work, and aside from the occasional meeting, most of the day is spent at my computer making art. We will often have a different task every day, so sometimes I am painting, sometimes modeling, sometimes scribbling on paper to figure out how to put things together, and sometimes digging through files to figure out why something is not working right. Making environment art is a process that takes weeks, not hours, so every day is only a small part of the total product.

### As an environment artist what is the most interesting part of your job?

Learning new things all the time! Environments are wildly varied and every different part of them—snow, forests, nighttime, daytime, clouds, mountains, rivers, outer space, and alien planets—is a new set of artistic and technical challenges.

### What is the most challenging part of your job?

Probably the same thing. Learning new things is fun and exciting, but it is always a challenge.

### What do you feel are the most valuable skills for an environment artist?

Patience, because even video game worlds are huge, and it sometimes takes a long time for things to come together. Versatility, because working in 3D for games has a hundred small challenges that all have different solutions, and you have to be able to change the way you work. Being observant, because this is a skill that is vital to any artist, and you have to know what the world looks like before you can improve upon it.

### What advice would you give to an aspiring environment artist?

Draw constantly—but if you are an aspiring artist, you probably do this already. Paint from life. Paint outside, and learn how to work with color and light. Take on some big projects and learn how to balance the fun little details with how the whole thing works overall. Have fun with it!

### What is an average day at work like for a studio art manager?

A work day for the studio art manager is very randomized—looking for areas of improvement in all aspects of art production and acting on them takes up much of the day. Working with individual artists on scheduling and mentoring is another important part of the day along with working with the executive team on long- and short-term strategies.

### As a studio manager what is the most interesting part of your job?

Being involved and facilitating the creation of cutting edge and visually stunning artwork is the most rewarding and interesting part of my job

### What is the most challenging part of your job?

Tight schedules and budgets, not finding the right talent for the job—every day is a new challenge, but this also keeps it interesting and finding solutions to these challenges is the best feeling ever!

### What do you feel are the most valuable skills for a studio art manager?

Seeing the big picture—knowing game production from A to Z and knowing the game industry inside and out.

### What advice would you give to aspiring to be a studio art manager?

Learn every aspect of what artist do to create their magic—every tool, every process—everything! Also, take management courses and always look for opportunities to better yourself as a coach and mentor for others, not just other artists but those around you. And finally, learn to manage upward, making sure that your boss knows you have got it covered (and do have it covered!) is the best way to build confidence in others toward you managing key areas of a company!

**Matt Dudley** | Lead Artist

### What is an average day at work like for a lead artist?

During production, most mornings start with plenty of caffeine and an informal look at the work in progress of each artist on the team. A typical day includes lots of communication; talking with artists, designers, and programmers. All this communicating includes feedback and reference for artists and animators on the team. After the bases are covered there is some stolen time spent on planning and concepts for the cool stuff that just has to go in (the kind of stuff that cannot be priority one on a schedule but is too cool to pass up). It makes for a really busy day!

### As a lead artist what is the most interesting part of your job?

The variety of creative minds and ideas that go into making a great game; when things click it is really exciting. It is fun and satisfying seeing the big plans take shape into a great-looking game.

### What is the most challenging part of your job?

Each project is different in terms of challenges, but things can get pretty challenging working within the limitations of time and money. All challenges can be solved with more time and more money!

### What do you feel are the most valuable skills for a lead artist?

It is really important to have a good eye and good observation skills. Good listening skills, lots of practice giving and receiving constructive critique. Plenty of experience in production and making art is key as well.

### What advice would you give to aspiring lead artists?

Production art comes before leading art. Work on projects that inspire you. Practice drawing, painting, photography, and so on, things that involve focused observation. When you are working with a team, practice really listening to what others have to say, even if it is not about your own work. This list could get long, but the things that make a great art team member make for a solid lead artist.

**Paul Zimmer** | Animator

### What is an average day at work like for an animator?

Depending on the exact career path, a combination of:

**Rigging**: Building bone structures for characters, vehicles, or anything with at least one moving part.

**Skinning**: Binding the modeled character to the bone structure so as to control the complex parts of the character with a simpler set of bones, joints, and controls.

**Actual animating**: Animating the character or object as requested by the art or animation lead. Previsualization or cinematics: Storyboarding or otherwise plotting out a cut scene or sequence of animations for a particular story element, special ability, or even just an amusing idle.

**Scripting**: Writing a bit of code to get all your wonderful animation work running properly in the game.

**Teamwork**: Meeting with the other departments to collectively stay on the right track, bring up problems in the pipeline, mention tools or features that will speed up production, or otherwise bounce ideas around.

### As an animator what is the most interesting part of your job?

Being the person in charge of breathing life into every player, enemy, door, talking tree, and City-Crushing-Mechasaurus. At the end of every project, the game can play smooth, the world can look stunning, and the code can be efficient, but it is the character, personality, and life in everything that I feel brings out the emotional responses in the player that maintains a lot of the fun they are having. For example: What good is responsive controls and game-play in a fighting game without the visual of that uppercut and the epic knockback on the victim in its way. Animation gives the player satisfying feedback, sheds light on the personality and style of a character, and visually grounds you within each moment. Every epic or hilarious moment you can think of more than likely involved characters and or props moving around to make it happen. As the animator, you get to build those moments.

### What is the most challenging part of your job?

Transitioning from the idea of a motion; its style, its personality, its character, to the actual finished product. No animator gets the exact look and feel they want on the first try, every time. The most challenging moments are when it is still not right on the 5th, 8th, 20th try. How do you make a talking trashcan feel witty, charming, and well-mannered when it walks? How about when it is just standing around? When it dies? When it swims? There is more than one right way to achieve what you need, but sometimes it takes longer than you would like to figure it out.

**What do you feel are the most valuable skills for an animator?**

A strong understanding of timing, weighting, and anticipation. A willingness to think past reality to find creative solutions that get the job done. The ability to clearly communicate needs, ideas, and techniques without sounding whiny, pompous, or preachy. A never-say-die attitude coupled with the ability to detach yourself, personally, from your work. Just in case the worst happens and everything you worked on gets cut. Understanding that there is never enough time to make anything perfect, settle for awesome and move on. Pay attention to how long it takes you to do certain tasks, and how much of each task can be done in certain amounts of time. Project managers and producers will love you forever when you can provide them with fairly accurate estimates. And do not forget to add 50 percent more time to every estimate you do give them, you never know when you will need that breathing room.

**What advice would you give to an aspiring animator?**

Make sure animation is something you actually want to do 8–12 hours a day 5–7 days a week. There will be days that just plain are not fun, but those days will not faze you if you love what you do. Beyond that, be adaptable. Keep up with new tools, techniques, and always be willing to learn. Like most technical careers, the environment changes fast, you will want to be able to keep up. Be open to any and all criticism. Push your critics to be constructive with their criticism so you can constantly better yourself. Work hard to not take negative critiques personally; there is not enough time in the day to get down on yourself when you could be growing instead. Get to know others in the industry you want to be in. Getting and maintaining your career is as much about what you know as it is about whom you know.

# Notes

Notes

# Autodesk®

## Curriculum
## Creative Careers Classified

### Curriculum
### Industry Careers Framework
www.students.autodesk.com

The demand for complex and high quality 3D modeling, animation and rendering is increasing rapidly and students using the Autodesk toolset can transition smoothly into the workplace.

The Industry Careers Framework (available as a no charge download through our Education and AREA community sites) is a tertiary curriculum solution that approaches learning 3D through the core subjects taught in traditional creative studies including modules on animation and interactive 3D space. The framework is designed to constantly evolve, created by leading industry professionals and influential academia in the global arts and animation community.

The framework can be customized to meet the unique and individual pedagogical needs of Entertainment and Gaming faculties and connects creativity, technical expertise and productivity into a seamless workflow to help students explore the fields of film, games and visual communications.

### Creative Careers Classified
www.autodesk.com/creativecareers

There's a gap between the skills students are learning in school and the job requirements for entry-level positions at top games and film studios. Most graduating students apply for a limited number of "animator" jobs, while hundreds of other entry-level positions go unfilled. Also 3D visualization is opening up and being used in many fields students don't even explore. Here are some lists of entry level position in film and games and a look at some areas of visualization with expanding job opportunities.

Creative Careers Classified is a new micro-site that lives within the **AREA** online community and is designed to expose students to a wide range of entry-to-mid level jobs and help them get the skills they need to obtain these jobs.

The site features:
* "Day in the life" video profiles of media professionals from top games and film studios.

* Job descriptions for careers such as associate prop artist, pre-visualization asset builder, lead for character rigging, and others.

* Downloadable tutorials to help students build the specific skills they need to compete for these jobs – using Autodesk® Maya®, Autodesk® 3ds Max®, and Autodesk® Mudbox™ software.

* Links to the latest job listings at top entertainment media companies.

This content is not only valuable for students to check out on their own, but it can also be used as a valuable teaching tool in the classroom.

# Autodesk®
## Autodesk Animation Academy 2010

The new **Autodesk® Animation Academy 2010** is a flexible curriculum for secondary schools that provides teachers with a sandbox style learning environment to introduce students to the same 3D software tools professionals use in film, games and design visualization.

The curriculum is designed for educators who want to make connections between disciplines and facilitate the type of creative thinking that will play a role in the jobs of the future. Autodesk Animation Academy has been created by leading industry professionals and academia in the global arts and animation community and the curriculum prepares students for the skills needed in the 21st century using 3D applications to tell their stories.

**Animation Academy** is structured to give students the autonomy to explore more than the technical; it provides the foundations for learning 3D applications, conceptual information about each topic along with applied exercises to explore the techniques. The goal is to engage students and stimulate their imagination and curiosity as they learn the applications.

Each Curriculum module is built on a three tiered structure and focuses on learning technology by approaching the technical through a series of conceptual and applied lessons. The projects are designed to enable the students to comprehend a broad range of information and ideas, encouraging innovation and critical thinking.

**Animation Academy** introduces students to professional tools and creative careers options, with project-based curriculum that:

- Supports achievement in art, design, and animation
- Blends traditional and digital creative learning into a seamless solution

**Animation Academy** includes the same software used by industry professionals in film, games and visual communications.

**Autodesk® 3ds Max® 2010**
**Autodesk® Maya® 2010**
**Autodesk® MotionBuilder® 2010**
**Autodesk® Mudbox™ 2010**
**Autodesk® Sketchbook® Pro 2010**

**Animation Academy** fits easily into any existing class structure and the broad range of topics covered relate to how the software is used by professionals in the industry. The core of the curriculum is about creativity and using the tools to explore creativity through a broad range of subjects.

The curriculum is easy to facilitate in the classroom and students will be hands on with the software quickly. It is designed to help teachers feel confident guiding students through the material. The industry focused, engaging projects and non-linear structure provide a sandbox for exploration, whether you're an experienced 3D instructor or new to these tools your students will find the material a doorway to their digital universe.

# Autodesk® Professional Excellence Program

# Enhance your knowledge.
# Advance your career.

Develop your instructional skills and increase your technical expertise with the Autodesk Professional Excellence Program.

## What is Autodesk Professional Excellence?

Autodesk® Professional Excellence (APEX) is a comprehensive collection of Autodesk Media & Entertainment professional development and accreditation programs. APEX provides professional educators with the opportunity to remain current with 3D and 2D software and technology trends. You can obtain accreditation that is recognized globally, connect with peers, find new career opportunities, and ultimately be instrumental in contributing to a more knowledgeable and aware industry.

If you teach Autodesk Media & Entertainment software at academic institutions or Authorized Training Centers around the world, you can benefit from APEX by increasing your expertise and honing your instructional skills. APEX programs offer you:

- Recognition: The opportunity to become an Autodesk Certified Instructor (ACI)
- Guidance: The chance to achieve "Master Trainer" status as an Autodesk Certification Evaluator (ACE)
- Learning: Train-The-Trainer (T3) courses offering professional career development
- Sharing: Resources for networking, learning, and exchanging knowledge within the Professional Instructor Community (PIC) portal on the Autodesk AREA online community
- Opportunities to fulfill Autodesk Training Center instructor authorization requirements by attaining Autodesk Approved Instructor (AAI) status*

    * Limited to instructors at authorized Autodesk® Training Centers

## Autodesk Certified Instructors (ACI)

This certification program sets the bar by providing instructional standards for teaching Autodesk® 3ds Max®, Autodesk® Maya®, Autodesk® Smoke®, Autodesk® Flame®, and Autodesk® Lustre® in the media and entertainment industry. Next, it raises the bar by providing coaching, mentoring, evaluation, and accreditation services to ensure that only the best instructors teach Autodesk software. The ACI Program is available worldwide and includes benefits such as:

- Official Autodesk® Completion Certificate for display
- Learning and training opportunities
- Autodesk® NFR software for instructional content development purposes (3D software products only)
- Featured listing on the Autodesk AREA online community
- Discounts on Autodesk education and training events
- Exclusive access to the Professional Instructor Community (PIC)

To apply or learn more, visit:
**www.autodesk.com/ACI**

Autodesk®

The ACI Workshop was probably the most intense evaluation I've ever had in my life! One of those 'didn't kill me, just made me stronger' type of moments that I'm sure I'll be lecturing my kids about when they get older. It was good to get out of my comfort level and have my weak points exposed. I am using the things I learned from the Workshop in my teaching right now. I feel much more confident in the classroom, and I am now starting to seek out peer evaluation more regularly.

—Geoff Beatty
  Philadelphia University

## Autodesk Certification Evaluators (ACE)

The ACE Program assembles industry-recognized "Master Trainers" from around the world with the goal of advancing APEX programs and expanding their availability. The primary responsibility of the ACE is to coach, mentor, and evaluate candidates that pursue the Autodesk Certified Instructor (ACI) Program. Membership to the ACE Program is through invitation only. Typical qualifications of an ACE include:

- Autodesk Certified Instructor
- High-level understanding of current production environments and workflow
- Experience in a variety of instructional environments
- Solid leadership capabilities
- Production experience in one or more industry markets (i.e. Film, Games, Television/Broadcast, Design Visualization)
- A background in CG or VFX curriculum development and/or instructional design
- Active contributor (i.e. Speaker/Instructor/Judge) at prominent industry events
- Interpersonal career development experience (i.e. mentoring, tutoring)
- Foreign language skills

Other requirements may apply. To learn more, contact: me.certification@autodesk.com.

## Autodesk Professional Instructor Community (PIC)

The PIC is a portal on the Autodesk AREA online community where instructors can network, exchange knowledge, and share best practices for instructing with Autodesk Media & Entertainment products. This resource is exclusive to Autodesk Certified Instructors and invited guests. The site includes:

- Discussion forums
- Interviews with industry professionals
- Job boards
- Member galleries showcasing instructor and student work

To learn more, visit http://area.autodesk.com or contact: pic@autodesk.com.

## Realize your potential with APEX

The Autodesk Professional Excellence Program helps professional educators succeed by staying ahead of the curve. To learn more about how you can benefit from APEX, visit www.autodesk.com/apex.

Autodesk®

A FREE SUBSCRIPTION LETS YOU
DISCOVER MANY WAYS TO DEVELOP
YOUR SKILLS—AND IT PUTS YOU
IN TOUCH WITH THE EXCITING AUTODESK[R]
3D ANIMATION COMMUNITY.

TUTORIALS & TIPS

DOWNLOADS

COMMUNITY NETWORK

ARTISTS' SHOWCASE

**AREA**

WWW.THE-AREA.COM   < GO